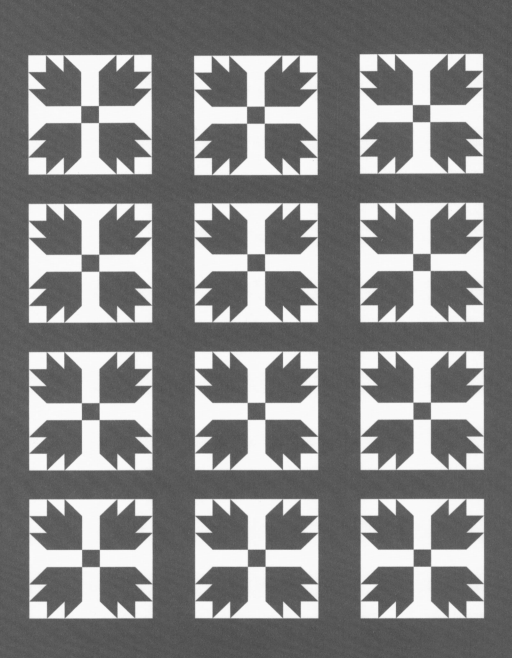

# BLACK AMERICAN PORTRAITS

# BLACK AMERICAN PORTRAITS

From the Los Angeles County Museum of Art

Edited by Christine Y. Kim and Myrtle Elizabeth Andrews

Texts by

Hilton Als

Naima J. Keith

Myrtle Elizabeth Andrews

Christine Y. Kim

Bridget R. Cooks

Dhyandra Lawson

Ilene Susan Fort

Jeffrey C. Stewart

Produced by
Los Angeles County Museum of Art
in collaboration with Spelman College

Published by
Los Angeles County Museum of Art
DelMonico Books • D.A.P. New York

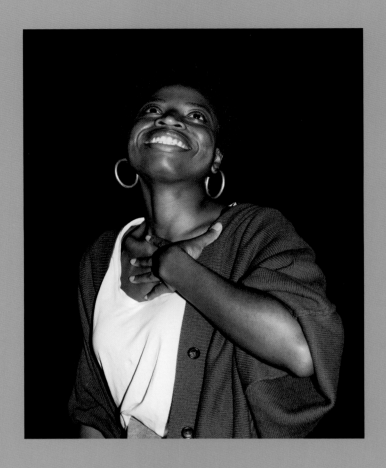

*Such is the power of the photograph, of the image, that it can give back and take away, that it can bind.*

—bell hooks, *Art on My Mind: Visual Politics*

# Table of Contents

# Foreword

The Los Angeles County Museum of Art (LACMA) organized *Black American Portraits* (November 7, 2021–April 17, 2022) to address representation in a way that would encompass both its exhibition program and its collection. The reckoning of 2020 illuminated the existing need to focus on this issue—compelling us to do something urgently that would also have a lasting impact—and our presentation of *The Obama Portraits Tour* from the National Portrait Gallery provided the perfect opportunity to take a deeper look at how Black artists and subjects have appeared on LACMA's walls and in its permanent collection. The *Black American Portraits* show was inspired in part by *Two Centuries of Black American Art: 1750–1950*, a seminal exhibition curated by David C. Driskell that opened at LACMA in 1976. As we planned *Black American Portraits*, we looked back at the museum's history since *Two Centuries*, directly and honestly, to see where there were gaps and omissions.

Since museums play such a visible role in writing and rewriting histories of art for wide-ranging audiences, it is imperative that we recognize the importance of representation. Portraits have been an especially powerful mode of visual communication throughout history, and they have a unique relationship to our current moment. While we imagined a big show that would also allow us to build on—or establish—relationships with the communities of Los Angeles in new ways, we were deeply humbled to receive feedback that the *Black American Portraits* exhibition at LACMA brought with it for many the experience of seeing oneself in the museum, some for the first time. The LACMA show featured 140 objects drawn primarily from the permanent collection. More than sixty of those were new acquisitions, meaning that these works will be seen by the public for generations to come. Many will also appear in other venues as part of the *Black American Portraits* tour, allowing more communities across the country to appreciate these important expressions of Black subjectivity.

We at LACMA are thrilled that the tour will kick off at the Spelman College Museum of Fine Art in Atlanta, part of a Historically Black College that has long supported Black artists and art historians, and we are excited to publish this book to coincide with that exhibition. Since books serve as historical markers—and the catalogue for *Two Centuries* set a particularly high bar in that regard—it was essential for us to produce a publication that would document the confluence of ideas and circumstances that led to the *Black American Portraits* exhibition and collection-building effort, one that would celebrate these exceptional artworks. I commend exhibition co-curators Christine Y. Kim and Myrtle Elizabeth Andrews on their landmark show and on this significant publication, which will carry the momentum of *Black American Portraits* far into the future. Finally, I extend my heartfelt gratitude to the artists represented in these pages; their vision, creativity, and vitality continue to guide and inspire us.

**Michael Govan**
CEO and Wallis Annenberg Director,
Los Angeles County Museum of Art

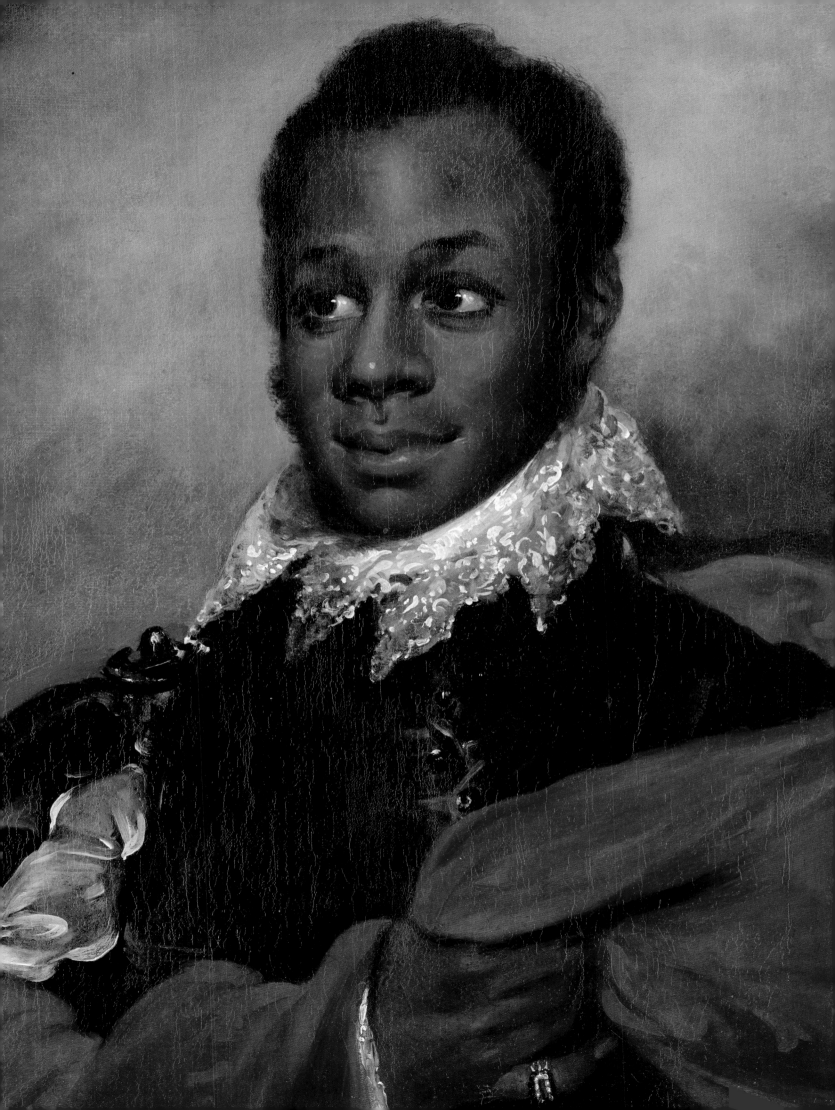

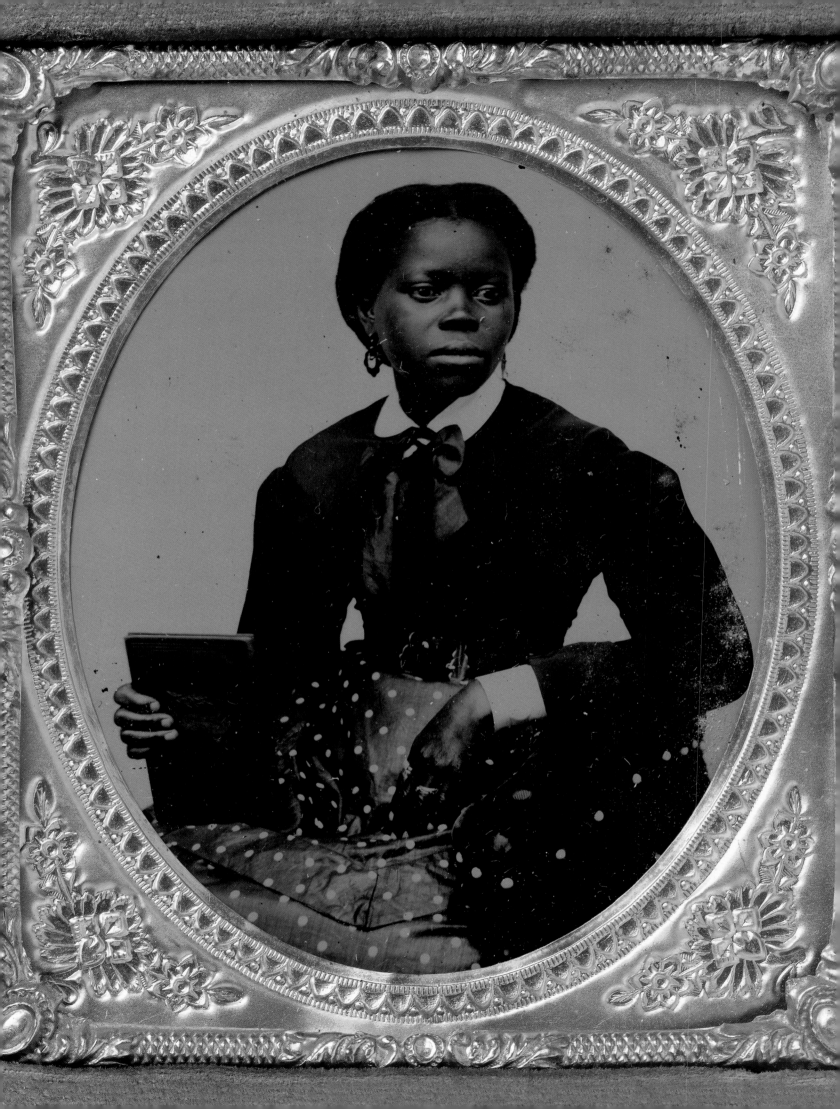

# Foreword

Spelman College is proud to partner with Los Angeles County Museum of Art (LACMA) on the exhibition *Black American Portraits* and this publication. Merging the historic and the contemporary, the exhibition and book document and celebrate narratives of perseverance, love, and struggle that represent Black people as fully actualized figures. *Black American Portraits* is one of the first shows presented by Myrtle Elizabeth Andrews in her role as director of the Spelman College Museum of Fine Art. The exhibition will no doubt awaken countless Atlanta artists, art historians, and curators to new ways of seeing portraiture.

There is a long history of artists and art historians at Historically Black Colleges and Universities (HBCUs). James A. Porter graduated from Howard University in 1927 and went on to serve as an instructor and the head of the art department and gallery at Howard for over forty years. Here in Atlanta, Hale Woodruff founded the art department at the Atlanta University Center (AUC) in 1931 and, along with it, the Atlanta University Art Annuals. This annual purchase prize enabled Atlanta University to build one of the world's great collections of African American art. The AUC, which comprises Spelman and several other colleges, has been home to many brilliant artists—recently including Amy Sherald, First Lady Michelle Obama's official portraitist. Aaron Douglas, another outstanding visual artist, founded the art department at Fisk University in 1939 and oversaw the priceless collection of modern art that Georgia O'Keeffe and Alfred Stieglitz deposited at Fisk in 1949. For over a century, HBCUs have served as incubators for talented Black artists and art historians in which to train, exhibit art, and form art collections that reflect the persistent creativity and excellence of Black Americans.

The presentation of *Black American Portraits* comes at a fortuitous time in the evolution of the arts at Spelman College. For the past seven years, faculty and staff across the college have been reimagining the role of the arts through innovative uses of technology, the establishment of the AUC Art History and Curatorial Studies Collective, and the creation of the forthcoming Center for Innovation & the Arts (CI&A). The CI&A will include new public-facing galleries for the Spelman College Museum, as well as classrooms and study spaces for the AUC Art History and Curatorial Studies Collective. Spelman and the AUC are forging paths for the next generation of artists and art historians.

Spelman College commends LACMA for taking on the important work of collecting and exhibiting work by Black American artists. This effort builds on the legacy of the historic 1976 exhibition *Two Centuries of Black American Art: 1750–1950*, curated by David C. Driskell at LACMA, which was the first comprehensive survey of work by Black artists. The current portraiture project sends a strong message to the museum field: though museums may have neglected the work of Black artists, that work has always belonged in the collections of major museums. Spelman is honored to be part of an exhibition and publication that honor the rich history of Black American portraiture and point toward a future that places the works of Black artists where they belong: at the center of the history American art.

**Mary Schmidt Campbell**
President Emerita, Spelman College

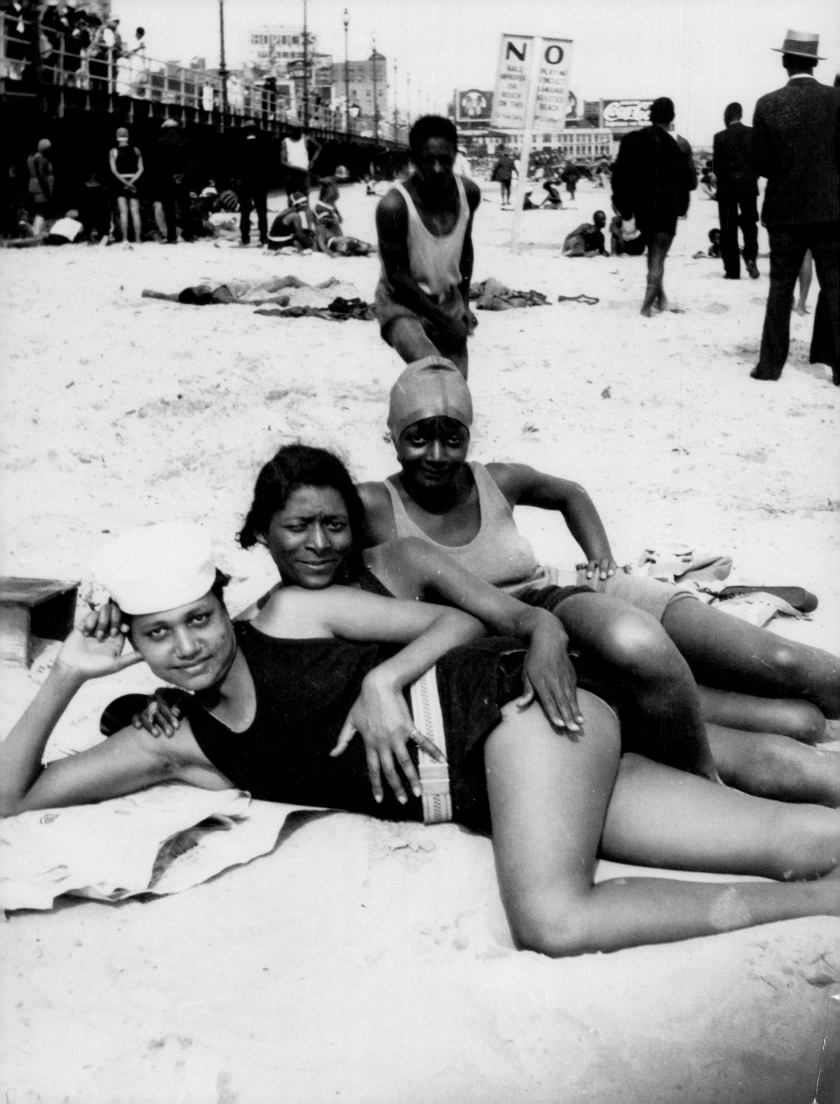

# Introduction

The book you are holding in your hands marks a moment in time. Neither a museum collection handbook nor an exhibition catalogue, this publication borrows aspects of each to explore the role of exhibitions in collection building and to look at what it means to see oneself—as a subject, as an artist, as a community, as a people—on the walls and in the collection of a museum. It is inspired by the exhibition *Black American Portraits*, which opened at the Los Angeles County Museum of Art (LACMA) in 2021, and by the museum's explosive effort to collect works of art representing Black American subjects, sitters, and spaces.

Focused on the theme of portraiture, the book offers a selection of work mainly from LACMA's collection to underscore the ways in which African Americans have envisioned themselves through art. This mission-driven publication features portraits and portrayals presenting Blackness as powerful, beautiful, joyful, abundant, complex, and nuanced. Paintings, sculptures, photographs, videos, and mixed media and augmented reality works are illustrated alongside essays by curators and cultural historians that meditate on the meanings of works of art, the past omissions of Black figures in art history, and the power of collecting art that centers Black histories.

The *Black American Portraits* project began at the tail end of 2019, when we were preparing for the Los Angeles presentation of *The Obama Portraits Tour*, featuring the official portraits of President Barack Obama by Kehinde Wiley and First Lady Michelle Obama by Amy Sherald, from the National Portrait Gallery. The immense popularity of the Obama portraits meant that many people would be visiting LACMA to witness them. As plans for a companion exhibition picked up steam in 2020, we looked around at the world—in the midst of a global pandemic, an increase in the visibility of violent racism and protests against that violence, and an outpouring of performative responses to calls for institutional accountability—and decided to do something different. We wanted people to come for the Obama portraits and walk away with a history.

This objective coalesced into the exhibition *Black American Portraits*. Recalling *Two Centuries of Black American Art: 1750–1950* (1976), a show guest curated by David C. Driskell at LACMA over forty-five years prior, *Black American Portraits* was envisioned as a history of portraiture centering Black American subjects, sitters, and spaces. The exhibition at LACMA spanned two centuries, from 1800 to the present day, and chronicled the ways in which Black Americans have used portraiture to reimagine Blackness in their own eyes. The works in the exhibition were drawn primarily from LACMA's permanent collection and included early studio photography, scenes from the Harlem Renaissance, portraits from the Civil Rights and Black Power eras, and more contemporary works

made between 1990 and 2021. Countering a visual culture that often demonizes Blackness and fetishizes the spectacle of Black pain, these images center love, abundance, family, community, and exuberance.

In order to tell a comprehensive story within the exhibition, we borrowed key works to supplement LACMA's own collection of Black American portraits. Normally, it would stop there; after the exhibition closed, the loaned works would be sent back to their owners and LACMA's own works would re-establish their places at the museum, to be shown sporadically in service of a wide range of stories. However, an essential message of LACMA's *Black American Portraits* exhibition was the importance for Black folks of seeing themselves on the walls of the museum. It was therefore incumbent upon the institution to hear this message and accept the challenge: not simply to mount one exhibition and move on, but to bring more works into its collection that could be seen over and over again in new ways.

Because many works came into the collection as this exhibition gained momentum and community support, it was clear that a conventional exhibition catalogue—photographed, designed, and produced many months in advance of the show for release on opening day—was not the solution for this circumstance. Moreover, such a book would miss sharing the critical lessons learned during the making of LACMA's *Black American Portraits* exhibition; it would miss the opportunity for transparency around historical successes and omissions; and it would be unable to tell readers how the acquisitions came about and how the works brought into the collection will meet the audiences of the future. The hope is that, propelled by the generosity of those who supported the *Black American Portraits* exhibition at LACMA by donating precious works of art or funding this publication, the gallery of faces will grow with each successive generation.

In this volume, Bridget R. Cooks recalls an interview with Driskell, and the way he spoke about the catalogue for *Two Centuries of Black American Art*: "The catalogue became a textbook or resource...like an encyclopedia or some sort of reference book...proof that we could have this enormous exhibition and here is the record of it." We present this book at a different moment in history when centering Black subjects and perspectives is crucial.

The contributions contained here reflect a range of viewpoints and lived experiences. In "Face It," Hilton Als grounds the publication in the moment that made both the book itself and the *Black American Portraits* exhibition urgent: the heightened brutality inflicted on Black bodies we witnessed during the multiple and ongoing crises of 2020. Als makes clear that the threat to the Black body is ever-present and depends on a centuries-long effort to make Blackness seem monstrous.

In "A Museum's Commitment to the Trayvon Generation," Christine Y. Kim takes us behind the scenes of the effort to build an incisive and inclusive collection at LACMA, chronicling many of the significant acquisitions that occurred in the context of the museum's *Black American Portraits* exhibition. While it is powerful for viewers to see this history temporarily hung on the walls of a museum, the legacy of collection building will last for generations.

In "Black American Art at LACMA: A History," LACMA curator emerita Ilene Susan Fort draws on her decades of experience at the museum to recount key moments when works by Black American artists came into LACMA's collection. This historical account both celebrates the accomplishments of the past and acknowledges the many missed opportunities and omissions that have occurred over the years in the context of collecting and exhibiting work by African American artists.

Jeffrey C. Stewart's essay "Beyond the Master" offers a counter-history of portraits and portraiture. Stewart draws our attention to the stories of people who are often outside the frames of early American portraits, such as those enslaved by many of the Founding Fathers. "Having one's portrait made in the West means one's life *matters* more than others'," Stewart writes, his point making clear the importance of uplifting portraits of Black figures.

In "Proof of Life," Bridget R. Cooks looks closely at works by two artists who are primarily recognized for their work as art historians. One is David C. Driskell, a powerful voice in the history of African American art. The other is Deborah Willis, who has dedicated her career to shifting the lens of photography history to focus on Black artists and subjects through publications, exhibitions, courses, and convenings. By bringing works by Driskell and Willis to the fore, Cooks offers a fuller, deeper view of their contributions to art.

In "A Lil' History of Photography: African American Photography Before Barack Obama," Myrtle Elizabeth Andrews examines photographs from LACMA's collection of and by Black Americans. Building on the scholarship of Willis and others, she uses specific photographs to show how generations of images made by African Americans created a visual language that set the stage for the iconic rise of President Barack Obama.

Moving beyond the traditional understanding of portraiture as an image of a subject, Dhyandra Lawson engages artworks by Mark Bradford and David Hammons in "The Elusive Body." Looking at two highly charged works, she locates traces of their makers and explores how each piece points to violence and a specific subject even while omitting that figure's face. Examining the processes and materials used to make these works, Lawson considers the ways the viewer is asked to engage with these abstract portraits.

In the afterword, Naima J. Keith explores the impulse to celebrate Black joy that so powerfully drove the *Black American Portraits* exhibition and this publication. Reflecting on the jubilant reception of the show by a wide array of museum visitors, she acknowledges the importance of connecting community members with works of art through both events and investments. We thank her and the other authors for their fresh and honest examinations of the ways in which museums in general—and LACMA in particular—have heretofore overlooked some of our greatest American artists.

The *Black American Portraits* exhibition—which served as the catalyst to LACMA's historic collection-building effort and, consequently, this publication—was made possible through the contributions of numerous individuals who saw the importance of bringing this history to light. LACMA CEO and Wallis Annenberg Director Michael Govan's engagement and encouragement enabled us to make this a museum-wide effort that will serve the public for generations. We are especially thankful for the tireless effort and advocacy of Jennifer King. Our colleagues who participated in the (B)LACMA employee resource group were a source of support and insight over the months and years. Several curators provided essential context and advice, including Carol Eliel, Ilene Susan Fort, Dhyandra Lawson, Leah Lehmbeck, and Staci Steinberger. Neither this book nor the exhibition would have been possible without the patience, organization, and grace of curatorial assistant Breanne Bradley. Countless other LACMA employees contributed to the planning and execution of the *Black American Portraits* exhibition, and we are immensely grateful for their commitment and hard work.

We thank the artists, living and departed, whose work was included in the exhibition, a list that differs from the artists represented both in this book and in the touring version of *Black American Portraits*: Cedric Adams, Laura Aguilar, Njideka Akunyili Crosby, Charles Alston, Benny Andrews, Alvin Baltrop, Chelle Barbour, Anthony Barboza, Sadie Barnette, Richmond Barthé, Dawoud Bey, Edward Biberman, John Biggers, Kwame Brathwaite, Greg Breda, Bisa Butler, Jordan Casteel, Elizabeth Catlett, Jonathan Lyndon Chase, Elizabeth Colomba, William Cordova, Eldzier Cortor, Renee Cox, Kim Dacres, Bruce Davidson, Karon Davis, Kenturah Davis, Roy DeCarava, Beauford Delaney, Woody De Othello, Emory Douglas, Sam Doyle, David C. Driskell, rafa esparza, Shepard Fairey, Tatyana Fazlalizadeh, Kohshin Finley, Genevieve Gaignard, Charles Gaines, Rico Gatson, Jerrell Gibbs, Todd Gray, Chase Hall, Lauren Halsey, Lyle Ashton Harris, Barkley L. Hendricks, Reggie Burrows Hodges, Arthur Jafa, Lee Jaffe, Sargent Claude Johnson, Kahlil Joseph, Isaac Julien, Glenn Kaino, Consuelo Kanaga, Titus Kaphar, Clifford Prince King, Jacob Lawrence, Deana Lawson, Simone Leigh, Samella Lewis, Whitfield Lovell, Kerry James Marshall, Wangari Mathenge, Archibald J. Motley Jr., Alice Neel, Ralph Nelson, Lorraine O'Grady, Toyin Ojih Odutola, Kambui Olujimi, Catherine Opie,

Gordon Parks, Ada Pinkston, James A. Porter, Robert Pruitt, Otis Kwame Kye Quaicoe, Nathaniel Mary Quinn, Umar Rashid, Calida Rawles, Betsy Graves Reyneau, Deborah Roberts, Alison Saar, Betye Saar, Lezley Saar, Augusta Savage, Vivian Schuyler Key, William Scott, Paul Mpagi Sepuya, Amy Sherald, Xaviera Simmons, Lorna Simpson, Ming Smith, Shinique Smith, Edward Steichen, Tavares Strachan, Martine Syms, Henry Taylor, Hank Willis Thomas, Mickalene Thomas, Tourmaline, James Van Der Zee, Kara Walker, Laura Wheeler Waring, George Kendall Warren, Fulton Leroy Washington (aka Mr. Wash), Carrie Mae Weems, Charles White, Kehinde Wiley, D'Angelo Lovell Williams, Deborah Willis, Richard Wyatt Jr., and numerous artists whose names are unknown to us. LACMA is privileged to hold work by many of these individuals in its collection, and we are similarly grateful to include work by a number of these artists in this book. We sincerely hope that more artworks by the individuals listed here will enter LACMA's collection in the coming years.

The exhibition relied on the much-needed support of a vast array of generous patrons, many of whom were giving to LACMA for the first time. We thank Alpha Kappa Alpha Sorority, Incorporated®; Bank of America; Janine Sherman Barrois and Lyndon J. Barrois, Sr.; Stanley and Joyce Black Family Foundation; Kimberly A. Blackwell; Lizzie and Steve Blatt; Rebecca and Troy Carter; Ava L. Coleman and Debra L. Lee; Ina Coleman; Brickson E. Diamond; The Claire Falkenstein Foundation; Far Western Region, Alpha Kappa Alpha Sorority, Incorporated®; George and Azita Fatheree; Danny First; Foundation for Advancement in Conservation and Tru Vue, Inc.; The Gilford Family; Gucci; Kristen Boggs Jaeger and Jeffrey Jaeger; Deon T. Jones; Gail and George Knox; Jill Lawrence and Paul Koplin in honor of Martha Koplin; Arthur R. Lewis; Chrystal and Melvin D. Lindsey; Andrea Nelson Meigs and John Meigs; Issa Rae; Janet Dreisen Rappaport; Jason and Susan Riffe; Julie and Bennett Roberts, Roberts Projects; D'Rita and Robbie Robinson; V. Joy Simmons, MD; Snapchat; Ryan Tarpley; Treehouse; Abbey Wemimo and Taylor Goodridge; Ric Whitney and Tina Perry-Whitney; and Dr. Francille Rusan Wilson and Dr. Ernest J. Wilson III. We also extend our gratitude to LACMA's Board of Trustees.

For their visionary gifts of art, we thank the many individuals, artists, groups, and organizations who responded to our call to bring Black American works into LACMA's permanent collection. We also retroactively extend our gratitude to the prescient supporters who donated works of Black American art to LACMA in years and decades past.

This publication was driven by LACMA's indefatigable publisher, Lisa Gabrielle Mark; we thank her, Claire Crighton, and Dawson Weber for making the *Black American Portraits* book a reality on a tight timeline and in creative ways. We were lucky to work with Adraint Bereal, whose dynamic book design has enabled the work of these artists and authors to shine. This book project was made possible through the generosity of the 2021 Collectors Committee; Karma, New York; and Catherine and Michael Podell in honor of Janine Sherman Barrois and Lyndon J. Barrois, Sr.

Portraiture is a tool of power that Black Americans have used for generations. This publication presents over two hundred years of works centering Black Americans, and comes at a moment when there is a new thirst for knowledge about the history of Black figuration. We hope that LACMA continues to develop and share this knowledge for centuries to come.

**Christine Y. Kim**
*Black American Portraits* co-curator

**Myrtle Elizabeth Andrews**
*Black American Portraits* co-curator

# FACE IT

Hilton Als

You forget, that's all. Forget that you are anyone but yourself. Forget the moments that came before as you cross the street, pick up a bottle of something at the store. Forget as you take out your handkerchief and rub it across your face, and the salt of perspiration from your handkerchief linen brushes against your lips. A memory of lips: the boyfriend who thought your lips were too big and you didn't even realize that until decades later, when you recall how he wanted to kiss you—closed mouthed, mostly, and tight—because his lips felt overwhelmed by yours, a memory that didn't even come to mind until you were watching a dumb TV show called, ironically enough, *Love Is Blind*. The show's premise is that people fall in love according to who they are as opposed to what they look like; the potential lovers get to know each other without a glimpse of face or body. In the episode I saw, a Black woman and a white man meet for the first time after establishing intimacy through conversation. They're attracted to each other. The man proposes. But after he leaves, the woman confesses to that off-camera God that all reality-based characters seem to confess to—she confesses that when she first kissed her intended, she was worried that her lips were too big for his mouth. You forget your disgust with people who feel this way, or can feel this way, about themselves, and volunteer that information to TV people of all people, for some kind of validation, and is nothing real unless it's being broadcast to millions, or posted on Instagram, or spoken to that off-camera God? When I saw that woman apologizing for her lips, I remembered that former lover who caused pain in order to feel pain, but honest to God I didn't realize what he was doing or trying to do until I saw that woman on TV, and it all came back to me, and wow think about how heartsick that former lover was when he couldn't get to me through my lips; he grew up in a gay world where looks mattered for everything, and every which way, but he forgot to look and see that he had hurt my heart, and he couldn't get me out of my color or physiognomy, even though he tried. "They do not love your hands," Baby Suggs says to the assembled in Toni Morrison's *Beloved*. She says, too: "You got to love it, you! And no,

they ain't in love with your mouth. Yonder, out there, they will see it broken and break it again. What you say out of it they will not heed. What you scream from it they do not hear. What you put into it to nourish your body they will snatch away and give you leavins instead. No, they don't love your mouth. You got to love it."[1] You forget how to love it when you're in Houston, say, and you're the guest of a prestigious museum, and staying in one of the bungalows owned by the museum, and you're getting dressed to give a talk at the museum, and suddenly there's a loud knocking on the door. And because you have been so content—content in your work, happy in the feeling that your work and sharing it feeds you, still, and pleased by the idea that your language might inspire a good feeling and thought in others—you open the door when you hear the police say, Houston Police, because they're banging on the door, and they're the police, and you forget about Breonna Taylor, and Anjanette Young from Chicago, handcuffed while naked in her own home and the police had the wrong home. You forget because you love language so much, and relish the opportunity to get better at it, that you forget you are a monster, an alien with alien lips at the door of their home, their country, their state, their land, their well-being, and who wouldn't want to blow the Other away if you are threatening their actual presence with your presence, you monster you, he of the wild eyes and skin that hardly seems worth mentioning because we know it's a problem, and then there are the lips that are meant to devour, that's what they were made for, only, to devour, and what else can you do with a monster but kill its grinning smile? You forget all of that as you open the door, and the police say there's been some suspicious business here, do you know anything about your neighbors? And you say no, you just arrived, you're doing an event at the institution across the street, and you forget that whether you open the door or not, you can be blown away, you forget that because you're thinking about the language of the speech you're about to give in that subtropical city, you forget about it because you want to tell the story you've been writing for weeks, a story that has nothing to

1. Toni Morrison, *Beloved* (New York: Knopf Doubleday, 2007), 103–4.

do with police turning up at your door asking about the suspicious behavior of neighbors you didn't know you had, or have. You speak. People respond. You go back to where you've been staying, to rest, and it doesn't occur to you that you might have been harmed and possibly killed like those other people who were killed in their bedrooms, or those other people who were killed on the street, or those other people who were killed on the subway, or those other people who were killed in a hotel, not unlike the hotel you're writing these notes in now, in another city other than the city where you might have been killed for opening the door, or not opening the door, or just standing around with your monster hair, monster eyes, monster lips. In stories—fairy tales and other narratives—the monster is unbearable because one's subconscious is unbearable. I wonder what your subconscious looks like as you look at these pictures and the men and women in these pictures and the men and women related to the men and women in these pictures? I wonder if these images and people who can be blown away at a moment's notice like these folks rise up in the subconscious as something far more awful, terrifying, and deadly than Black, but as ugly as the subconscious can be, wants to be, when it shows itself in the world with guns, and feet on necks. The subconscious wants to make itself known, and at the same time it wants to kill anything in its path, and at the same time it exists to be repressed. It's a terrifying jungle of impulses down there underneath our socialized faces and for some people the very act of socialization—of having respect and empathy for another human being—is too much, and it's their "birthright" to stomp at the guts of all those monsters that embody the monsters in their head. Some call this a will to annihilate politics while others say your lips are too big to kiss, or I was afraid my lips were too big to kiss. Back in that temporary room, after the lecture, after the cops came asking what you might know about your neighbors that you didn't know you have, you forget while you get undressed after the event. You go to bed forgetting, but your body remembers because at 2 a.m. you wake up like a shot, your body suddenly exposed, like the in-

side of an electric light bulb, and in the meantime your body has been thrown to the other side of the room, and the tears running down your face are part of the delayed reaction to potentially being blown away, your monster hair splattered across your face, because of someone else's suspicious activity, it just hits you, and your body flies off into a corner of the room because it can't help you now in the potential of having been blown away, can't help you now as you try to sleep in the dark of a person's subconscious as he knocks on your door because of someone else's activity but you know it's you, it's always been you, but then you forget. What does forgetting feel like? It feels like the moments in which you and your consciousness are one, and there is nothing but air, and you move through the air with everything intact, with no harm as part of the air, and no harm or potential harm clouding the day. It's as though, in those moments, you can exist not as a thing but as yourself, and how dare they come for you with those ideas about who you are on other days, imagine if you did that to them, made a whole world based on them being you as they see you. But for today you are not you as they see you; you're yourself, and the air is fine, and there's some sea spray on your nose, and the world is fine, filled with palm trees or oaks depending on where you're walking, and then there's the earth, with none of you buried beneath it because the world was different, but it isn't. That dream is just a moment, and it contributes to you forgetting. But then you open a newspaper, and there's an article about Black people dating outside the race, and how they negotiate their bodies with their presumed loved ones, and, swear to God, this is reported as though there's nothing wrong with this mindset, we're all disfigured by it, and can't see ourselves, and the ways in which we mangle one another just for that moment of a kiss, when the world is filled with love, if the world can ever be filled with love, given what it has to forget to get there.

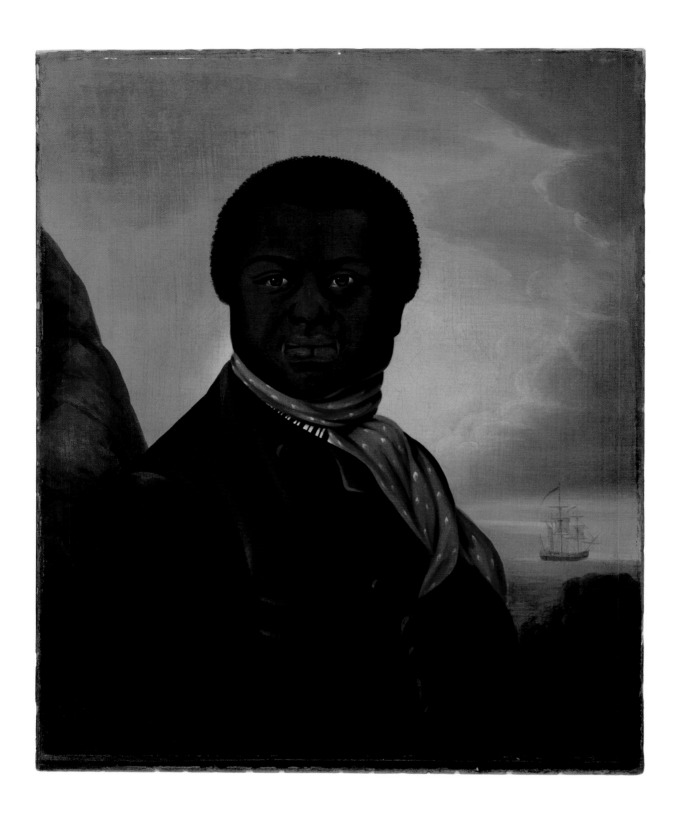

Artist not recorded, *Portrait of a Sailor (Paul Cuffe?)*, c. 1800

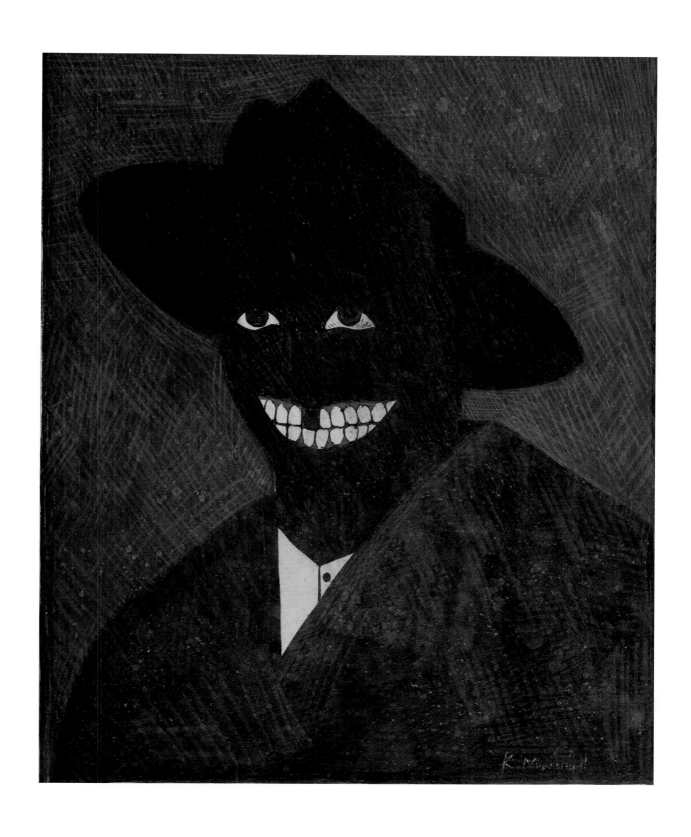

Kerry James Marshall, *A Portrait of the Artist as a Shadow of His Former Self*, 1980

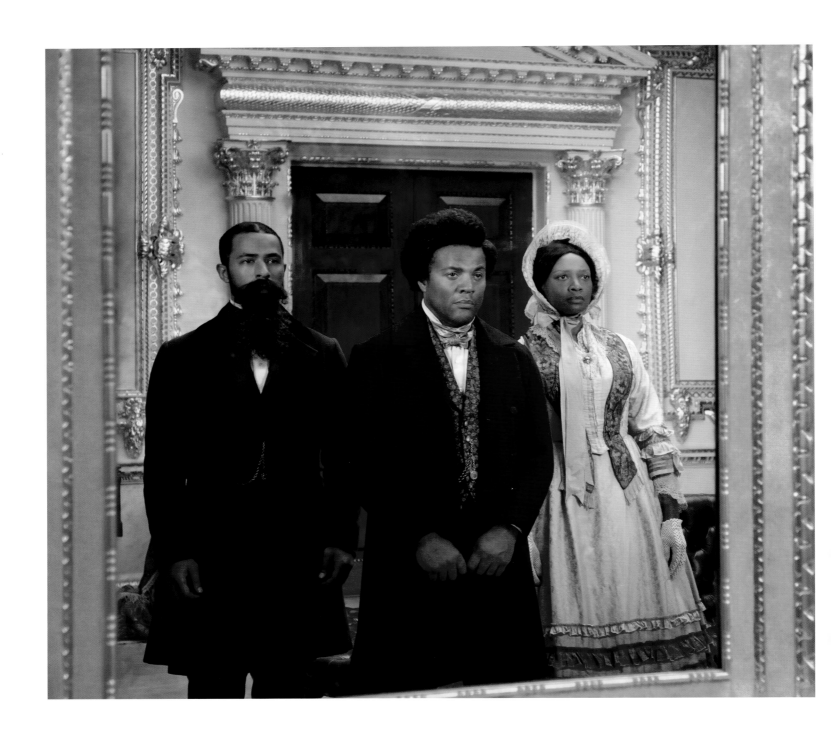

Isaac Julien, *Serenade (Lessons of the Hour)*, 2019

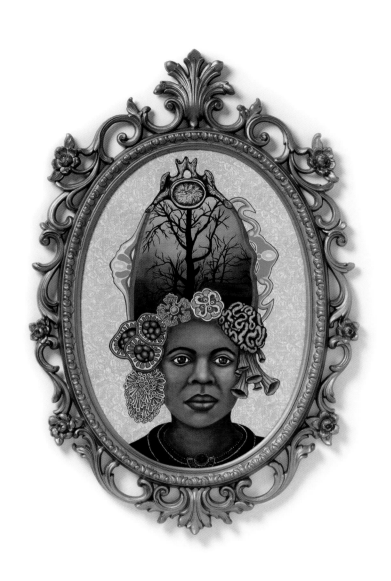

Lezley Saar, *Of a bed of night iris shredding petals*
*one by one, like the hours of darkness*, 2020

Ada Pinkston, *The Open Hand is Blessed*, 2021

*The Open Hand is Blessed* is an augmented reality memorial artwork by Ada Pinkston. This work, commissioned as a part of the LACMA x Snapchat: Monumental Perspectives project and experienced as a Snapchat filter, includes layers of narration, a soundscape, images of Black residents of nineteenth-century Los Angeles, and the only existing photograph of Bridget "Biddy" Mason.

Installation view of Kahlil Joseph, *BLKNWS*, 2019

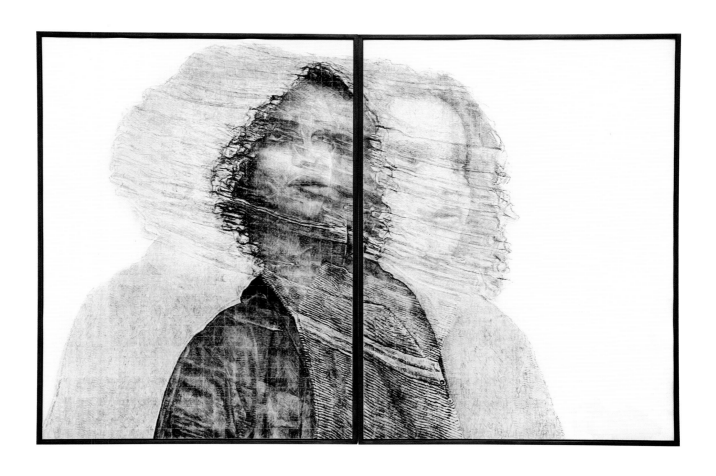

Kenturah Davis, *A Question Only Answered With Another Question*, 2019

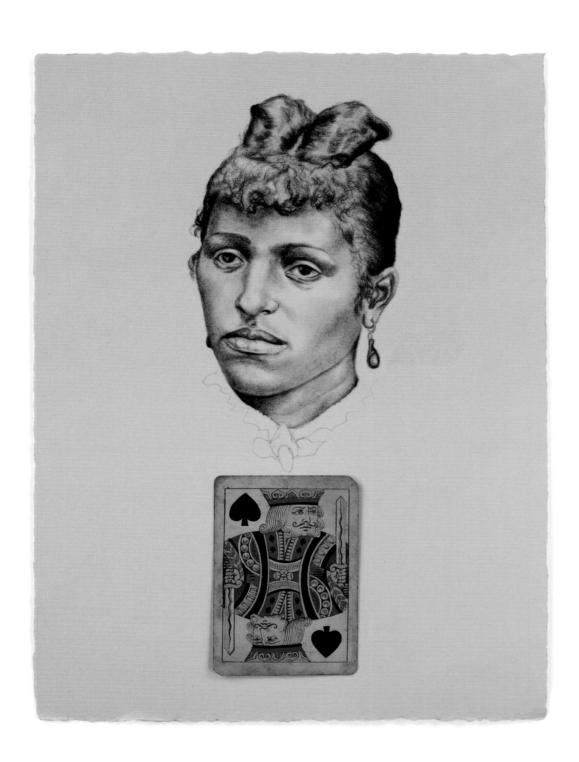

Whitfield Lovell, *#3 (After the Card Series)*, 2009

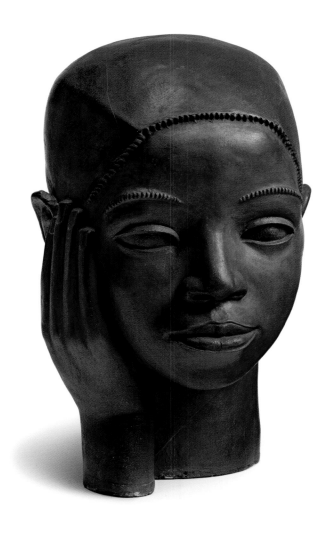
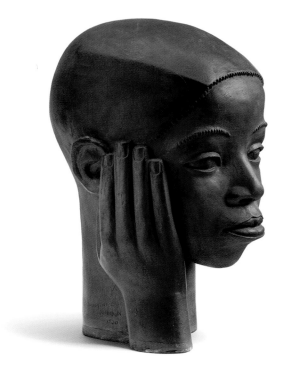

Sargent Claude Johnson, *Chester*, 1930 (two views)

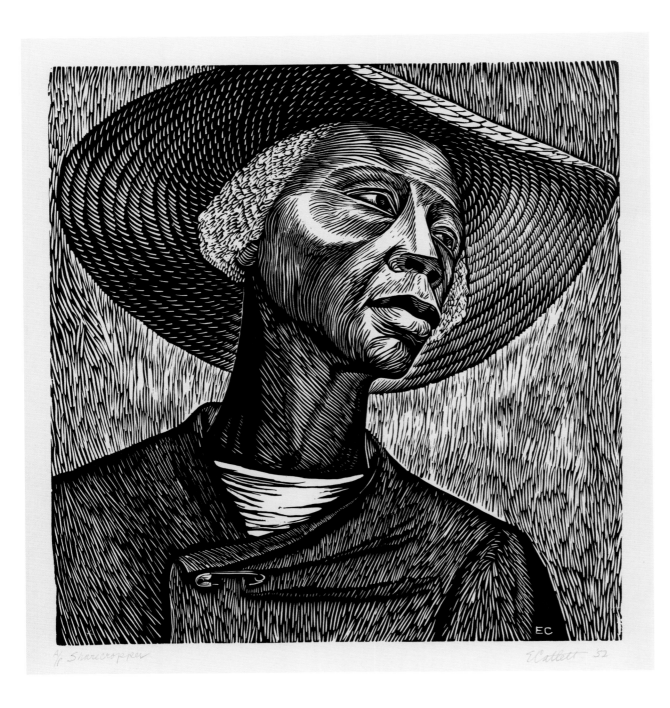

A/p Sharecropper

ECatlett 52

Elizabeth Catlett, *Sharecropper*, 1952

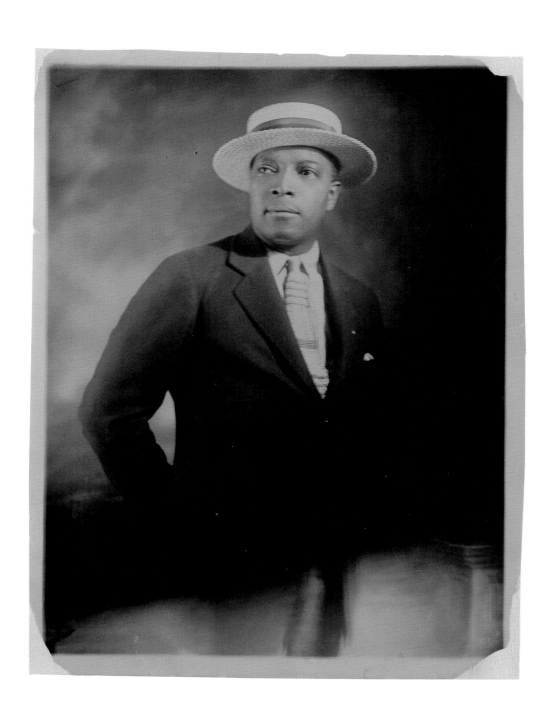

James Van Der Zee, *Self-Portrait in Boater Hat*, c. 1925

Pp. 32–34: Lorna Simpson, *1957–2009 Interior Group 3*, 2009

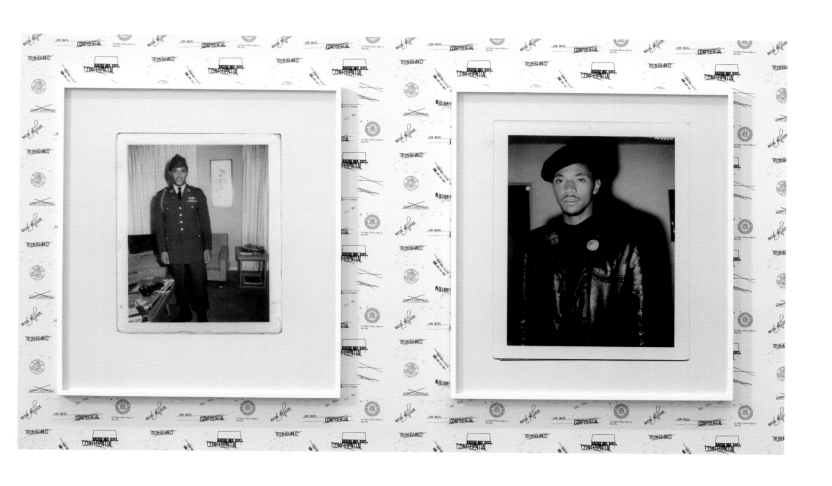

Sadie Barnette, *Untitled (Dad, 1966 and 1968)*, 2016

Roy DeCarava, *Image/eye, Sherry*, 1970, printed 1981

36

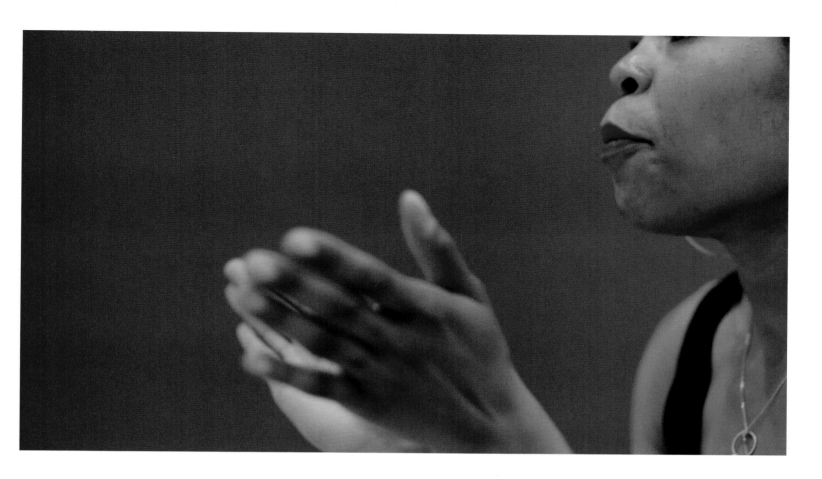

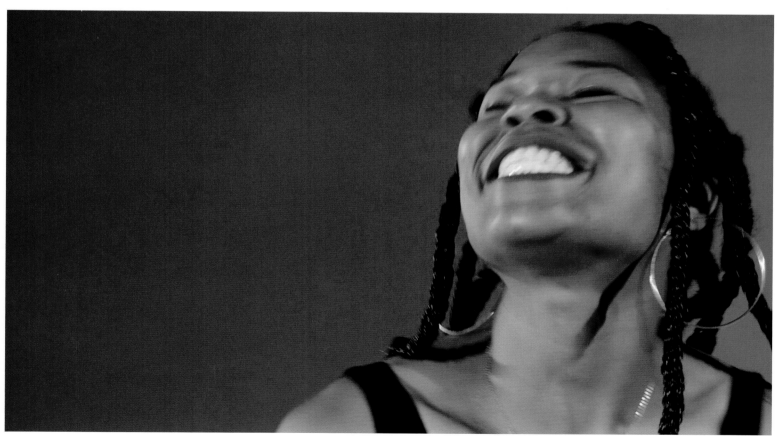

Stills from Martine Syms, *Notes on Gesture*, 2015

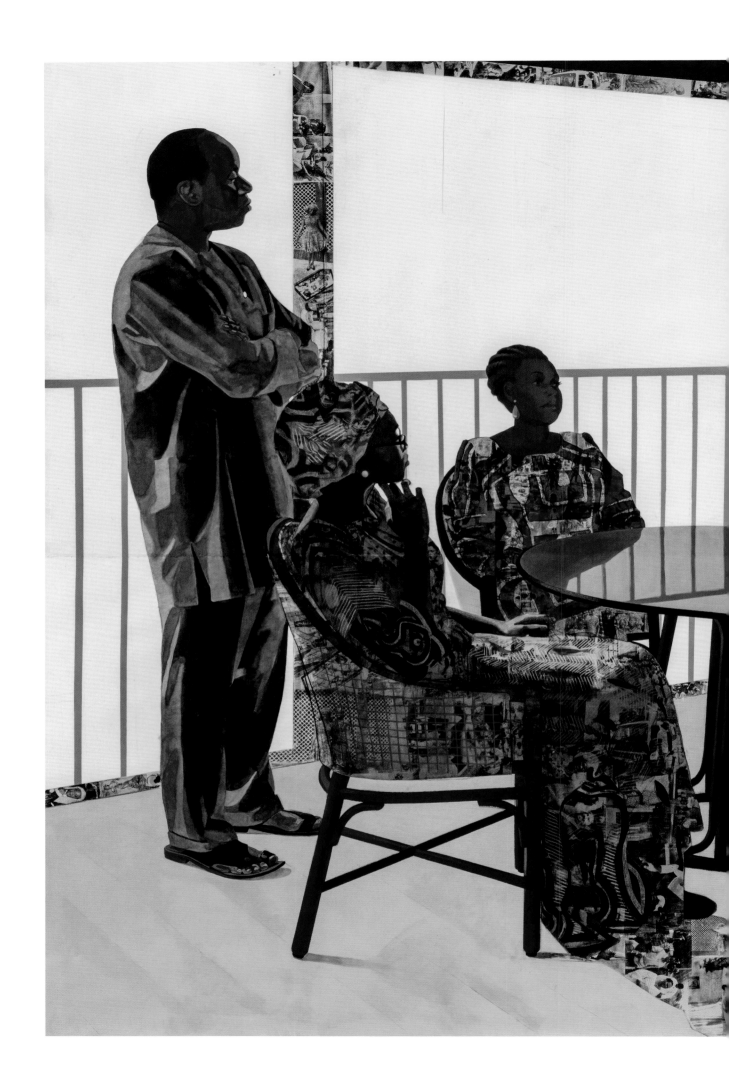

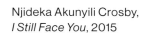

Njideka Akunyili Crosby,
*I Still Face You*, 2015

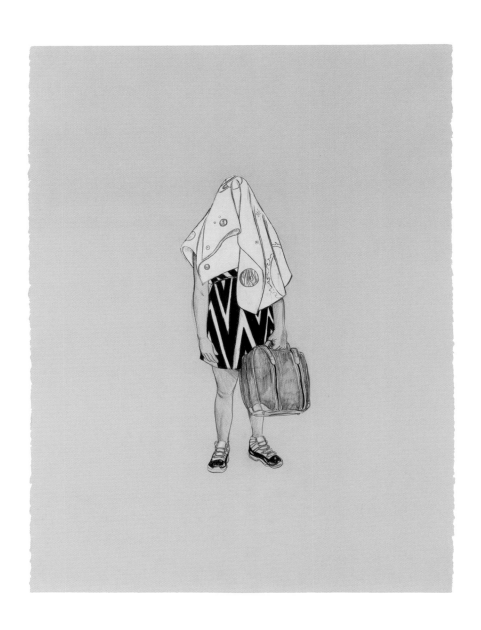

Robert Pruitt, *Tau Ceti*, 2020

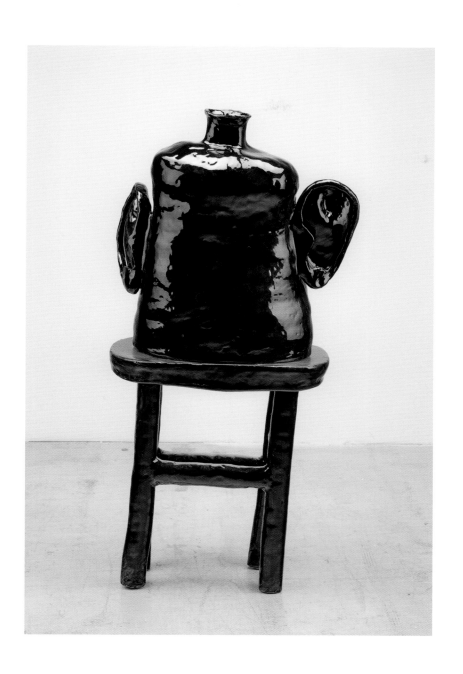

Woody De Othello, *Blank Faced*, 2020

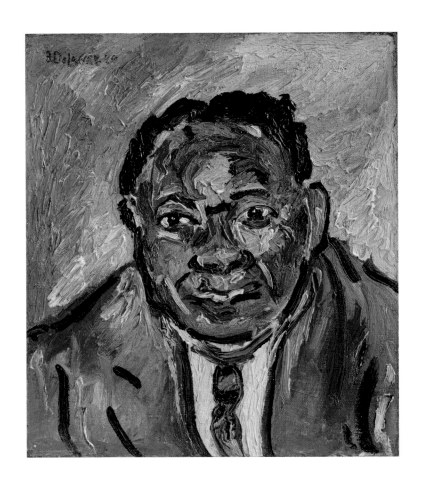

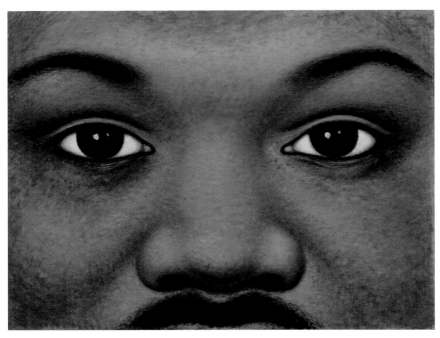

Beauford Delaney, *Negro Man* [Claude McKay], 1944

Edward Biberman, *I Have a Dream*, 1968

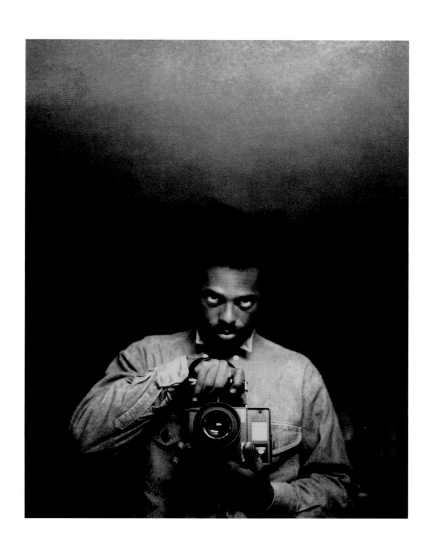

Arthur Jafa, *Monster*, 1988, printed 2017

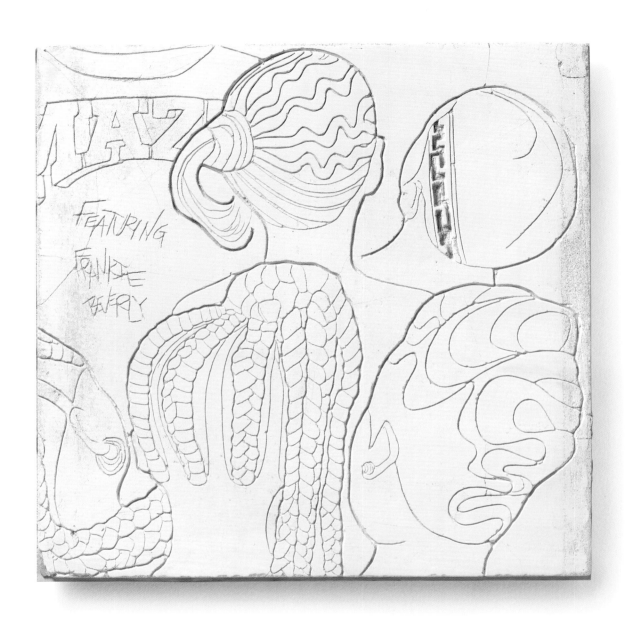

Lauren Halsey, *The Crenshaw Hieroglyphic Project:*
*Exterior Wall (Featuring Frankie Beverly)*, 2018

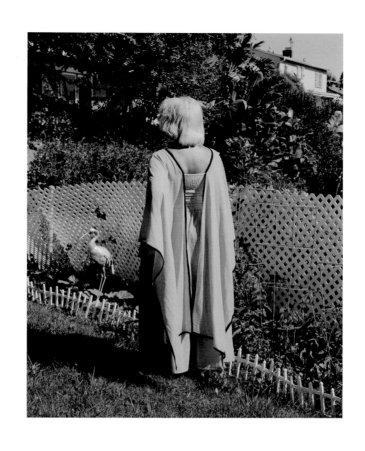

Dannielle Bowman, *Vision (Bump' N' Curl)*, 2019

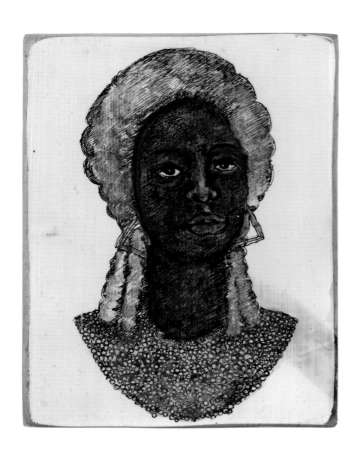

Umar Rashid, *Yolanda, Lady of Yerba Buena*, 2015

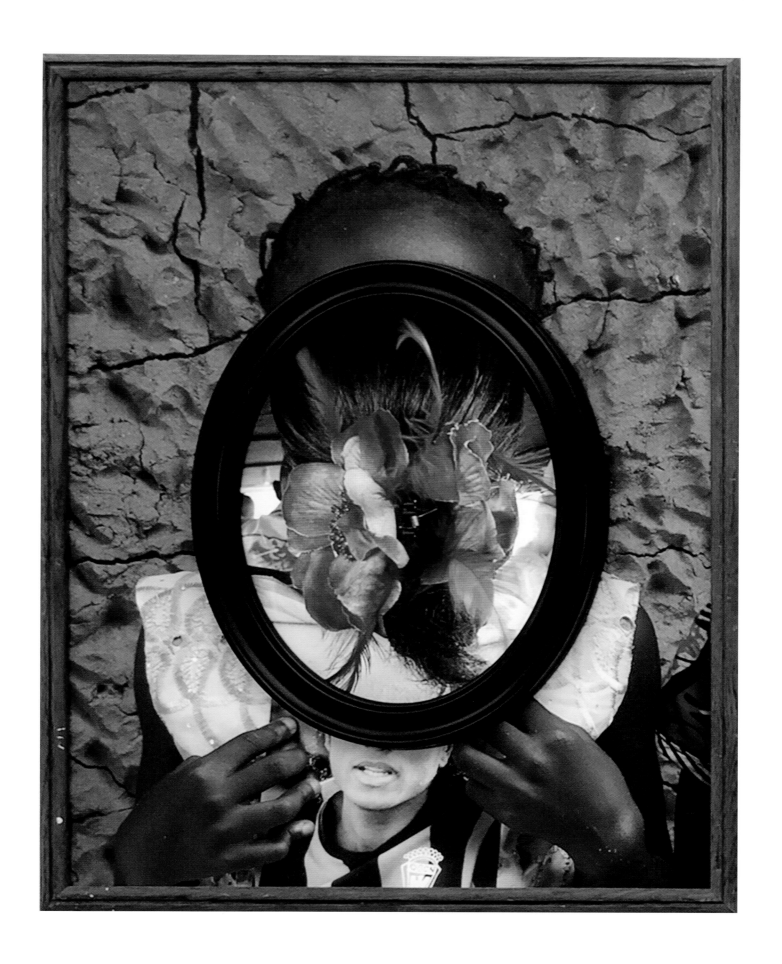

Todd Gray, *Mirror Mirror*, 2014

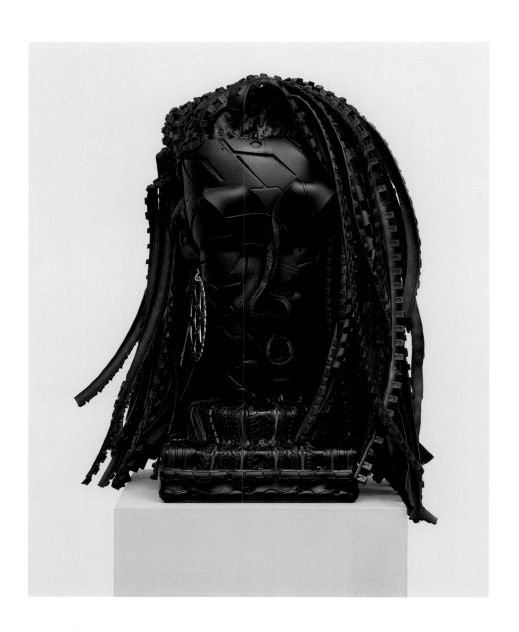

Kim Dacres, *No, my first name ain't baby*, 2020

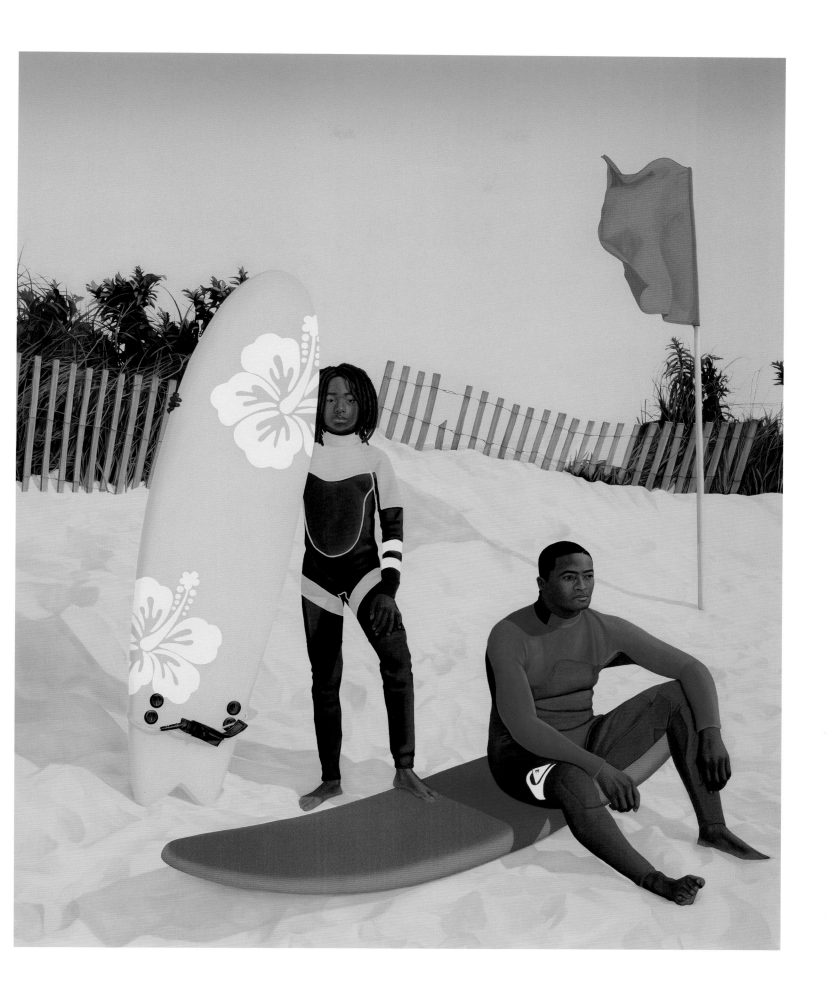

Amy Sherald, *An Ocean Away*, 2020

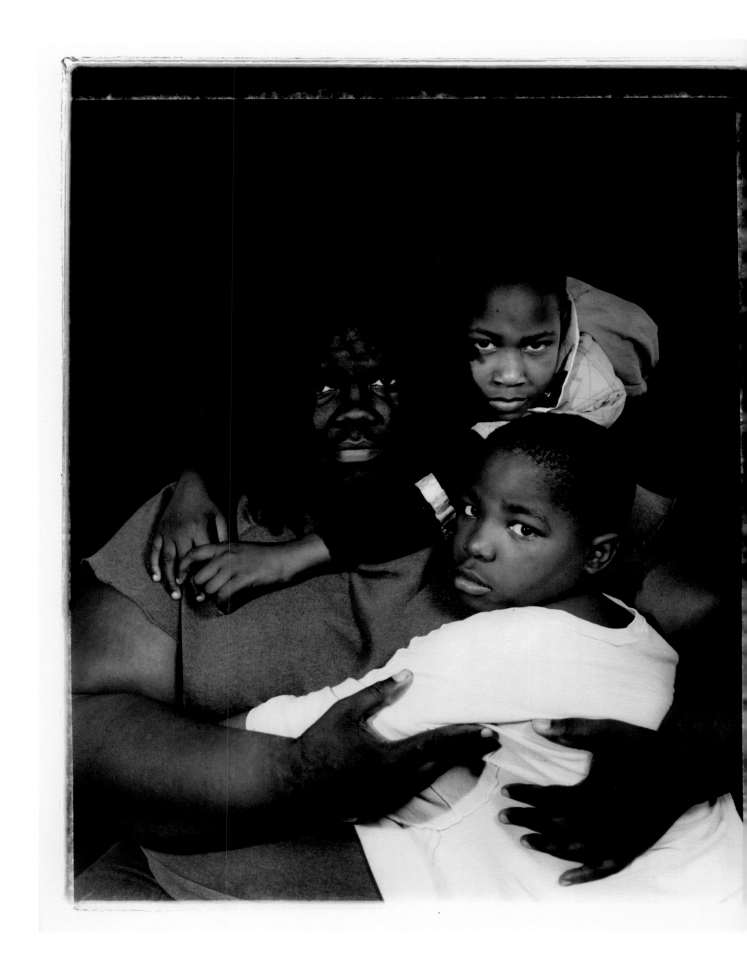

Laura Aguilar, *Clothed/Unclothed #34*, 1994

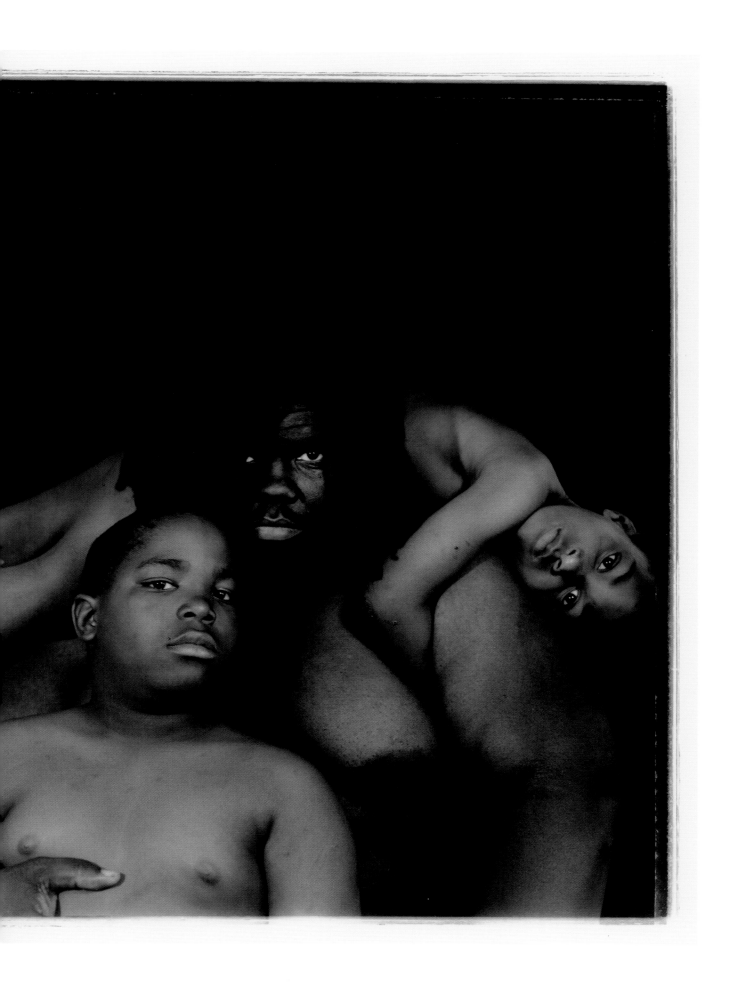

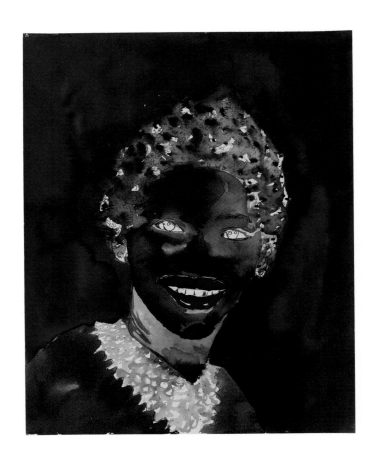

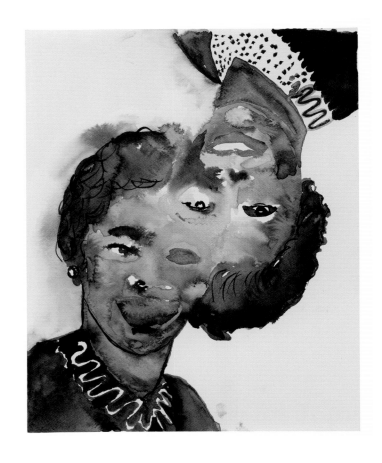

Kambui Olujimi, *Untitled*, 2015–20

Kambui Olujimi, *Untitled*, 2015–20

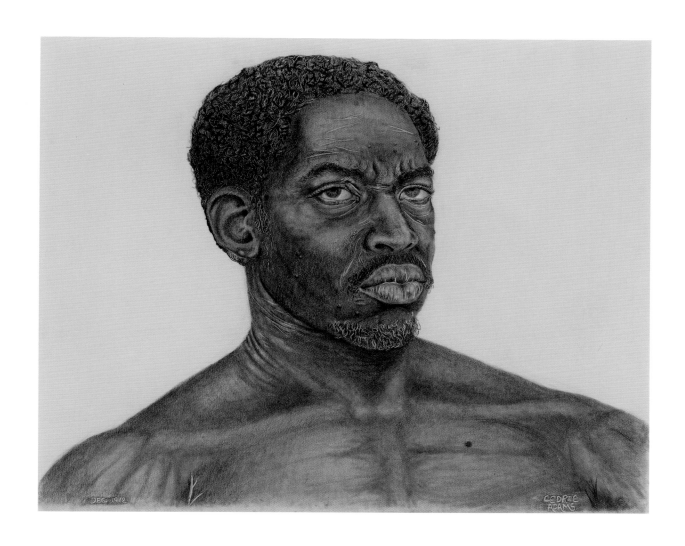

Cedric Adams, *Just How I Feel*, 1972

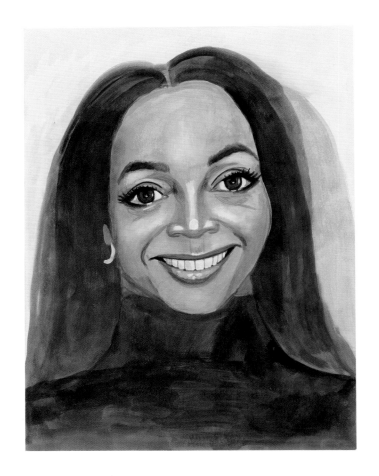

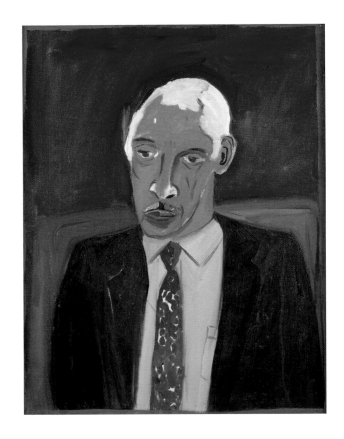

William Scott, *Untitled*, c. 2008

Frederick J. Brown, *Dr. Leon Banks (Study for Last Supper)*, 1982

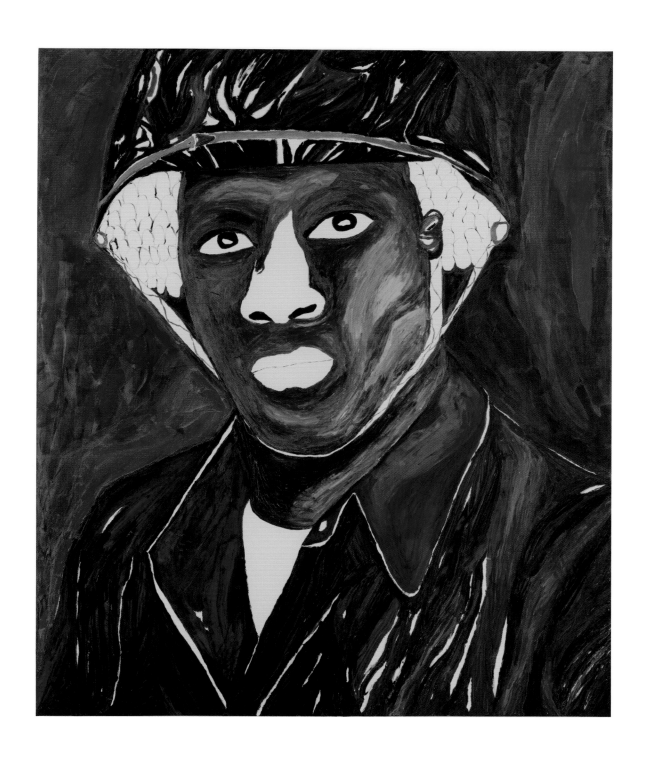

Chase Hall, *Big David (Walk Around Heaven All Day)*, 2020

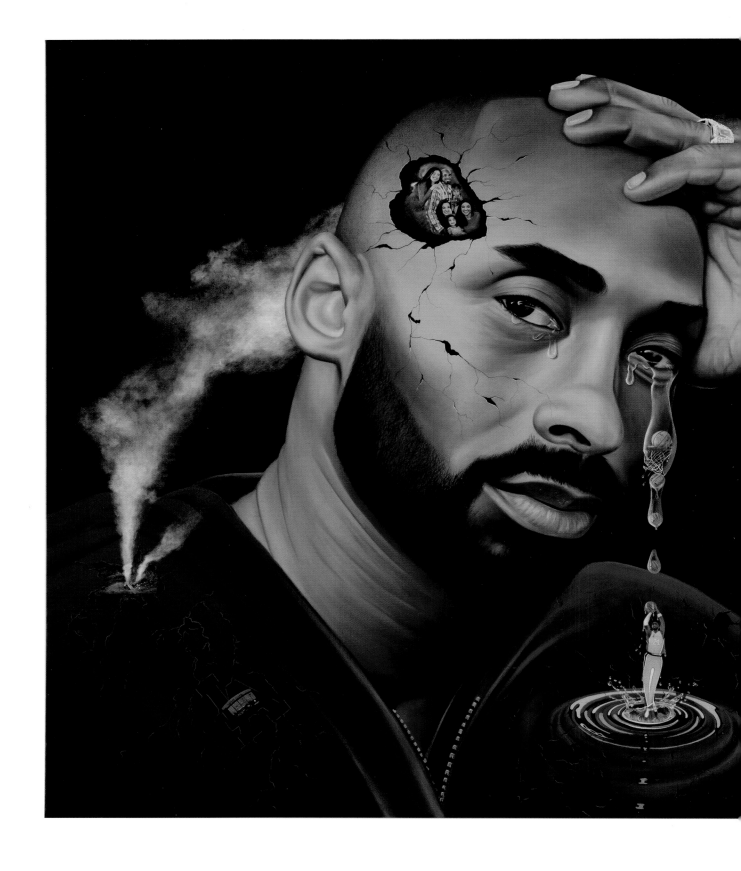

Fulton Leroy Washington (aka Mr. Wash), *Shattered Dreams*, 2020

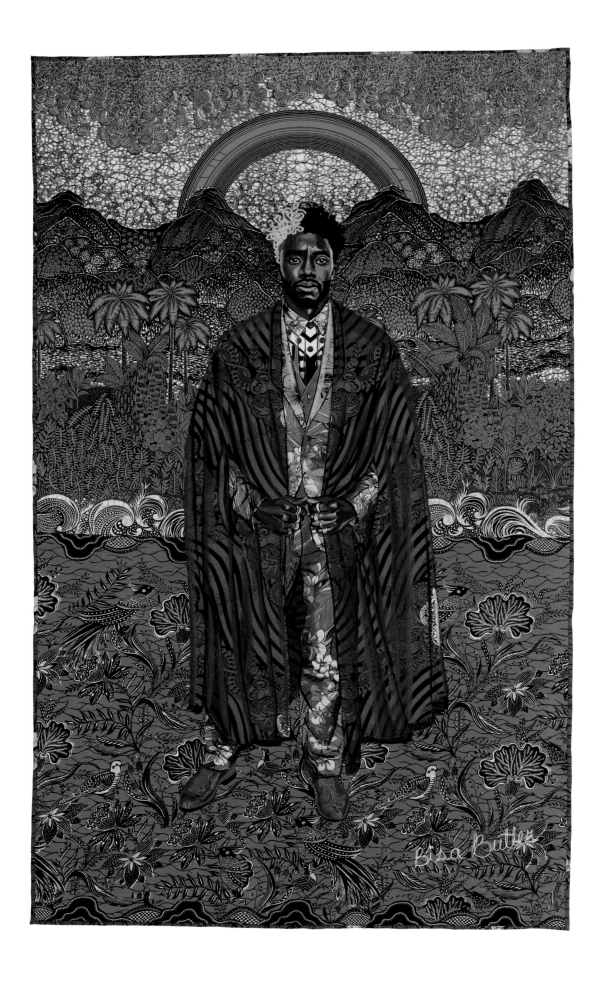

Bisa Butler, *Forever*, 2020

D'Angelo Lovell Williams, *Daddy Issues*, 2019

Clifford Prince King, *Safe Space*, 2020

Alvin Baltrop, *The Piers (three men on dock)*, n.d. (1975–86)

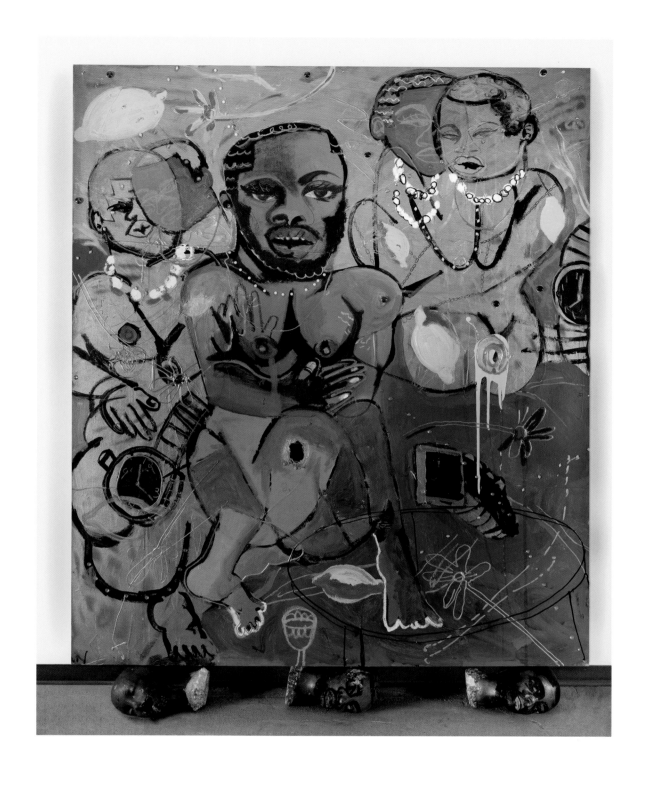

Jonathan Lyndon Chase, *butt naked dressed in nothing but pearls*, 2018

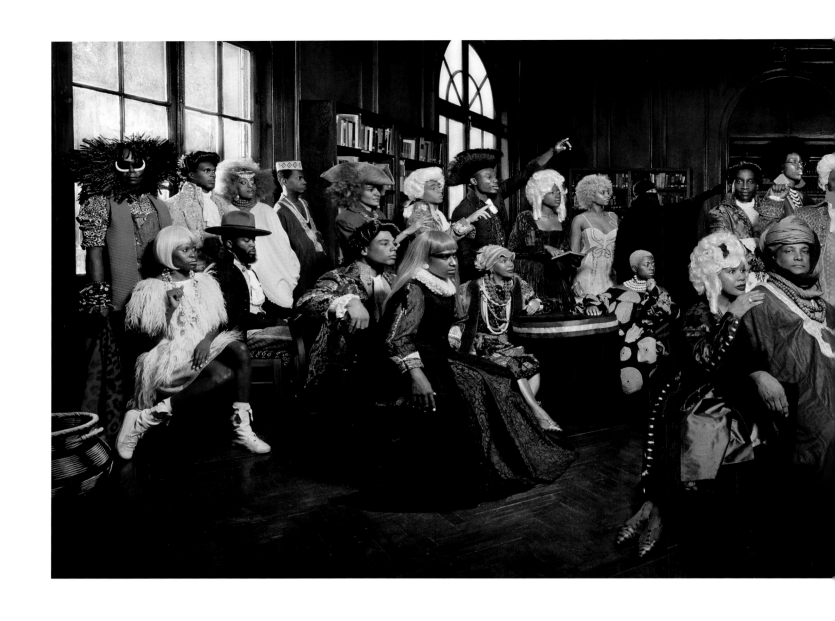

Renee Cox, *The Signing*, 2017

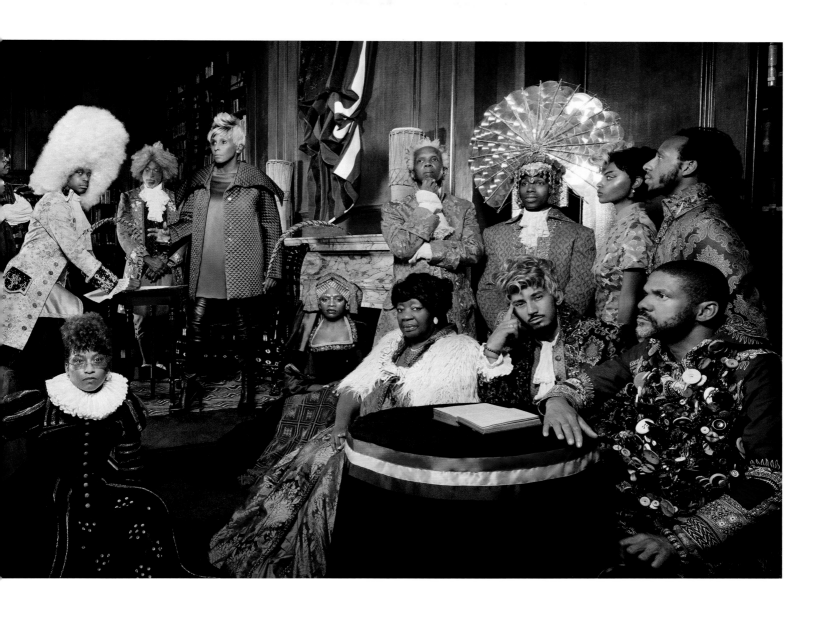

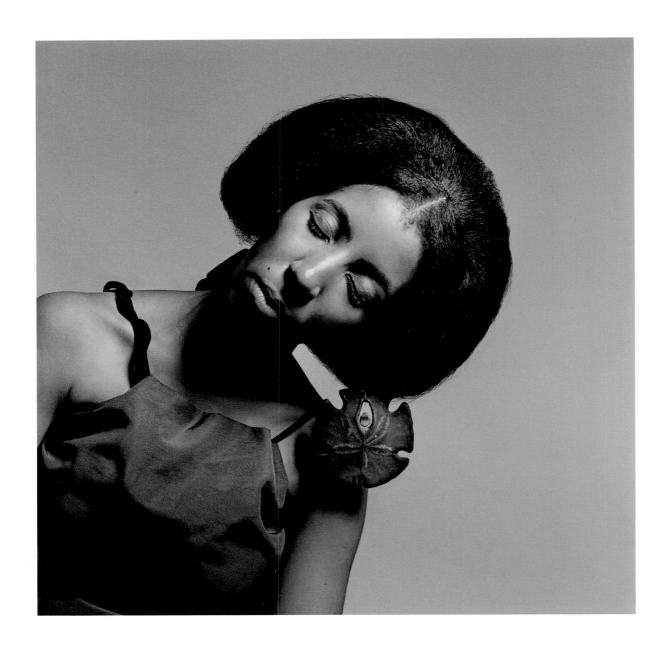

Kwame Brathwaite, *Untitled (Carolee Prince Wearing Her Own Designs)*, 1964, printed 2018

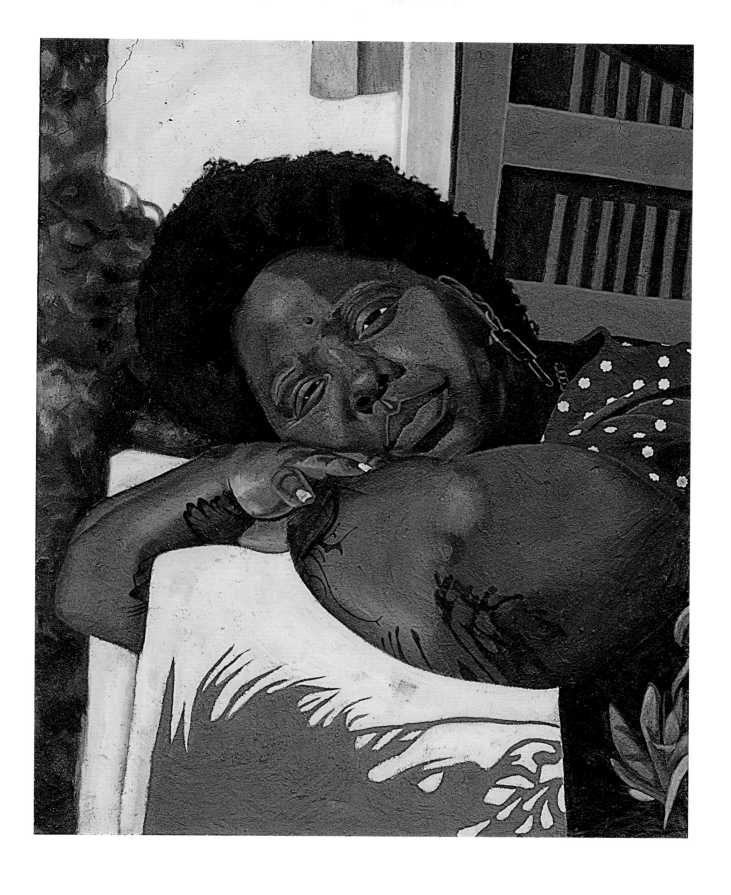

rafa esparza, *big chillin with Patrisse*, 2021

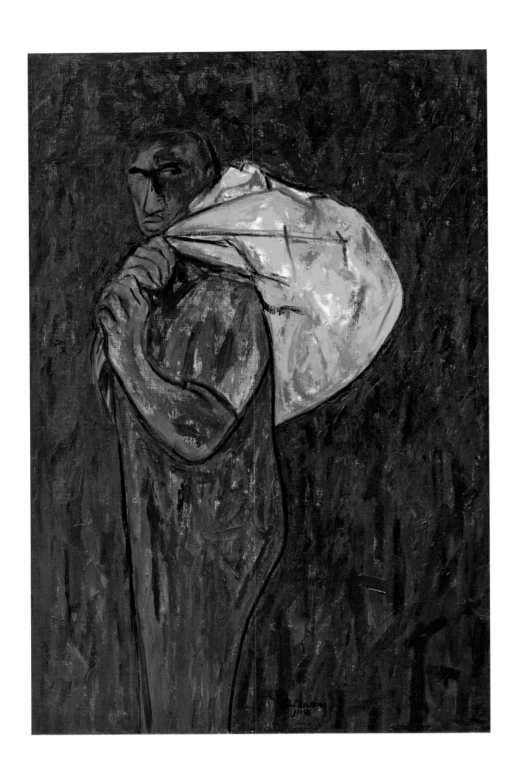

Samella Lewis, *Bag Man*, 1996

Stills from Nicole Miller, *The Conductor*, 2009

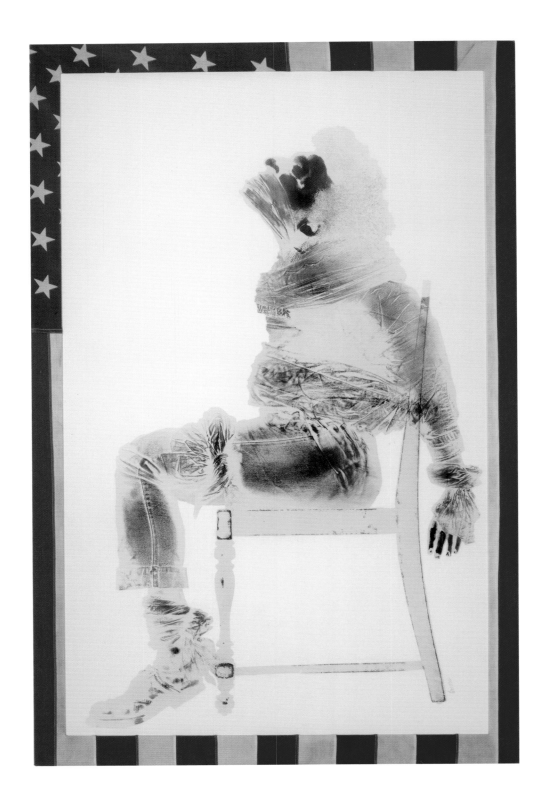

David Hammons, *Injustice Case*, 1970

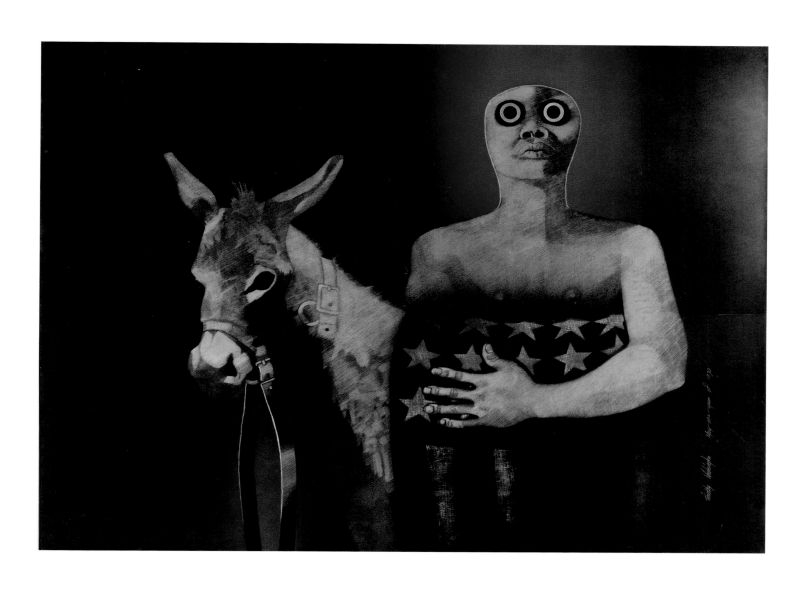

Timothy Washington, *One Nation Under God*, 1970

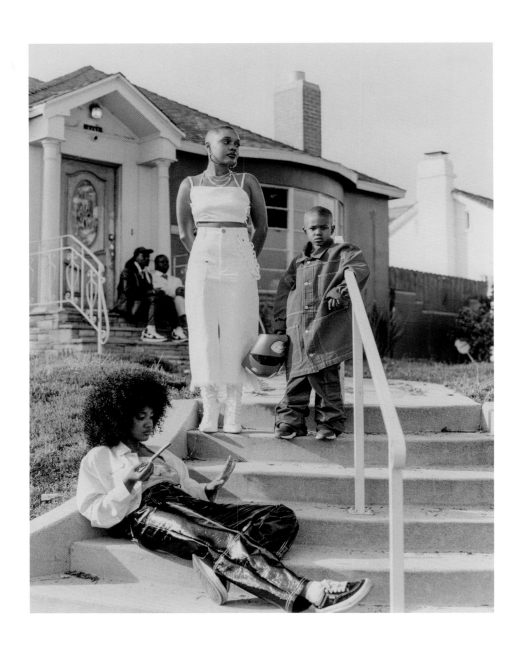

Micaiah Carter, *Family*, 2020

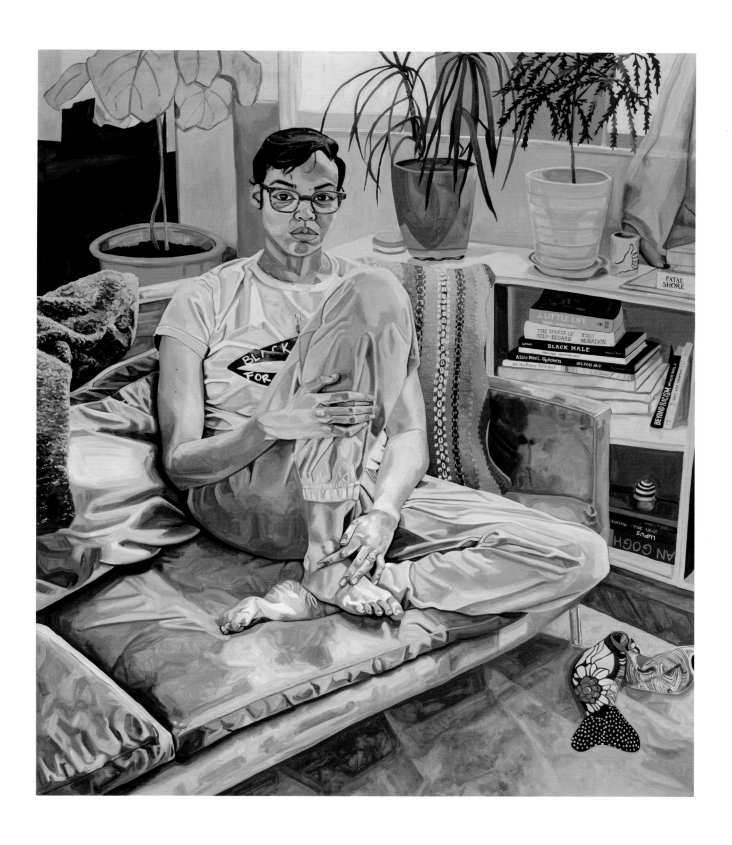

Jordan Casteel, *Jordan*, 2020

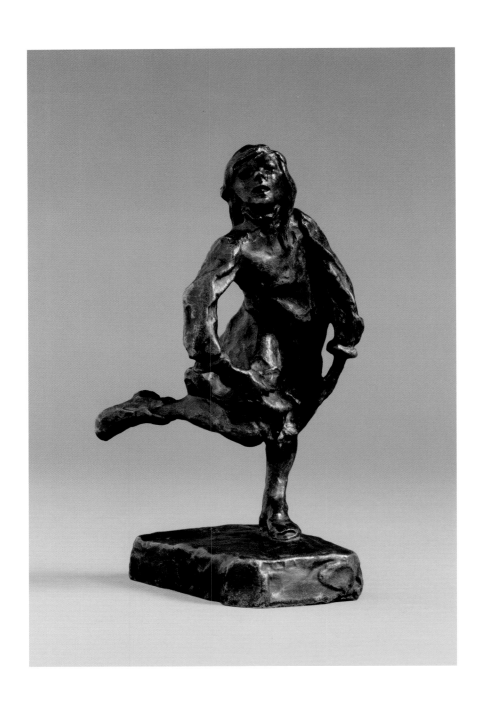

Meta Vaux Warrick Fuller, *The Dancer*, cast c. 1902

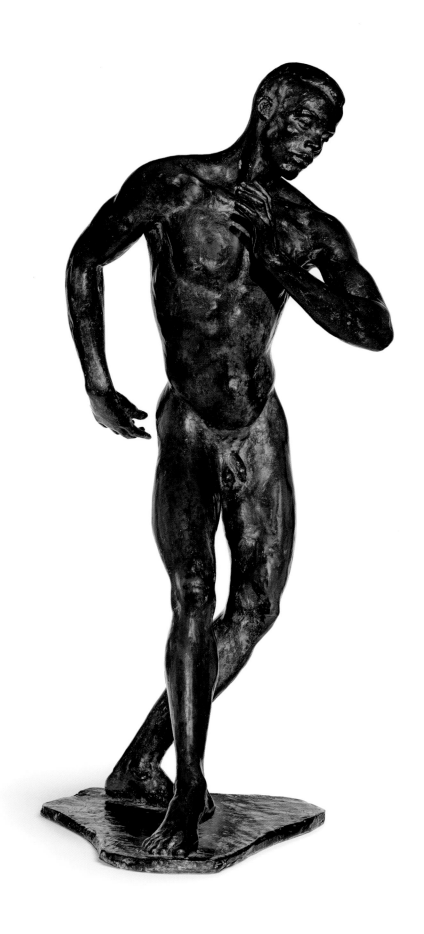

Richmond Barthé, *Inner Music*, 1956

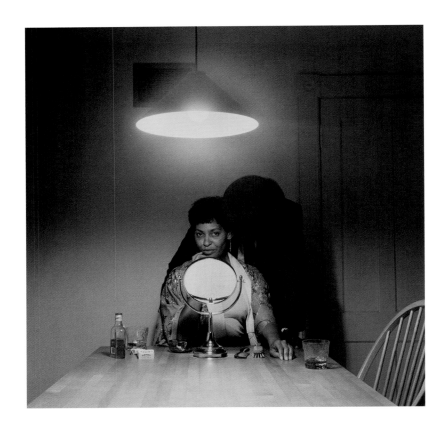

They met in the glistening twinkling crystal light of August/September sky. They were both educated, corn-fed-healthy-Mississippi-stock folk. Both loved fried fish, greens, blues, jazz and Carmen Jones. He was an unhardened man of the world. She'd been around the block more than once herself, wasn't a tough cookie, but a full grown woman for sure.

Looking her up, down, sideways he said, "So tell me baby, what do you know about this great big world of ours?" Smiling she said, "Not a damn thang sugar. I don't mind telling you my life's not been sheltered from the cold and I've not always seen the forest or smelled the coffee, played momma to more men than I care to remember. Consequently I've made several wrong turns, but with conviction I can tell you I'm nobody's fool. So a better question might be: what can you teach me?"

He wasn't sure, confessing he didn't have a handle on this thing called life either. But he was definitely in a mood for love. Together they were falling for that ole black magic. In that moment it seemed a match made in heaven. They walked, not hand in hand, but rather side by side in the twinkle of August/September sky, looking sidelong at one another, thanking their lucky stars with fingers crossed.

Carrie Mae Weems, *Untitled*, 1990, from the Kitchen Table Series

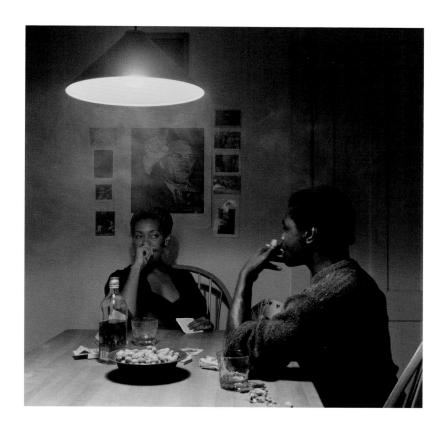

She felt monogamy had a place but invested it with little value. It was a system based on private property, an order defying human nature. Personally she wasn't in the mood for exploring new rocky terrain. But nonetheless assured him she was secure enough in herself and their love to allow him space to taste the exotic fruits produced in such abundance by mother nature.

He was grateful for such generosity. He certainly knew the breadth of his own nature, so felt human nature was often in need of social control. For now he chose self-sacrifice for the long term benefits of her love and their relationship. Testing the strength of the relationship in this way was a dangerous game; taking a chance now might be more than either of them bargained for.

Carrie Mae Weems, *Untitled*, 1990, from the Kitchen Table Series

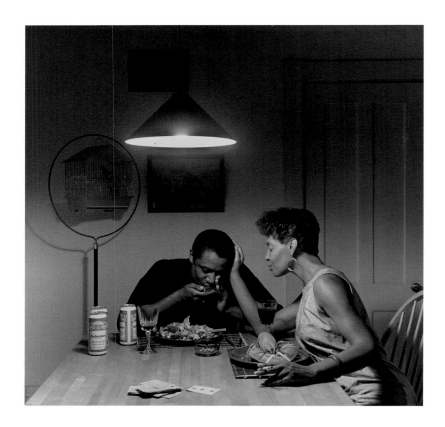

$S$he'd been pickin em up and layin em down, moving to the next town for a while, needing a rest, some moss under her feet, plus a solid man who enjoyed a good fight with a brave woman. She needed a man who didn't mind her bodacious manner, varied talents, hard laughter, multiple opinions, and her hopes were getting slender.

$H$e had great big eyes like diamonds and his teeth shined just like gold, some reason a lot of women didn't want him, but he satisfied their souls. He needed a woman who didn't mind stepping down from the shade of the veranda, a woman capable of taking up the shaft of a plough and throwing down with him side by side.

Carrie Mae Weems, *Untitled*, 1990, from the Kitchen Table Series

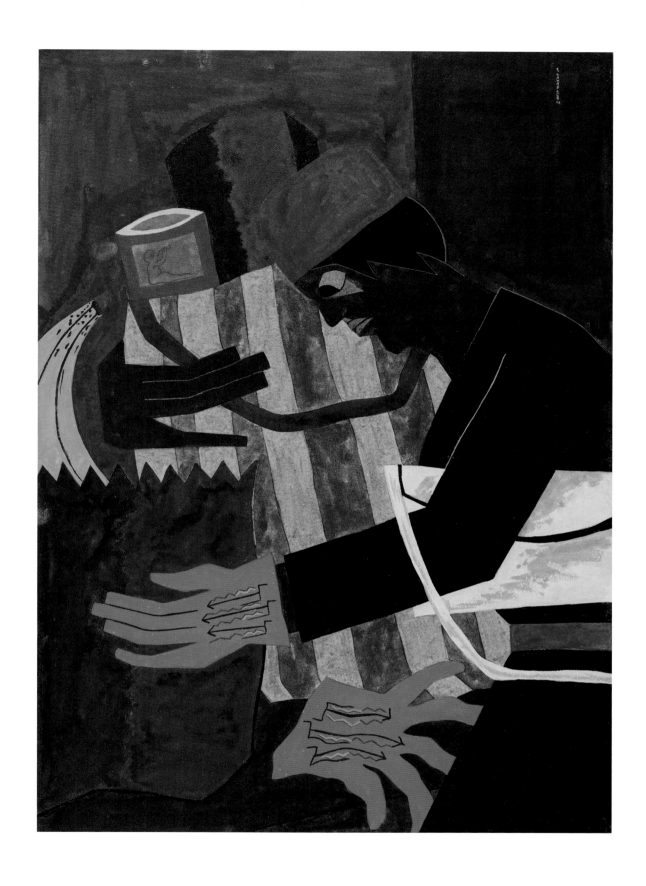

Jacob Lawrence, *Woman with Groceries*, 1942

James Van Der Zee, *Daddy Grace, Harlem*, 1938

James Van Der Zee, *Marcus Garvey & Garvey Militia, Harlem*, 1924

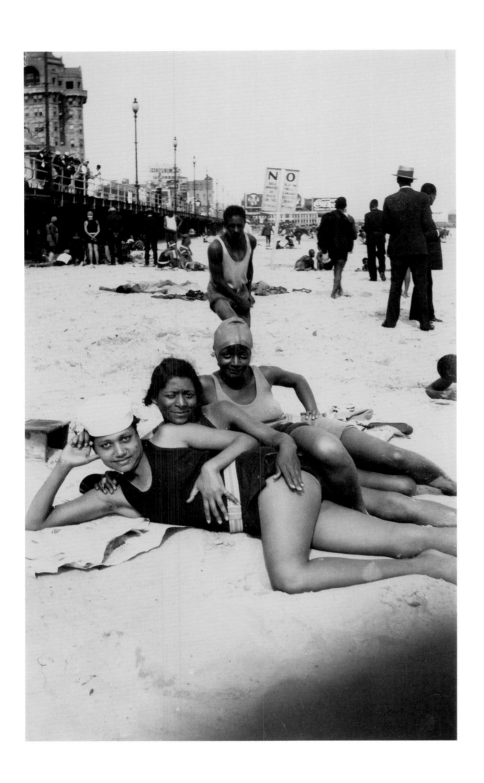

James Van Der Zee, *Atlantic City*, 1930

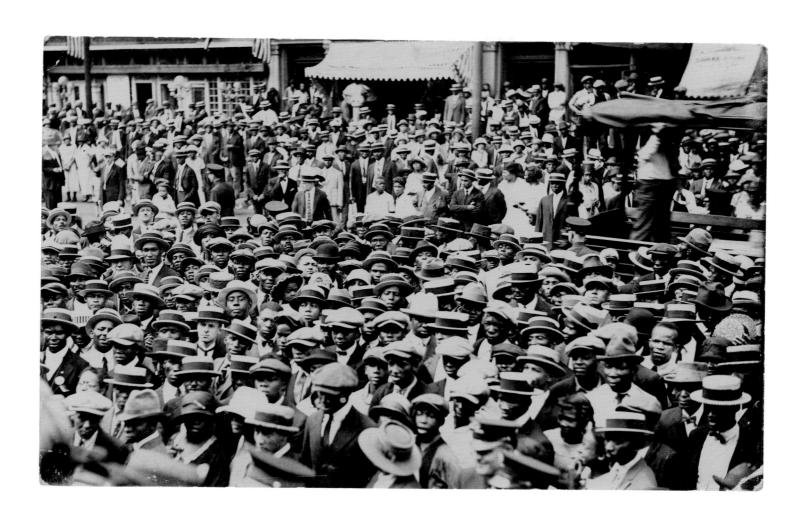

James Van Der Zee, *Crowd in Harlem*, 1920

Calida Rawles, *The Space in Which We Travel*, 2019

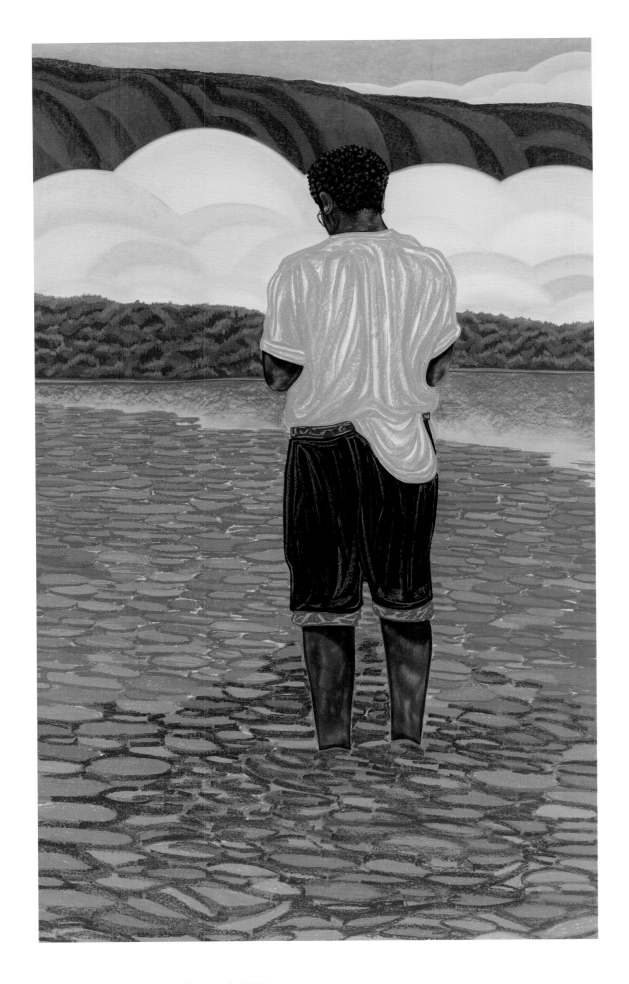

Toyin Ojih Odutola, *Junior's Research*, 2018

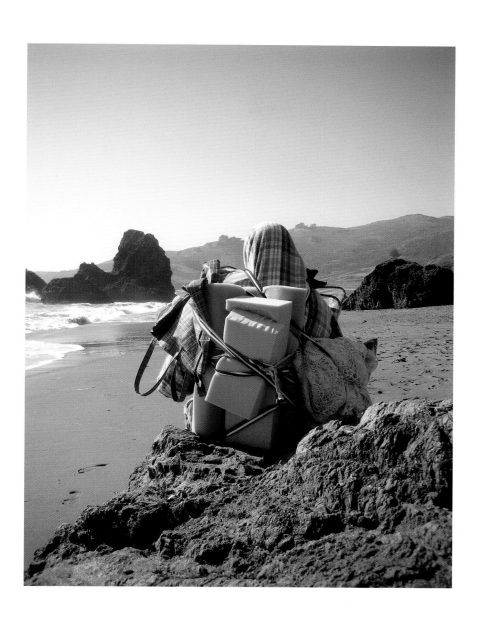

Shinique Smith, *Untitled (Rodeo Beach Bundle)*, 2007

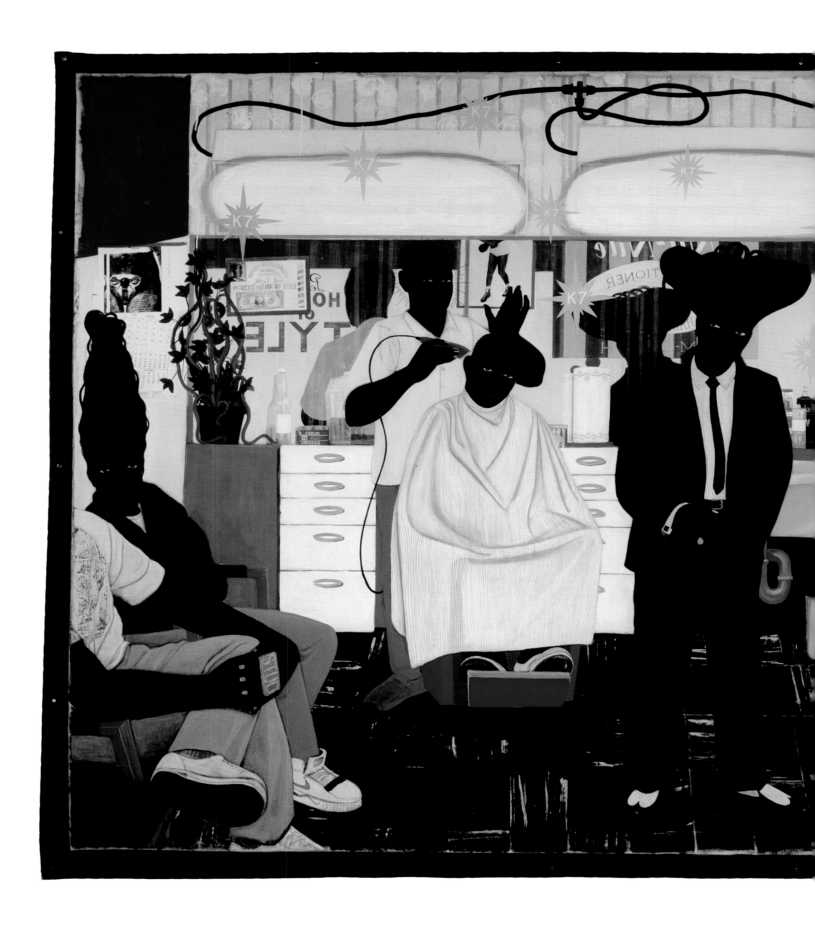

Kerry James Marshall, *De Style*, 1993

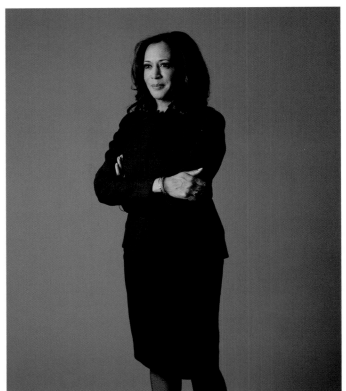

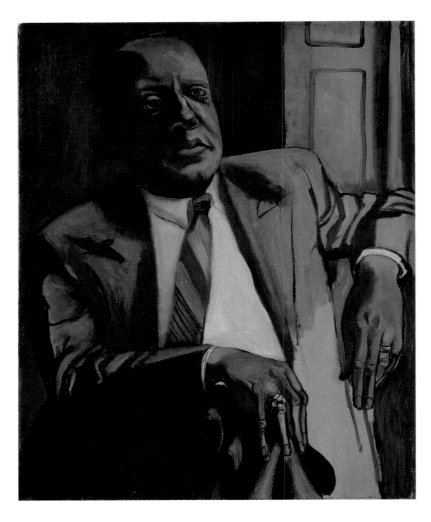

Alice Neel, *Horace Cayton*, 1949

Catherine Opie, *Kamala Harris*, 2015

Janna Ireland, *Wife and Mother*, 2018

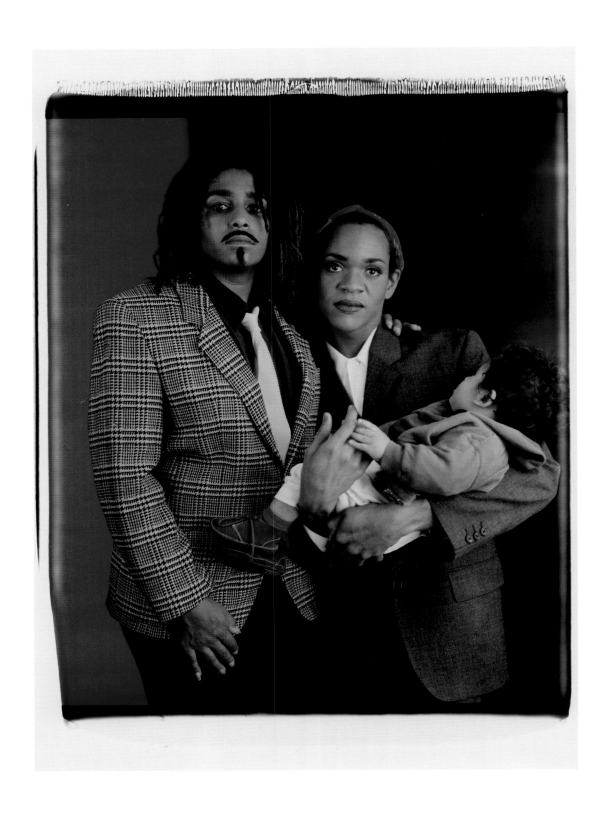

Lyle Ashton Harris and Renee Cox, *The Child*, 1994

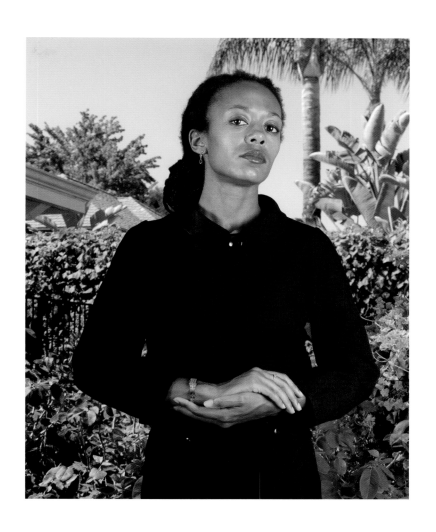

Janna Ireland, *The Black Suit*, 2012

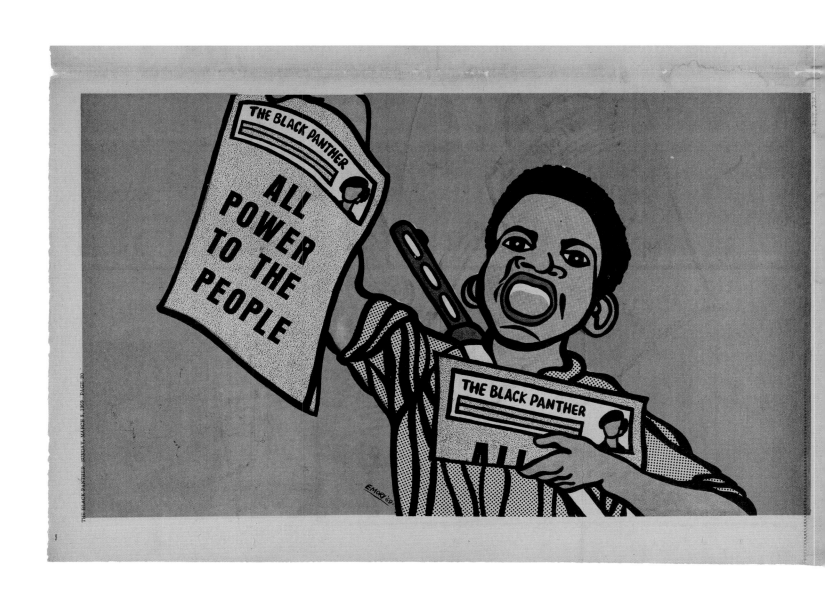

Emory Douglas, *The Black Panther, vol. 2, no. 25*, March 9, 1969

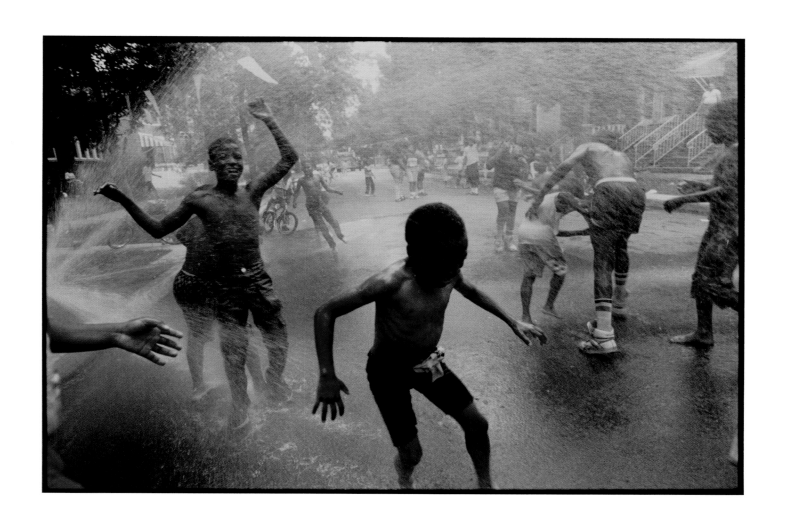

Bruce Davidson, *Untitled*, c. 1989

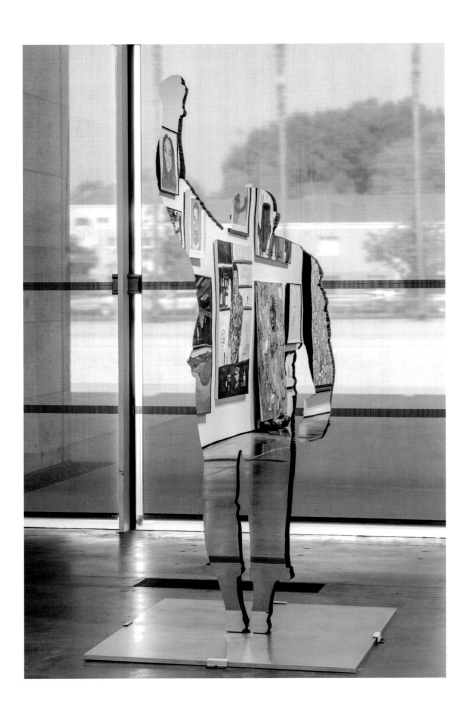

Glenn Kaino, *Invisible Man (Salute)*, 2018

Alison Saar, *Breach*, 2016

Genevieve Gaignard, *Trailblazer (A Dream Deferred)*, 2015

Diedrick Brackens, *look spit out*, 2019

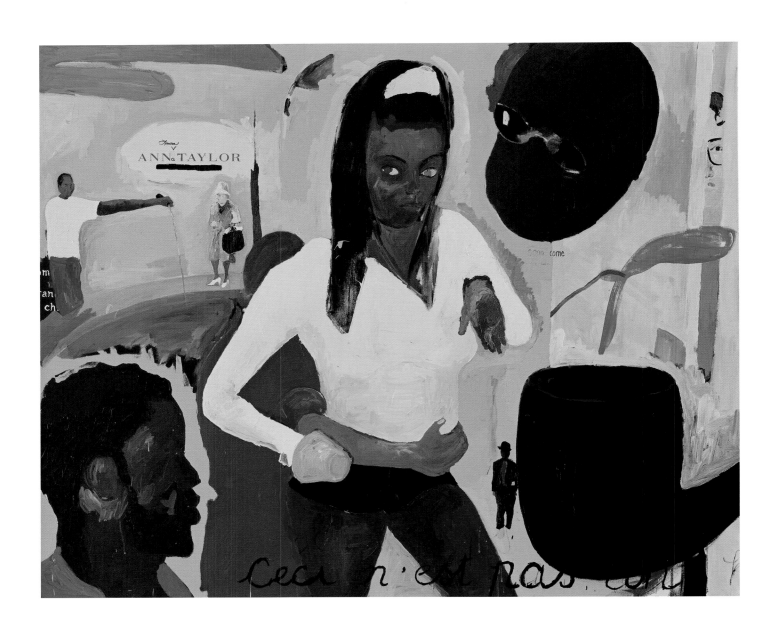

Henry Taylor, *She is not a ho*, 2005

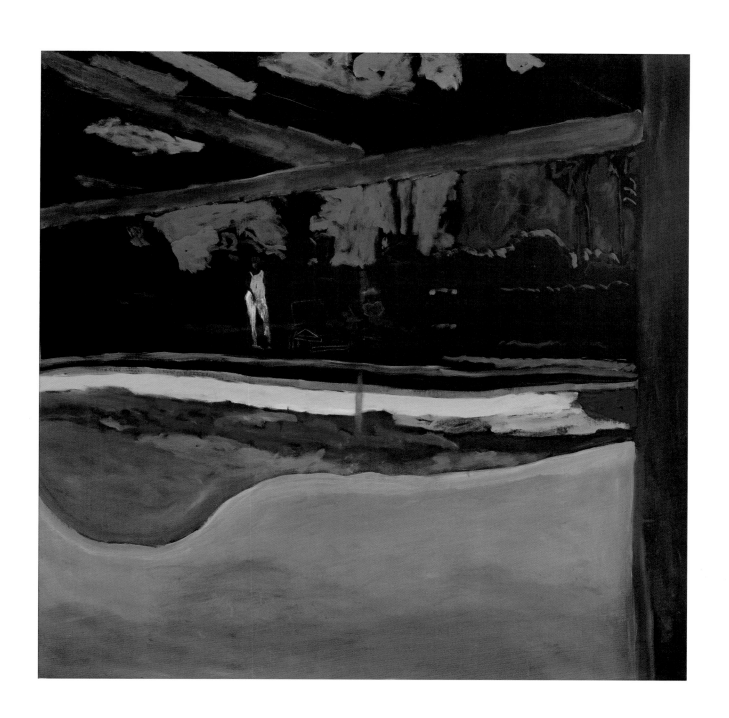

Reggie Burrows Hodges, *Swimming in Compton: Auntie B*, 2019

Lee Jaffe, *Jean-Michel Basquiat*, 1983, printed 2005

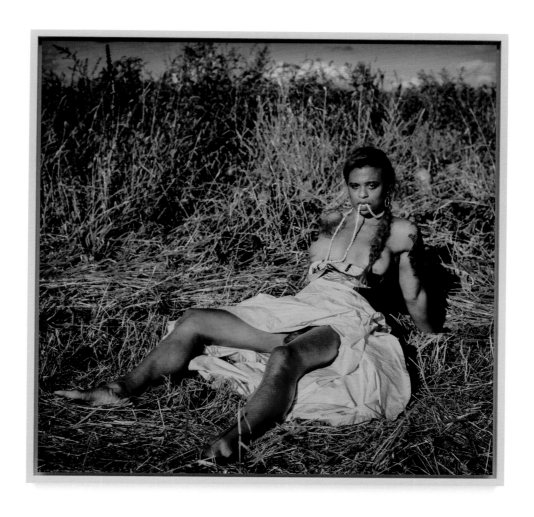

Tourmaline, *Swallowtail*, 2020

Lorraine O'Grady, *Art Is... (Man with Rings and Child)*, 1983, printed 2009

Lorraine O'Grady, *Art Is... (Unisex Barber Shop)*, 1983, printed 2009

Lorraine O'Grady, *Art Is... (Man with Baby)*, 1983, printed 2009

Lorraine O'Grady, *Art Is... (Nubians)*, 1983, printed 2009

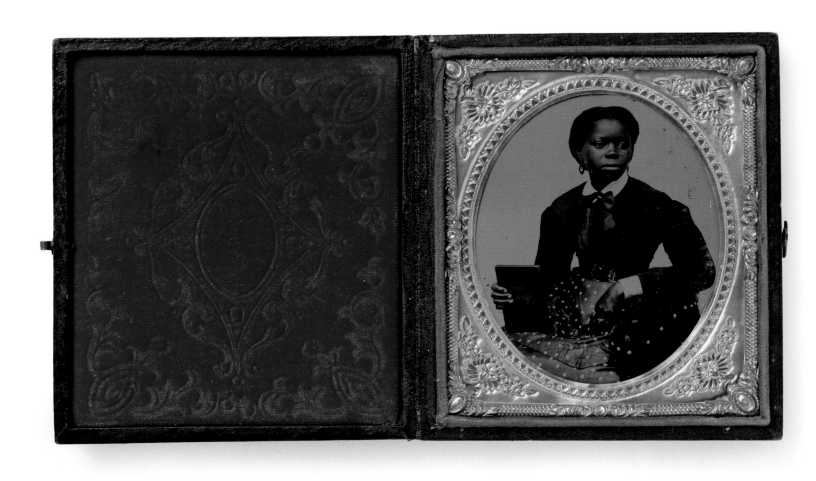

Artist not recorded, *Untitled*, late 19th century

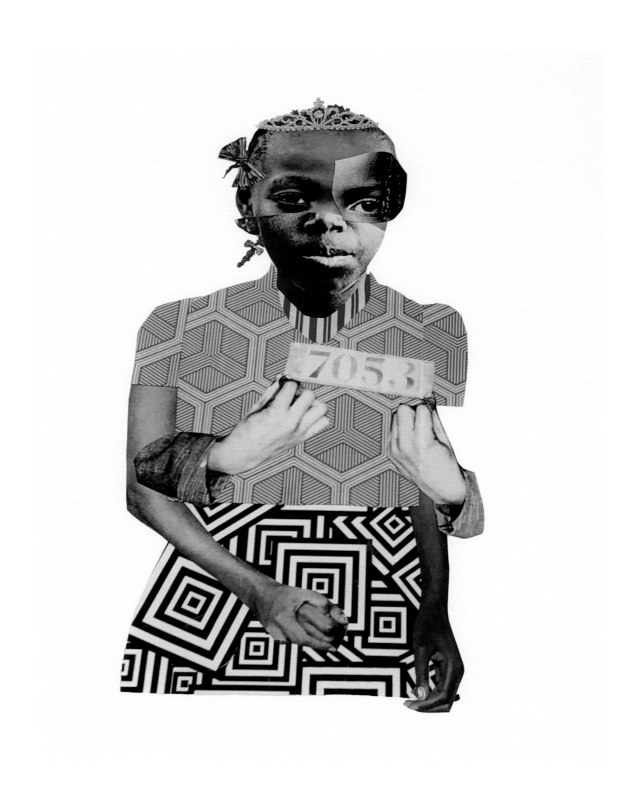

Deborah Roberts, *Breaking ranks*, 2018

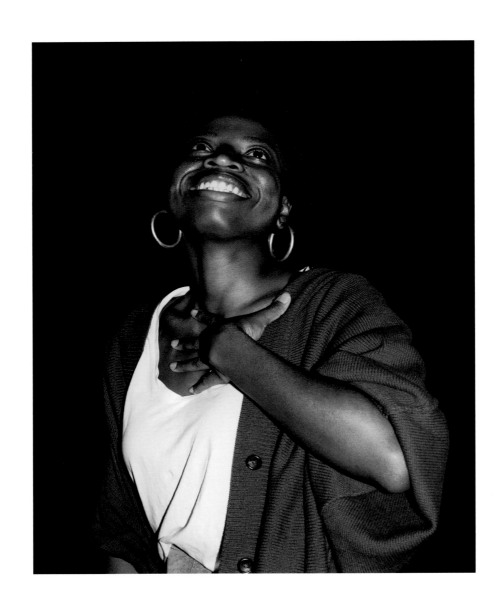

Zora J Murff, *American Mother*, 2019

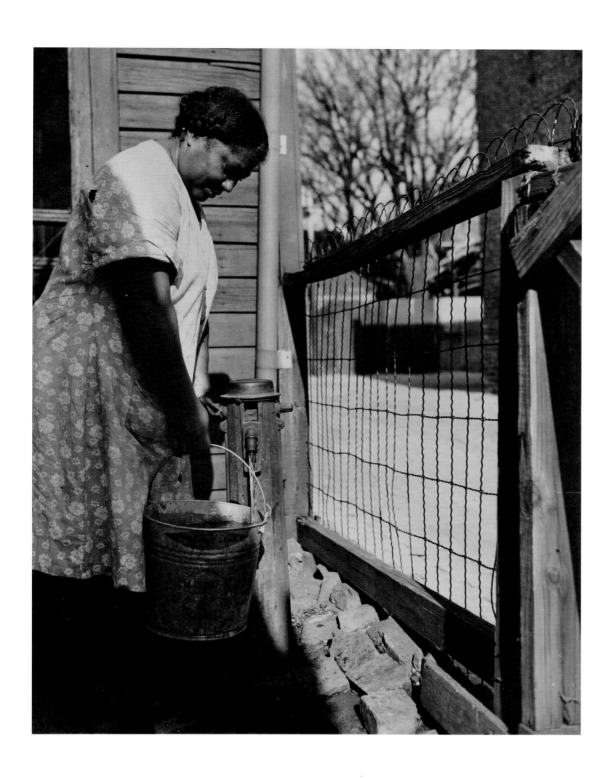

Gordon Parks, *Untitled, Washington, D.C.*, 1942

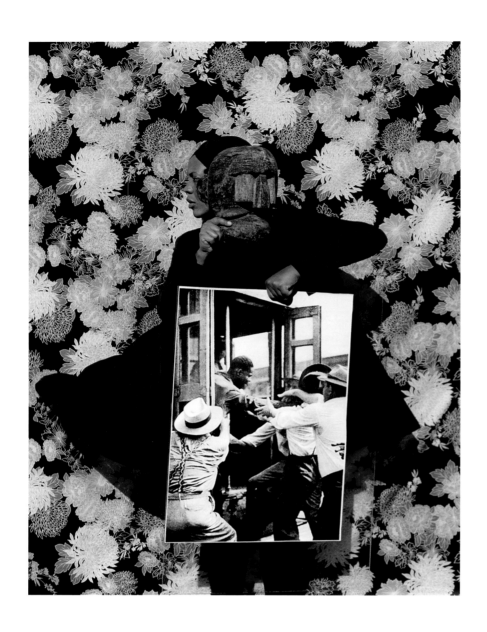

Xaviera Simmons, *Sundown (Number Twenty)*, 2018

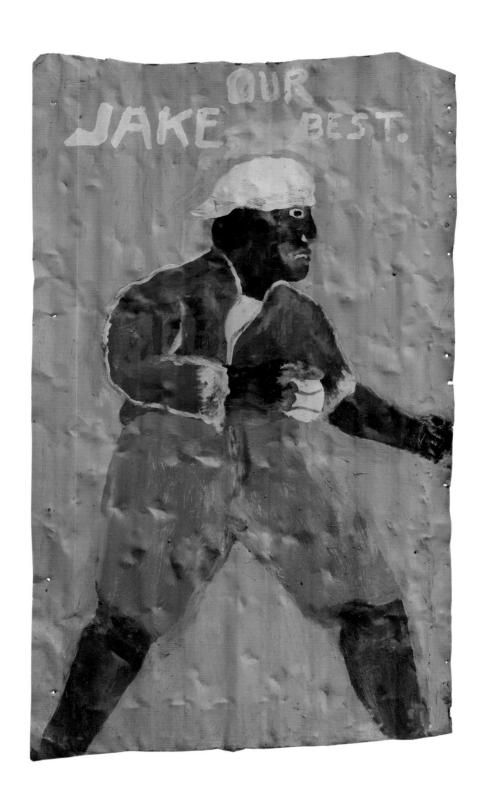

Sam Doyle, *Jake, Our Best.*, 1978–83

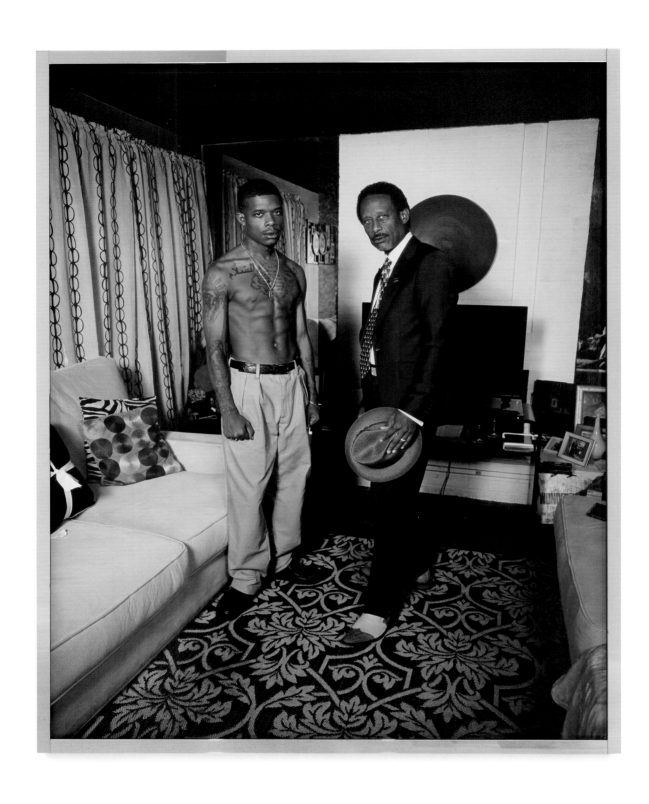

Deana Lawson, *Barrington and Father*, 2021

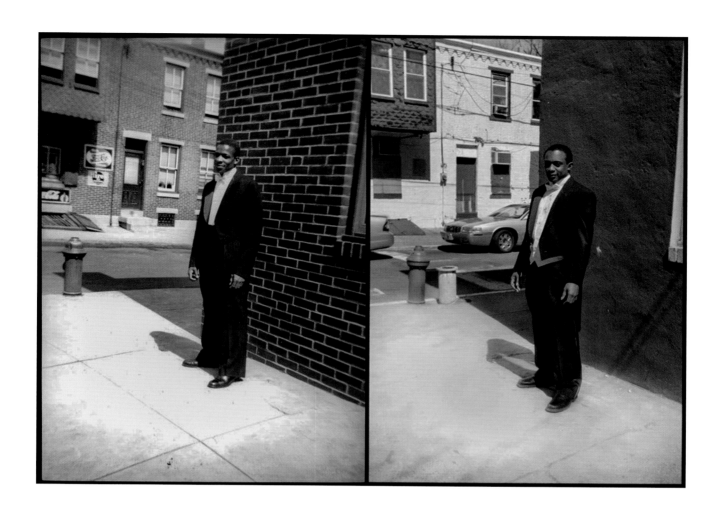

Deborah Willis and Hank Willis Thomas, *Thomas and Thomas*, 2008

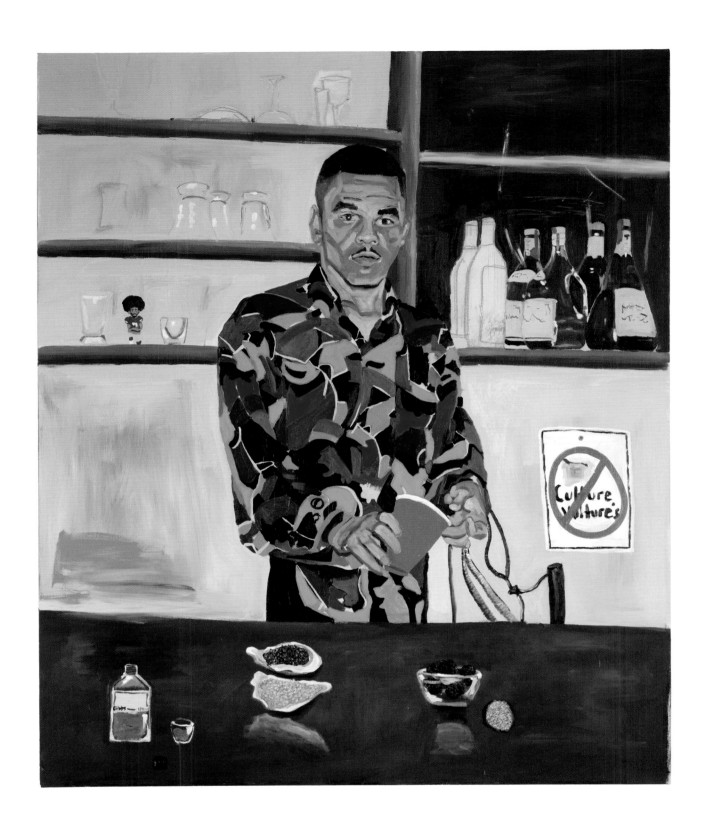

Jerrell Gibbs, *Top Shelf*, 2020

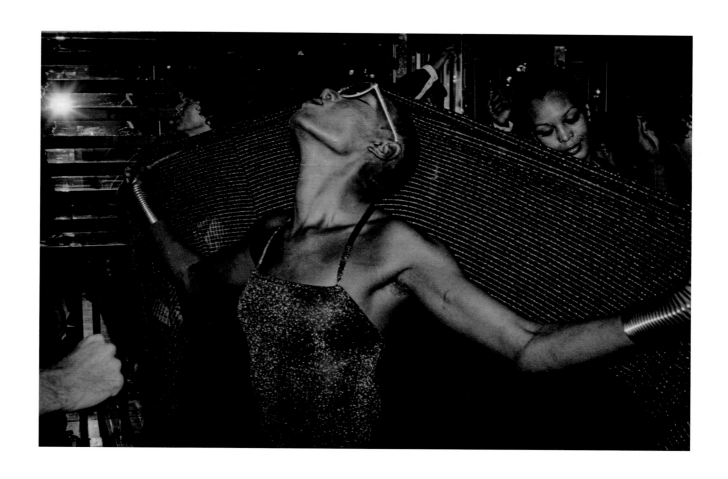

Ming Smith, *Grace Jones, Studio 54 II*, 1979

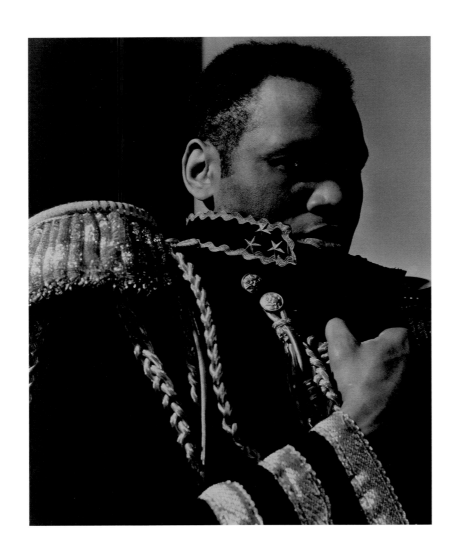

Edward Steichen, *Paul Robeson as "The Emperor Jones,"* 1933

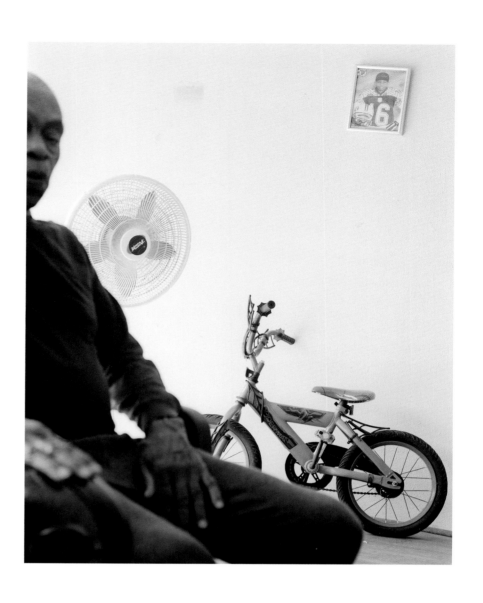

Dannielle Bowman, *Vision (Garage)*, 2019

Kerry James Marshall, *Black Beauty (Tyla)*, 2012

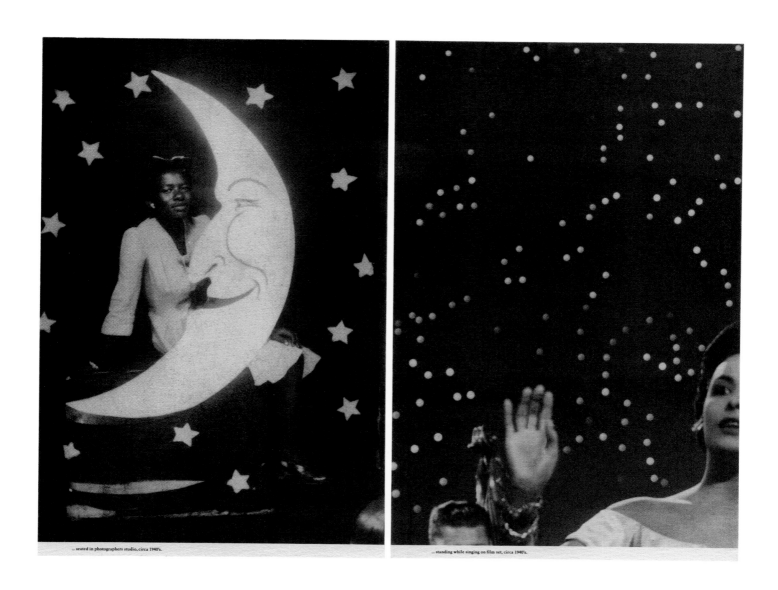

Lorna Simpson, *Backdrops, Circa 1940s*, 1998

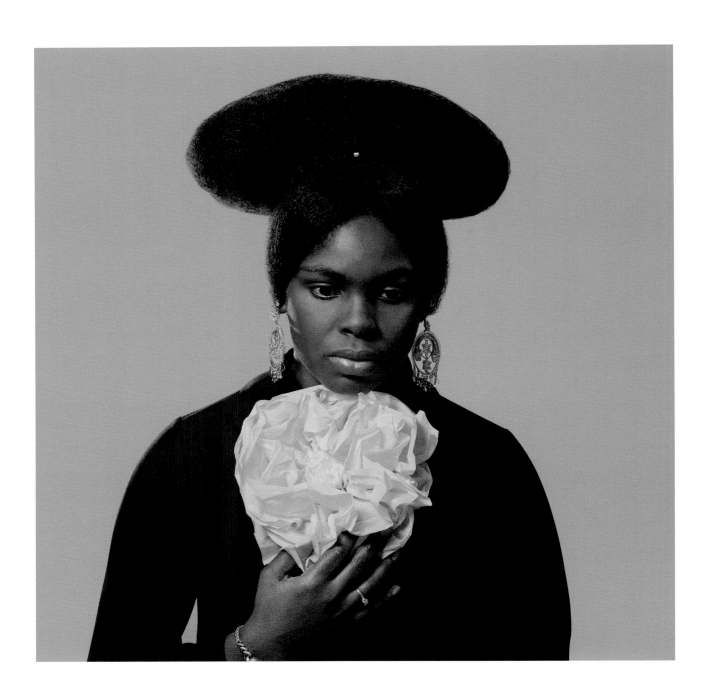

Kwame Brathwaite, *Untitled (Clara Lewis Buggs with Yellow Flower)*, 1962, printed 2020

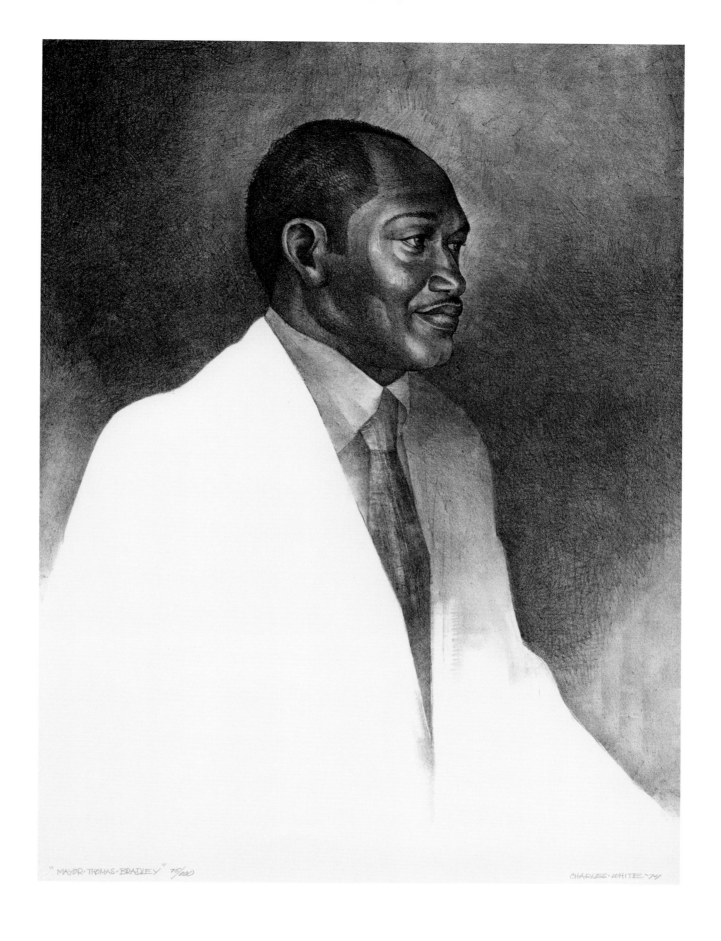

"MAYOR·THOMAS·BRADLEY" 75/200    CHARLES·WHITE·'74

Charles White, *Portrait of Tom Bradley*, 1974

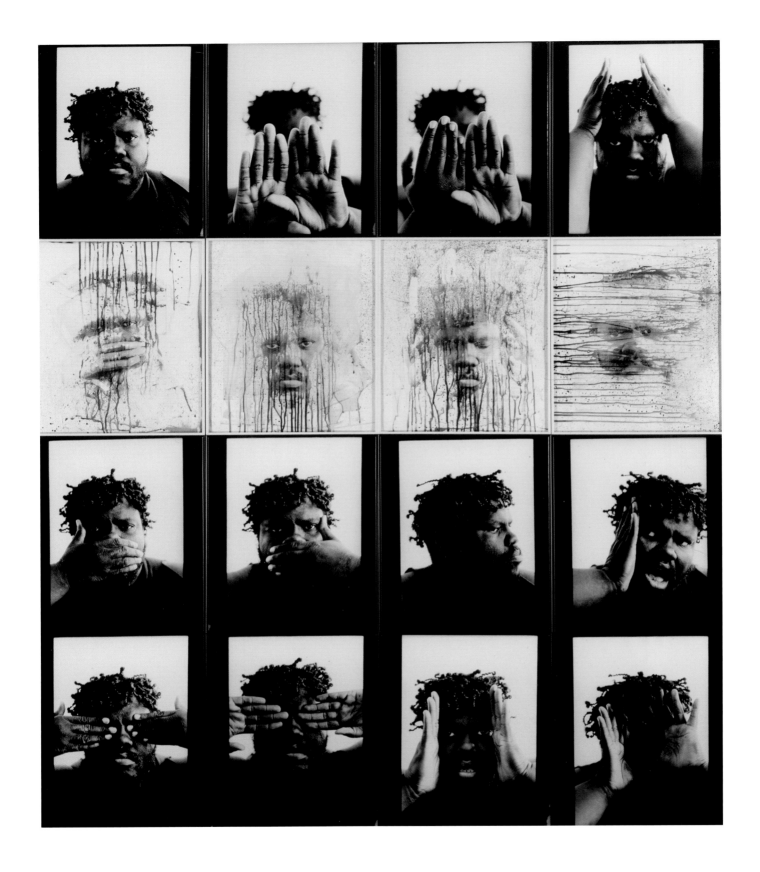

Willie Robert Middlebrook, *In His "Own" Image*, 1992

Betye Saar, *Phrenology Man with Symbols*, 1966

Shepard Fairey, *John Lewis: Good Trouble*, 2020

Shepard Fairey, *Yes We Did*, November 7, 2008

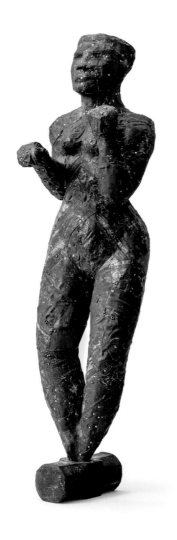

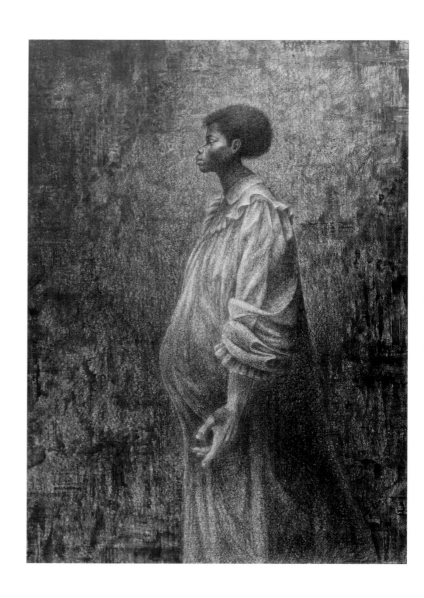

Alison Saar, *Sledge Hammer Mamma*, 1996

Charles White, *Seed of Love*, 1969

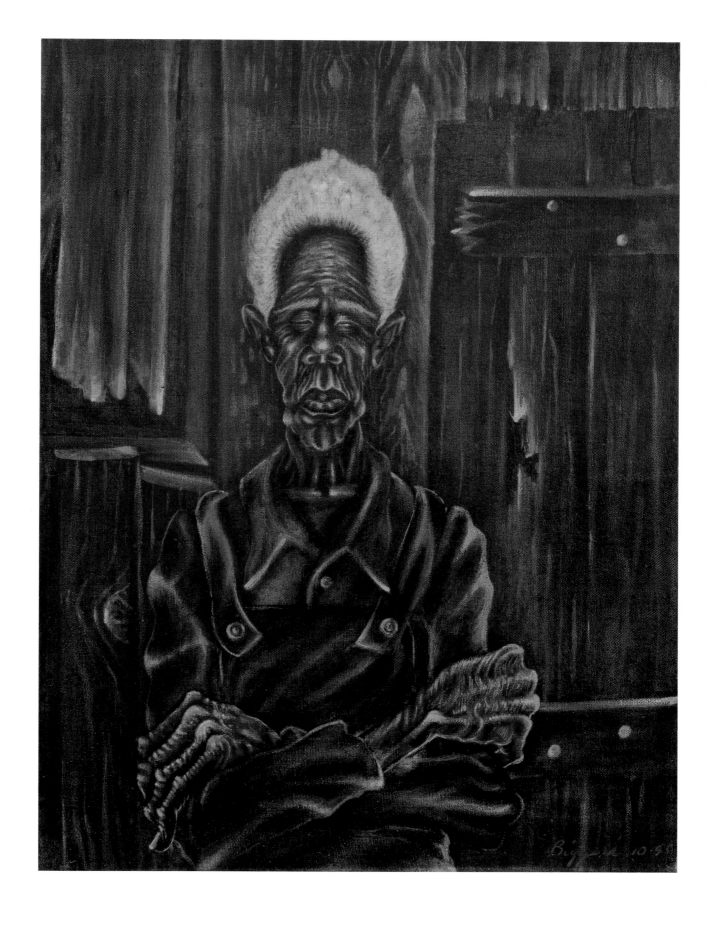

John Biggers, *Sharecropper*, 1945

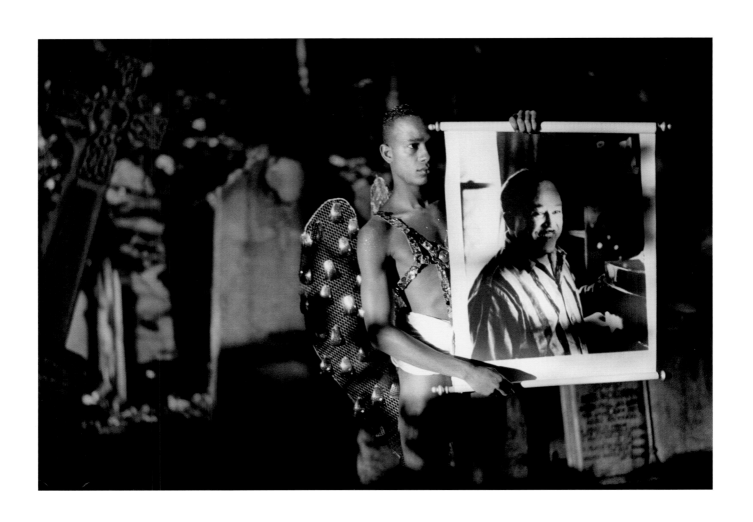

Isaac Julien, *The Last Angel of History*, 1989/2016

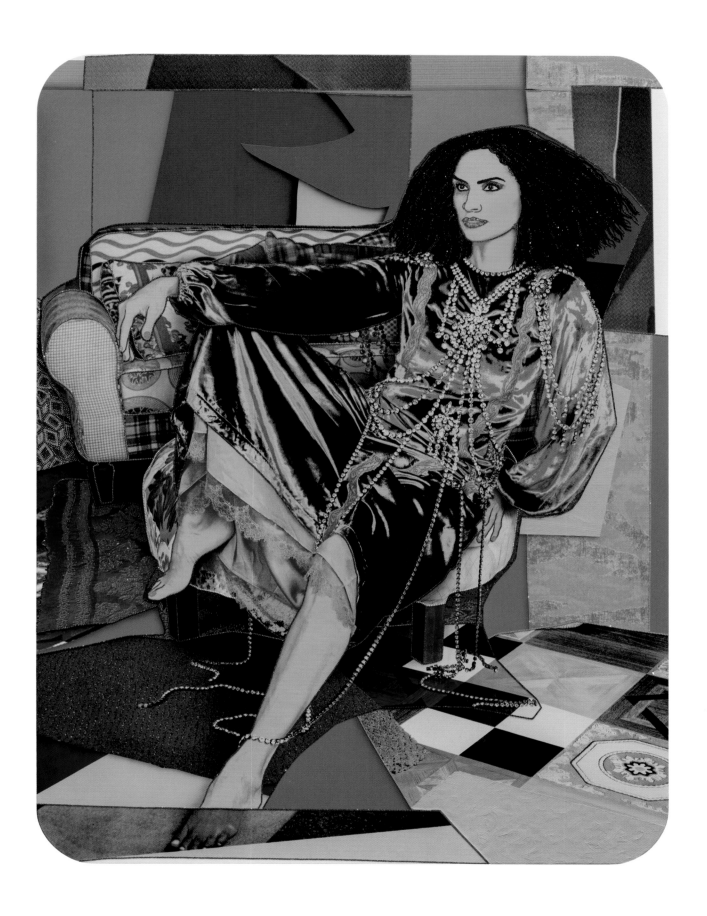

Mickalene Thomas, *The Inversion of Racquel*, 2021

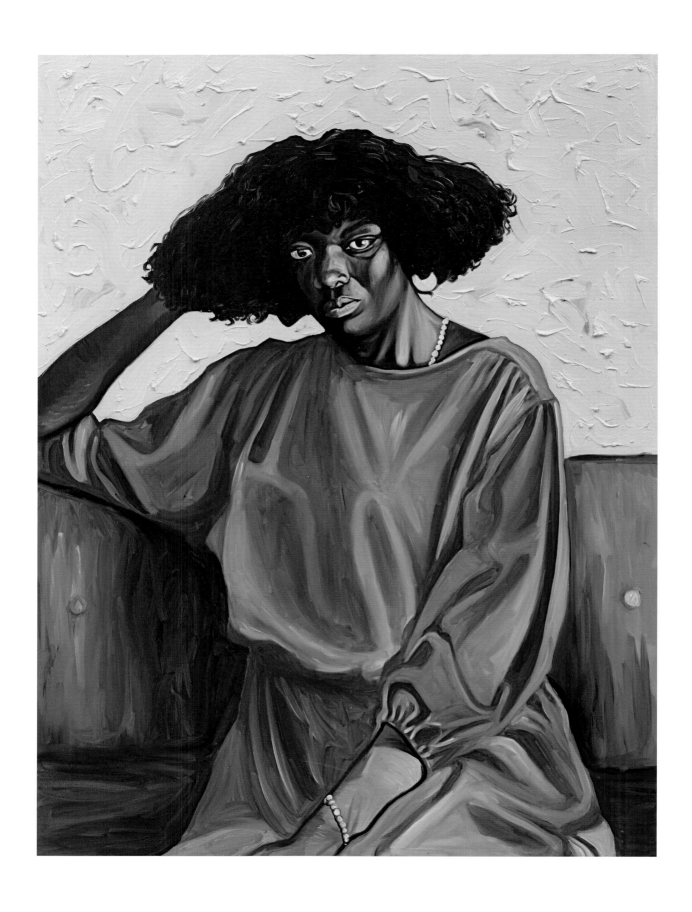

Otis Kwame Kye Quaicoe, *Lady on Blue Couch*, 2019

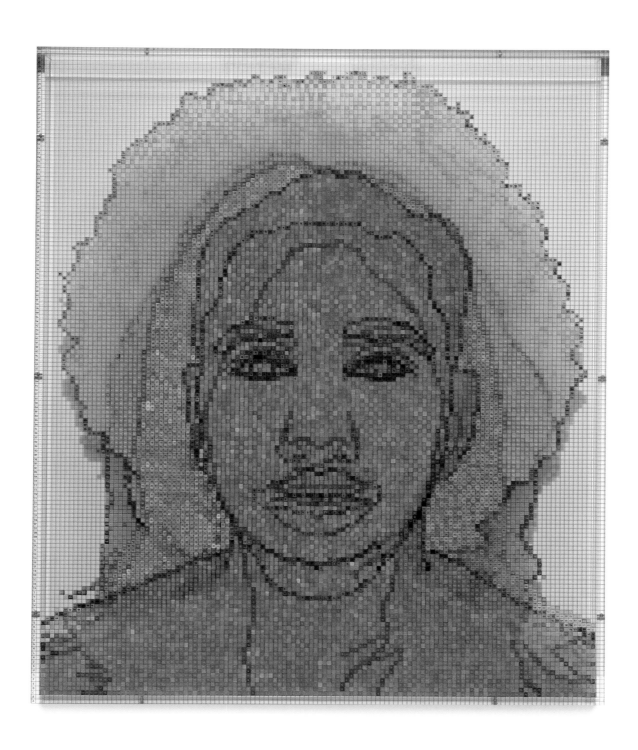

Charles Gaines, *Numbers and Faces: Multi-Racial/
Ethnic Combinations Series 1: Face #7, Eduardo
Soriano-Hewitt (Black/Filipino)*, 2020

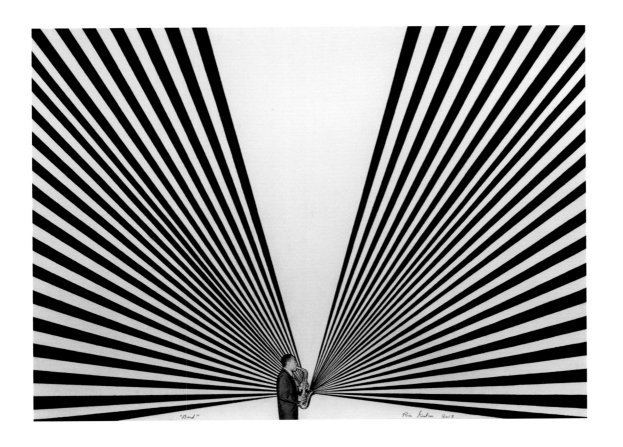

Rico Gatson, *Bird*, 2015

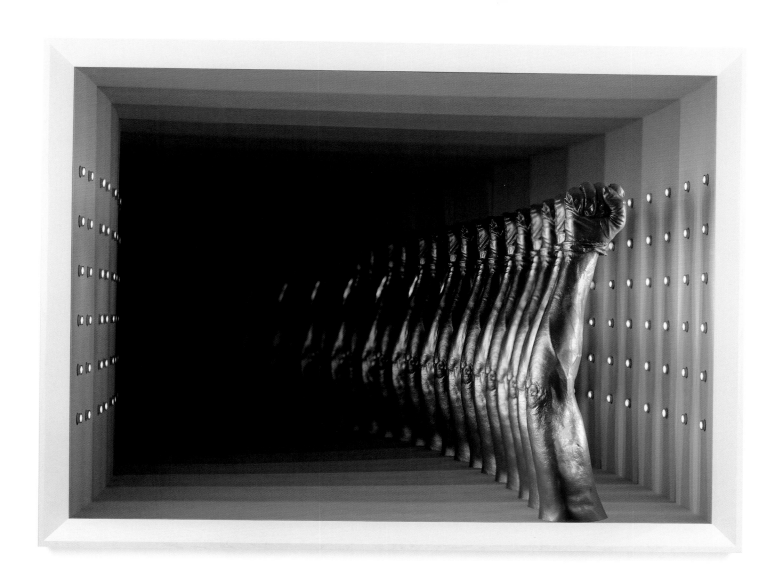

Glenn Kaino, *Salute (Second Salute)*, 2019

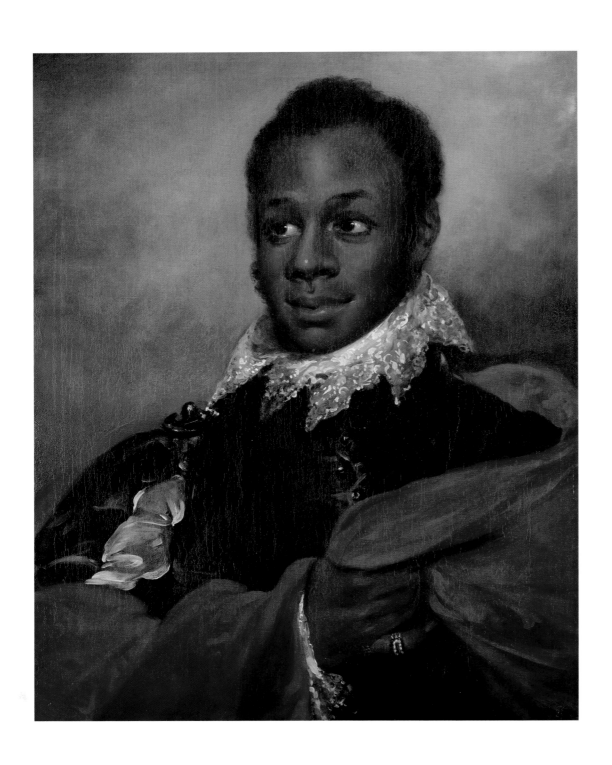

William Armfield Hobday, *Portrait of Prince Saunders*, c. 1815

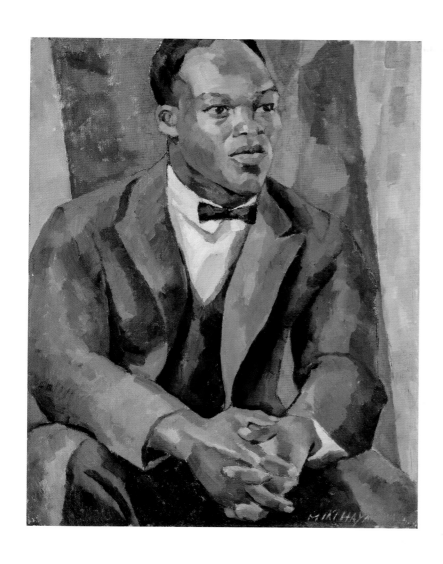

Miki Hayakawa, *Portrait of a Negro*, 1926

Deborah Willis, *Living Room Picture Stories*, 1994

Paul Mpagi Sepuya, *Darkroom Mirror Study (0X5A1525)*, 2017

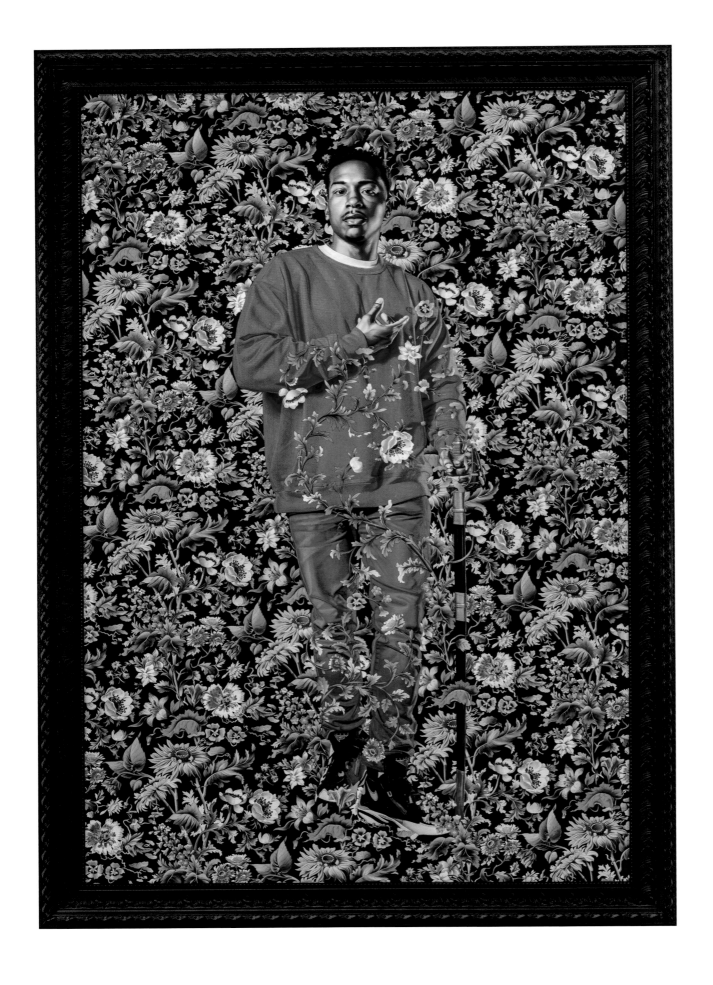

Kehinde Wiley, *Yachinboaz Ben Yisrael II*, 2021

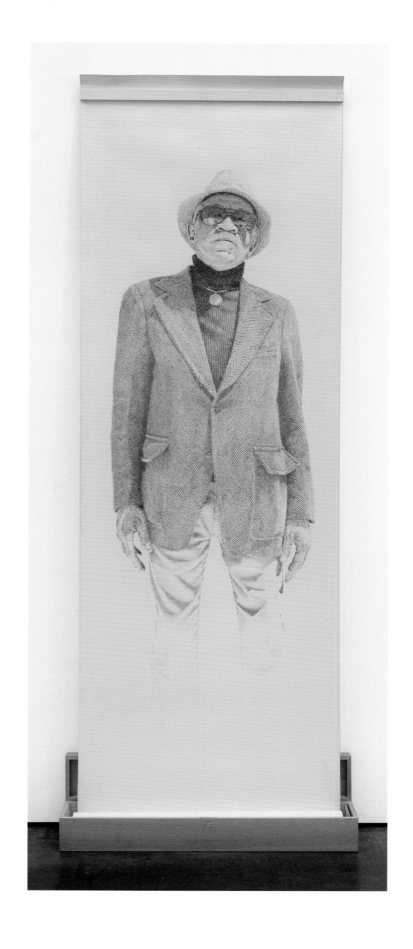

Kent Twitchell, *Portrait of Charles White*, 1977

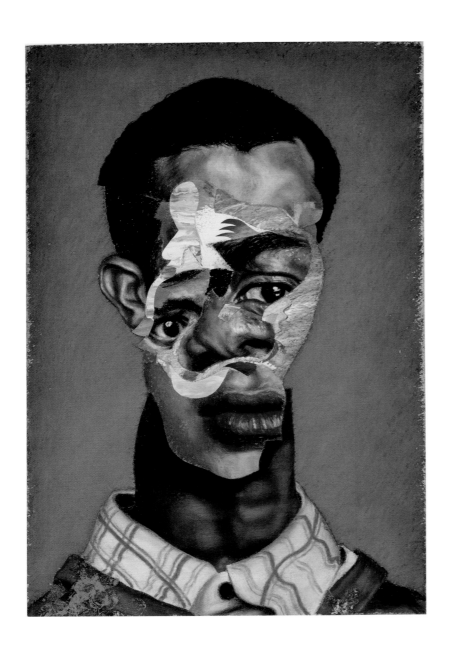

Nathaniel Mary Quinn, *Uncle Dope*, 2017

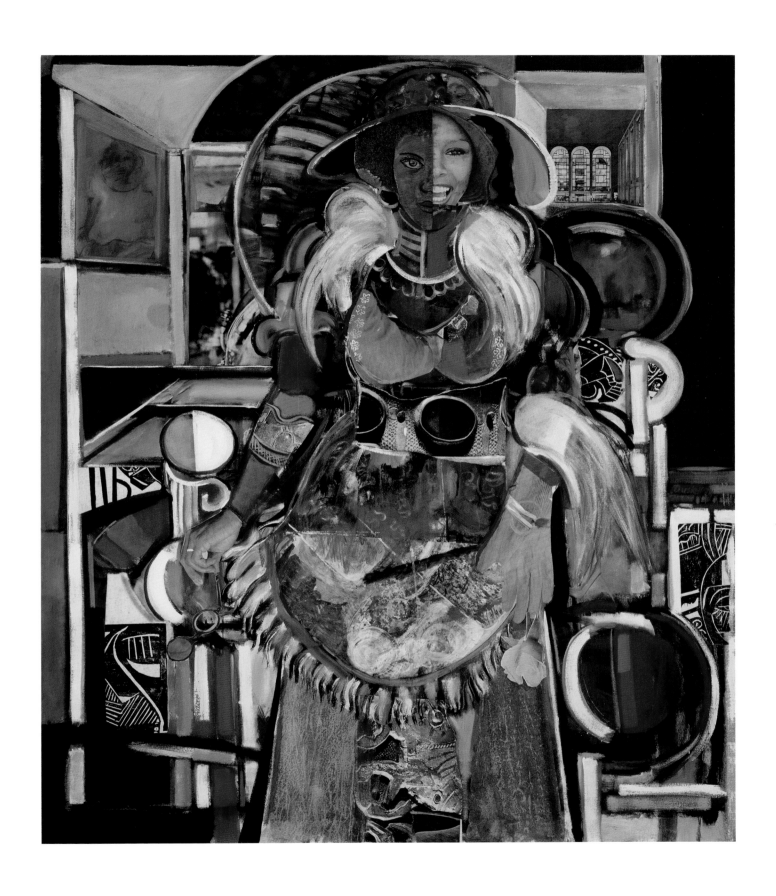

David C. Driskell, *Jazz Singer (Lady of Leisure, Fox)*, 1974

Still from Mark Bradford, *Dancing in the Street*, 2019

Wangari Mathenge, *Oh To Wander (Wonder What She'll See When She Sees)*, 2020

Deborah Willis and Hank Willis Thomas, *Sometimes I See Myself in You*, 2008

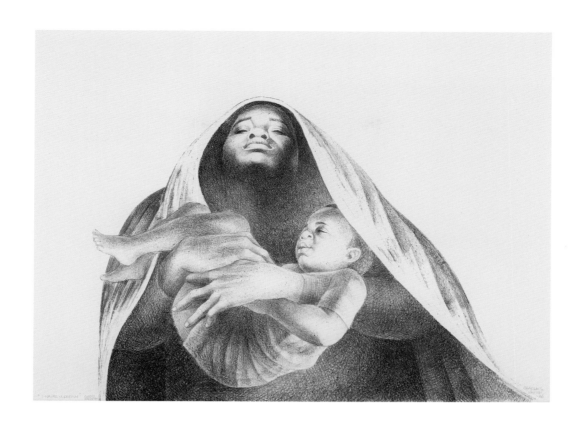

Charles White, *I Have a Dream*, 1976

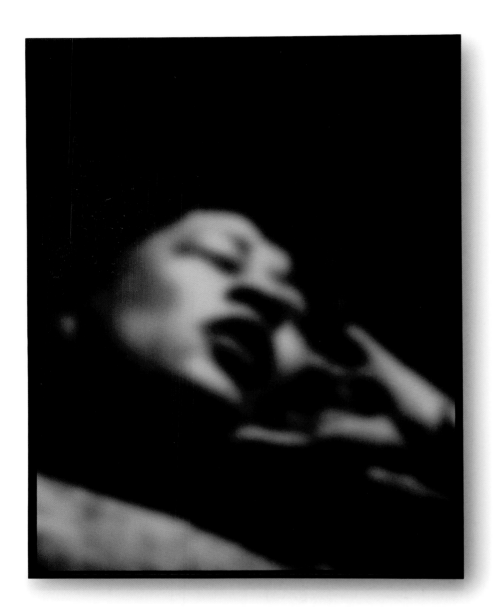

Carrie Mae Weems, *Untitled (Ella on silk)*, 2014

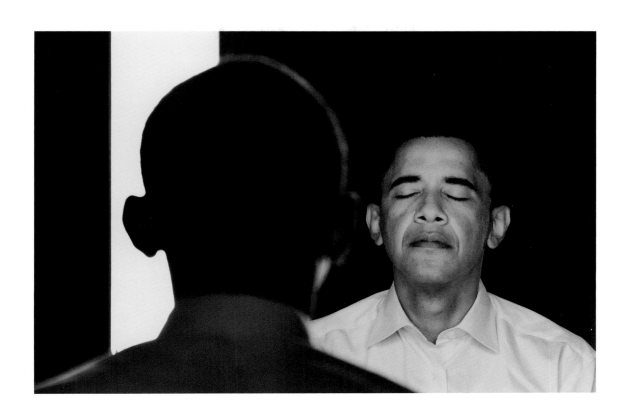

Ralph Nelson, *Untitled (Obama in Mirror, B&W)*, 2009

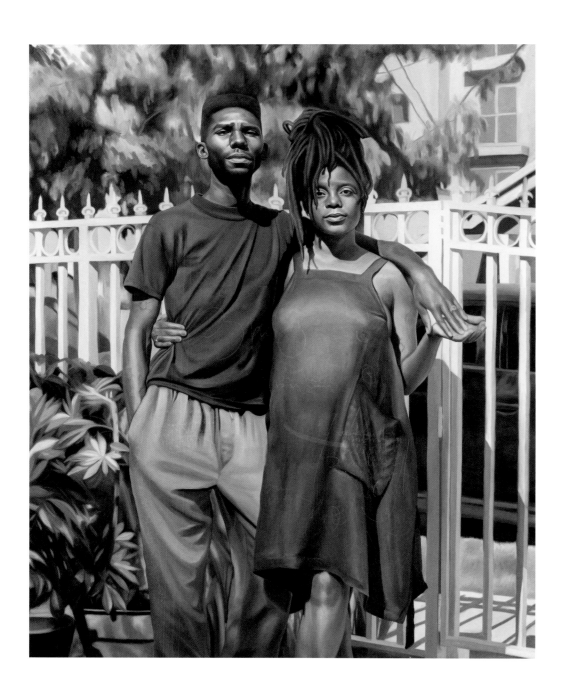

Kohshin Finley, *Essence and Jihaari*, 2020

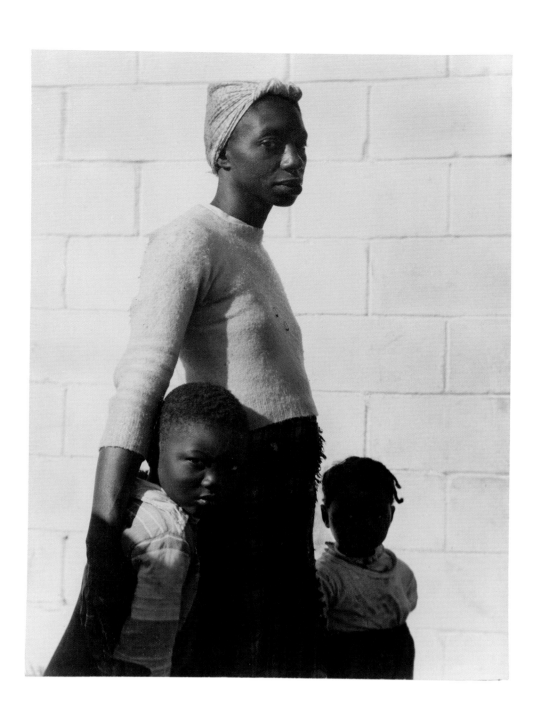

Consuelo Kanaga, *She is a Tree of Life to Them*, 1950

Stills from Stan Douglas, *Luanda-Kinshasa*, 2013

# A Museum's Commitment to the Trayvon Generation

## Christine Y. Kim

*Like holding a mirror up to the face of history and producing a reflection of a reflection, African Americans have been both the subjects and agents of representation since America began. In American image history, blacks dance and sing, they shuck and they jive, they weep and they wail, they pimp and they ho. They are dangerous and valuable commodities in a market where capital reigns and where images multiply the exchange values of that which they depict. A black body is a primitivist sculpture, a music video, a minstrel show, a silent film, a memorial to slavery and civil rights. In her effort to depict the sense of self, she's had the tenacity to create in the light of history that's been told about her in images; a black artist always becomes an actor in her own show.*

—Malik Gaines[1]

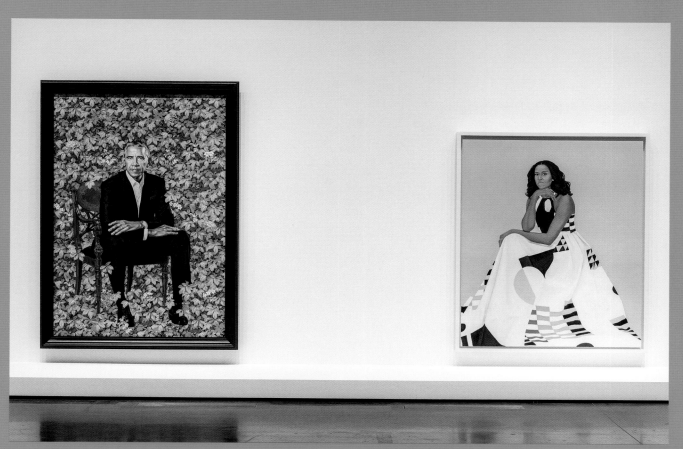

Fig. 1. Installation view in *The Obama Portraits Tour*, organized by the National Portrait Gallery, Los Angeles County Museum of Art, 2021

This publication is a result of a curatorial proposal that became a museum-wide effort to commit more deeply to Black artists, art, narratives, histories, and representation through portraiture.[2] Centered around transhistorical, affirming, nuanced, and joyful representations of Blackness, *Black American Portraits* was initially conceived as a companion exhibition to the Los Angeles County Museum of Art (LACMA) presentation of Kehinde Wiley's portrait of President Barack Obama and Amy Sherald's portrait of First Lady Michelle Obama (fig. 1).[3]

An opportunity for LACMA to evaluate its holdings in the area of Black representation—in particular, self-representation—*Black American Portraits* was intended to historicize Black portraiture and visibilize Black subjects in an American context. Through 140 works of art in painting, photography, sculpture, printmaking, time-based media, and other art forms—such as a bronze and gold sculpture by Tavares Strachan launched into low orbit via satellite (fig. 2), an augmented reality work by Ada Pinkston (pp. 24–25), and an evolving post-media enterprise by Kahlil Joseph that blurs the lines between art, journalism, and cinema (p. 26)—the exhibition strove to celebrate Black subjectivity in myriad ways.

The moment in which we are living, amid evolving racial and social justice movements and a deadly global pandemic, has revealed devastating inequities in our political, socioeconomic, and justice systems. The complicity of museums—living vestiges of capitalism, colonialism, and slavery—in these inequities has simultaneously been exposed. This historical dynamic fueled the project, by generating important questions around institutional responsibility over performativity, investment over optics, and collection-building over mere display. Here, I recount the process and reasons that compelled LACMA to make a meaningful investment in work depicting and made by Black Americans, at a time when museums have been challenged, compromised, and even vilified.

**Building a Checklist**

In late 2019, co-curator Myrtle Elizabeth Andrews, curatorial assistant Breanne Bradley, and I started to comb through LACMA's collection database to devise a curatorial context for

Fig. 2. Tavares Strachan, *ENOCH (display unit)*, 2015–17. Bronze, 24k gold, sand, steel, aluminum, and sacred air blessed by Buddhist monk; 11⅞ × 4 × 4 in. (30 × 10 × 10 cm). Isolated Labs, created in collaboration with LACMA as part of the Art+Technology Lab initiative

portraits and portrayals to consider. A majority of these depict white, European subjects of wealth and prominence, and a majority of them were made by white, male artists. Among the most celebrated portraits in the collection are Rembrandt Harmensz. van Rijn's *Portrait of Marten Looten* (1632; fig. 3), John Singleton Copley's *Portrait of Hugh Montgomerie, Later Twelfth Earl of Eglinton* (1780), Edgar Degas's *The Bellelli Sisters (Giovanna and Giuliana Bellelli)* (1865–66), and Pablo Picasso's *Portrait of Sebastià Junyer Vidal* (1903), all of which have spent ample time on view in the European and Modern

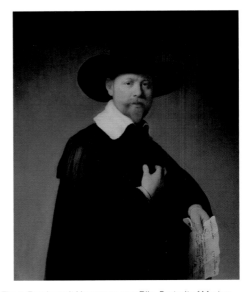

Fig. 3. Rembrandt Harmensz. van Rijn, *Portrait of Marten Looten*, 1632. Oil on wood; 6½ × 30 in. (92.7 × 76.2 cm). Los Angeles County Museum of Art, gift of J. Paul Getty, 53.50.3

the presentation of the Obama portraits. Clearly, the life-size portrayals of the country's first Black president and first lady were going to attract massive crowds, and their upcoming installation in Los Angeles felt like an opportunity to conceive of a thoughtful and expansive presentation for them; in addition to honoring two celebrated sitters rendered by two iconic figurative painters, a companion show could launch a wider conversation about portraiture and representation.

The Obamas' portraits, made by Black artists, exemplify a model for diversity, equity, and inclusion in conventional political commemoration and twenty-first-century portraiture. The canvases speak to two meaningful realities: the highest office in the country is open to American-born citizens of all backgrounds and races, and the question of who paints whom—and how—is vital. Michelle Obama was especially committed to the idea that the portraits could inspire, educate, and uplift diverse viewers, and create more dynamic visibility beyond the halls of traditional presidential portraits, as she related to me during a private tour of the exhibition.

Inspired by the first lady's mandate, we analyzed a vast range of portraits and figurative imagery in LACMA's encyclopedic collection of over 200,000 objects dating back to the sixteenth century BCE. This yielded thousands of

Art galleries. The one painting of a historic African American subject that conveyed the same gravitas, *Portrait of a Sailor (Paul Cuffe?)* (c. 1800; p. 20), would become our curatorial and historic anchor for *Black American Portraits*.

Many early representations of Black, Indigenous, and other subjects of color in the collection were ethnographic, photojournalistic, or objectifying depictions of women, enslaved people, laborers, children, or exoticized subjects, including some "poverty porn." For the most part, these images reinforce the white gaze, which, as Toni Morrison once described, assumes a white reader, viewer, or audience, operating on the racist notion that Black lives "have no meaning and no depth without the white gaze."[4] The story told by the thumbnail images we scrolled through in the museum's permanent collection records is precisely what necessitated a visual counternarrative in the form of an exhibition.

At this juncture, we extracted what could be considered the most historically significant portraits of and by Black Americans in (or promised to) LACMA's collection in order to determine the feasibility and potential scope of an exhibition of African American portraiture. These works included James Van Der Zee's *Self-Portrait in Boater Hat* (c. 1925; p. 31), Sargent Claude Johnson's *Chester* (1930; p. 29),

multiple works by Charles White ranging in date from 1942 to 1976, Elizabeth Catlett's *Sharecropper* (1952; p. 30), Roy DeCarava's *Image/eye, Sherry* (1970; p. 36), David Hammons's *Injustice Case* (1970; p. 68), Sam Doyle's *Jake, Our Best.* (1978–83; p. 109), Kerry James Marshall's *A Portrait of the Artist as a Shadow of His Former Self* (1980; p. 21), Henry Taylor's *She is not a ho* (2005; p. 98), Lorna Simpson's *1957–2009 Interior Group 3* (2009; pp. 32–34), Njideka Akunyili Crosby's *I Still Face You* (2015; pp. 38–39), and Martine Syms's *Notes on Gesture* (2015; p. 37).

We also created an additional, general list of significant twentieth-century Black portraitists and figurative artists whose work would be ideal to include in an exhibition of Black portraiture—from modernism and the Harlem Renaissance: Charles Alston, Romare Bearden, Beauford Delaney, Archibald Motley (fig. 4), James Porter, Augusta Savage, and Laura Wheeler Waring; from the Civil Rights and Black Power eras: Benny Andrews, Dawoud Bey, Emory Douglas, Barkley Hendricks, and the Kamoinge Workshop photographers; with an eye toward the West Coast, Artis Lane, Samella Lewis, and Richard Wyatt Jr.; and, finally, more

Fig. 4. Archibald J. Motley Jr., *Portrait of a Cultured Lady*, 1948. Oil on canvas; 39½ × 32 in. (100.3 × 81.3 cm). Courtesy of Michael Rosenfeld Gallery, LLC, New York, NY

contemporary artists such as Jordan Casteel, Titus Kaphar, Hank Willis Thomas, and Mickalene Thomas. But there was one major problem: only a few works by these artists were in LACMA's collection.

## Missed Opportunities

By early 2020, our *Black American Portraits* research was well underway; the typical ten-month cut-off for loan requests to major museums necessitated swift work. We had built a bold

"wish list" of specific loans from public and private collections, mostly in the region but also dotted across the country. But there was also a nagging sense in the back of my head that works by these artists should be *in* LACMA's collection, to share with the public for generations to come. As Jeffrey C. Stewart writes in his essay "Beyond the Master" in this publication, "the Black portrait signifies absence," and these absences were palpable and agitating.[5]

By late spring of 2020, the explosion of COVID-19 illnesses and deaths and the full-frontal revelation of the structural inequities of our healthcare system and society at large coincided with the Black Lives Matter protests prompted by the breaking-point murders of unarmed Black civilians Breonna Taylor and George Floyd by the police. Structural racism became a topic of debate in education, corporate America, and museums, among other industries and institutions around the country. It felt critical to interrogate LACMA's own uneven legacy of African American representation in exhibitions and the collection, with honesty, transparency, and accountability, with the goal of developing an expansive and necessary shift in effort and perspective—and, ultimately, proverbially putting our money where our mouth is.

What did this analysis reveal? After just one solo exhibition of a Black artist at the Los Angeles County Museum of History, Science and Art in 1935, *African Masks by Beulah Woodard*, the museum failed to show or collect Black art for many years.[6] The 1970s were a more productive decade for Black art at the museum: following A Black Culture Festival, organized by the museum's Black Arts Council in 1968, LACMA presented three important exhibitions: *Three Graphic Artists: Charles White, Timothy Washington, David Hammons* (1971); *Los Angeles 1972: A Panorama of Black Artists* (1972); and the first comprehensive survey of African American art, *Two Centuries of Black American Art: 1750–1950* (1976; fig. 5), which was guest curated by David C. Driskell and became the most highly attended show at LACMA at the time. Then, in 1981, a solo show featuring a Black female artist, Maren Hassinger, was mounted, albeit in Gallery Six in the basement of the Ahmanson Building, with the exhibition resulting in zero acquisitions.[7] More than a decade later, the museum presented *A Graphic Odyssey: Romare Bearden as Printmaker* (1994) and *Roy DeCarava: A Retrospective* (1996), resulting in only one acquisition, a print, Bearden's *Falling Star* (1979).

When Michael Govan became LACMA's CEO and Wallis Annenberg Director in 2006, he committed to hiring more curators of color. I arrived at the museum in late 2009 and Franklin Sirmans was hired in early 2010, joining Rita Gonzalez and other then-junior curators in the Contemporary Art department. Together with curators Ilene Susan Fort in American Art and Carol Eliel in Modern Art, we set a series of Black-centered exhibitions in motion: *Glenn Ligon: AMERICA* (2011), *Shinique Smith: Firsthand* (2013), *Sam Doyle: The Mind's Eye—Works from the Gordon W. Bailey Collection* (2014), *Archibald Motley: Jazz Age Modernist* (2014), *Noah Purifoy: Junk Dada* (2015), *Outliers and American Vanguard Art* (2018), *Charles White: A Retrospective* (2019) and *Life Model:*

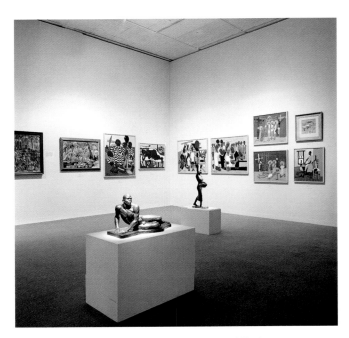

Fig. 5. Installation view in *Two Centuries of Black American Art: 1750–1950*, Los Angeles County Museum of Art, 1976

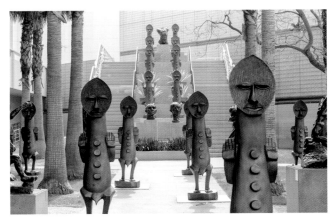

Fig. 6. Installation view of Zak Ové's *The Invisible Man and the Masque of Blackness*, Los Angeles County Museum of Art, 2019

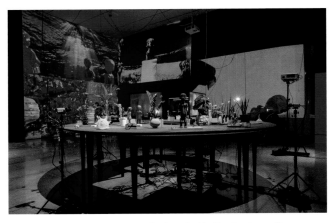

Fig. 7. Installation view in *Cauleen Smith: Give It or Leave It*, Los Angeles County Museum of Art, 2021

*Charles White and His Students* (2019), *Betye Saar: Call and Response* (2019), Zak Ové's *The Invisible Man and the Masque of Blackness* (2019; fig. 6), *Isaac Julien: Playtime* (2019), *Julie Mehretu* (2019), and *Cauleen Smith: Give It or Leave It* (2021; fig. 7) and *Cauleen Smith: Stars in My Pocket and the Rent Is Due* (2021). Most of these exhibitions resulted in at least one major acquisition, with the majority of these purchases occurring through acquisition groups and committees such as Collectors Committee, Contemporary@LACMA (C@L), the Decorative Arts and Design Acquisition Committee (DA²), Art Here and Now: Studio Forum, and various councils.

Although LACMA has made a concerted effort to show work by artists of color in the past decade, this record still represents missed opportunities. While exhibitions are vital interfaces with the public, permanent collection acquisitions—which often require enormous effort—represent a deeper commitment to artists and their legacies, and become markers of institutional responsibility and preservation in perpetuity. (To give a sense of relative costs, the purchase of one major work by an established artist can exceed the cost of mounting an entire exhibition.) Where were the funds and support to play catch-up in order to fill gaps in the collection left by decades of oversights and failures?

Working with curators across departments—including American Art, Modern Art, Contemporary Art, Photography, Prints and Drawings, Costume and Textiles, and Decorative Arts and Design—we continued to locate works and chart a course for *Black American Portraits*. Throughout the process, I kept three things in mind: the museum's inconsistent commitment to collecting work by African American artists since its founding in 1910; LACMA's lack of an overarching endowment for art acquisitions; and the specific works, artists, and moments LACMA would need to represent within its holdings in order to develop a more robust Black American exhibition and acquisition program.

## The Trayvon Generation

By summer 2020, museums around the country were being called out publicly for issuing virtue-signaling statements of support for and solidarity with the Black Lives Matter movement while failing to examine their own inequities in exhibition and collecting programs, as well as the uneven distribution of power and lack of diversity in their staffs, leadership teams, and boards. In addition, many of these institutions' COVID-related layoffs and furloughs disproportionately affected BIPOC workers. At LACMA, what emerged at the intersection of this focus on museum inequity and the upcoming portraiture exhibition was an opportunity to step up and make a deeper commitment to and investment in Black artists and art, and to fully devote our energy and funding toward acquisitions that exemplify Black self-representation and subjectivity.

For me, this perspective on Black subjectivity crystallized into a curatorial strategy after I read poet Elizabeth Alexander's personal-history piece "The Trayvon Generation" in June 2020. In it, Alexander discusses the particular worldview that many Black children and young adults have formed by endlessly scrolling through posts and articles about, and images and footage of, Black trauma, pain, and death on social media during a global pandemic. While body-cam, victim, and

bystander footage—including seventeen-year-old Darnella Frazier's record of the final eight minutes and forty-six seconds of George Floyd's life under Derek Chauvin's knee—has provided necessary proof of the threats and violence that Black people regularly face, there is another side to consider:

> These stories helped instruct young African-Americans about their embodiment and their vulnerability. The stories were primers in fear and futility. The stories were the ground soil of their rage. These stories instructed them that anti-black hatred and violence were never far. They watched these violations up close and on their cell phones, so many times over. They watched them in near-real time. They watched them crisscrossed and concentrated. They watched them on the school bus. They watched them under the covers at night. They watched them often outside of the presence of adults who loved them and were charged with keeping them safe in body and soul.[8]

As Frazier expressed through tears that day, "It is so traumatizing." The spectacle, commodification, and consumption of Black pain, and the retraumatizing effect of this cycle, could and should be addressed by art museums whose mode of communication is precisely images and visual culture.

Most museums flaunt photographs populated with BIPOC museum staff, visitors, and students on their websites, social media feeds, and brochures—whether these images are representative reflections or performative fantasies of who is actually managing and attending their spaces and programs. If museums aspire to support staff and serve audiences of color, especially young people, the concerns of and about the Trayvon generation's visual experiences and language seem paramount to understand with care, complexity, and inclusivity. Museums need to grow and use their collections to share real and thoughtful images, offer nuanced conversations, provide safe spaces, and propose counternarratives, especially in a moment of isolation, political division, and racial trauma.

This conundrum diverted into a series of institutional questions and proposals:

> How can LACMA counter, challenge, and disrupt the fetishization, commodification, spectacle, and consumption of Black pain and trauma?

> What is LACMA's responsibility and purpose to L.A. County and to wider publics at this moment?

> What if we flooded the public with images of Black joy, Black love, and Black abundance to counter, challenge, resist, or temper Black trauma and anti-Black racism and stereotypes?

> What if we used the museum's walls, collection, fundraising muscle, and cultural power to bring these images and narratives to the widest public possible?

> What if we discussed LACMA's historic racist omissions with honesty, transparency, and humility, before we—and in order to—recommit to African American art, by acquiring work instead of just borrowing it for exhibitions?

> How do we inspire greater cross-departmental collaboration; change fundraising models that favor the interests of historically white donors; incentivize thinking about diversity, equity, and inclusion issues in everyday choices; and dismantle internal processes and evaluations that are built on principles of structural racism and white supremacy?

## An Acquisition Effort

With these questions in mind, we boldly shifted gears from borrowing work to an all-hands-on-deck effort to identify significant African American portraits from the past two hundred years available for purchase,[9] or in private collections to ask for as gifts, and to acquire as many as possible before the exhibition's opening in eighteen months.[10] Some of the works in LACMA's collection represent post–Civil War photography, the Great Migration, the Harlem Renaissance, and the twenty-first century, but this was less than half of what felt critical to cover; we needed to consider more deeply the Works Progress Administration years, modernism, and the Civil Rights and Black Power eras, all of which would require collaboration with LACMA curators in other departments to broaden our knowledge base, collecting expertise, and resources. We called on trustees, patrons and supporters of the museum, artists' collectors and representatives, and individuals in our communities who understood that this was a moment for galvanization and mobilization. Requiring creative and proactive fundraising and support, this tentacular strategy relied on acquisition groups such as C@L, which acquired works including Robert Pruitt's *Tau Ceti* (2020; p. 40) in 2020 and Arthur Jafa's *Monster* (1988; p. 43) in 2021. The Decorative Arts department's DA² committee acquired Woody De Othello's *Blank Faced* (2020; p. 41) with the help of Allison and Larry Berg. In 2021, LACMA's Collectors Committee—a group that meets annually to vote on new acquisitions—gave funds for the production of this publication, and the following year the committee acquired William Armfield Hobday's early-nineteenth-century painting *Portrait of Prince Saunders* (p. 132) and Beauford Delaney's *Negro Man* [Claude McKay] (1944; p. 42).

The most challenging acquisition area, as expected, was expensive works from the nineteenth to mid-twentieth century. For works from this era, our strategy was to borrow available paintings that fit squarely into both the exhibition context and collecting mandate, and to continue to fundraise after the show opened, effectively using *Black American Portraits* as a vehicle for exposure and validation of the works' historic significance. For other major portrait artists without appropriate works on the market, we borrowed pieces from the National

Portrait Gallery (lender of the Obama portraits), in the hopes that significant works by these artists will become available for acquisition further down the road, allowing the museum to maintain its commitment to collecting African American portraiture for years to come.

Individual patrons represented an energized source of enthusiasm and support. We turned to collectors in Los Angeles who concentrate on work by artists of color and who understand the importance of supporting these artists by donating works from their personal collections to museums. Thanks to the generosity of Arthur Lewis (the new co-chair of C@L) and Hau Nguyen, who allowed us to comb through their collection database and art storage, LACMA was gifted Todd Gray's *Mirror Mirror* (2014; p. 47), Umar Rashid's *Yolanda, Lady of Yerba Buena* (2015; p. 46), and Richard Wyatt Jr.'s *Glimpse at Yourself* (2006). Janine Sherman Barrois and Lyndon J. Barrois, Sr., who first met at the Archibald Motley show at LACMA in 2014, generously promised to gift Chelle Barbour's *Portrait of Madame C. J. Walker* (2018–19), Greg Breda's *Embrace* (2007), William Cordova's *P'alante, Siempre P'alante (P' A B. Hutton)* (2006–7), Lauren Halsey's *The Crenshaw Hieroglyphic Project: Exterior Wall (Featuring Frankie Beverly)* (2018; p. 44), and Ming Smith's *Grace Jones, Studio 54 II* (1979; p. 113) to the collection.  Robert Iger and Willow Bay, vice chair of LACMA's Board of Trustees, purchased Amy Sherald's *An Ocean Away* (2020; p. 49) as a promised gift. D'Rita Robinson and LACMA trustee Robbie Robinson gave Bisa Butler's textile portrait of Chadwick Boseman, *Forever* (2020; p. 58), to the museum. And trustee Allison Berg and Larry Berg bought *Big David (Walk Around Heaven All Day)* (2020; p. 55), Chase Hall's portrait of his grandfather as a soldier in the Vietnam War, and gifted it to LACMA. These are just a few examples of patrons who understood the imperative and stepped up to meet it.

Early in the curatorial process, we decided to prioritize inclusivity in the backgrounds and biographies of the artists whose work we exhibited. Alongside works by established artists, we hung portraits by self-taught artists such as Hall and Fulton Leroy Washington (aka Mr. Wash), who taught himself and other inmates to paint while incarcerated for non-violent drug offenses. His portrait of Kobe Bryant, *Shattered Dreams* (2020; pp. 56–57), was acquired by musician and actor Aubrey Drake Graham and gifted to LACMA. *Untitled* (c. 2008; p. 54), a watercolor portrait of Terry Ellis by William Scott—a neurodiverse artist who makes portraits of church friends, musicians, politicians, and civil rights leaders at the non-profit organization Creative Growth—was gifted to LACMA by Detroit-based collector Burton Aaron, who also donated D'Angelo Lovell Williams's *Daddy Issues* (2019; p. 59).[11] Both artists exemplify Aaron's interest in supporting underrepresented artists. I call attention to particular donors of works of art here to point out the eagerness of a variety of collectors and patrons to participate as allies and supporters at a moment that demanded a celebration of Blackness in visual culture at one of the largest museums in the country, where Black absence had dominated historically.

Early on, we knew it would be important to feature queer and trans images and artists alongside heteronormative portraits. I asked Graham Steele and Ulysses de Santi, who focus on queer work in their collecting, to gift Alvin Baltrop's *The Piers (three men on dock)* (n.d.; p. 60) and Clifford Prince King's *Safe Space* (2020; p. 60) to the museum. I reached out to London-based collector Amar Singh, who supports queer and women artists of color, and he donated Isaac Julien's *Serenade (Lessons of the Hour)* (2019; p. 22) from Julien's multi-channel film on the life and work of abolitionist Frederick Douglass, as well as Renee Cox's *The Signing* (2017; pp. 62–63), an Afrofuturist reimaging of the signing of the Constitution. Longtime LACMA librarian Douglas Cordell wanted to support the acquisition of a work by a queer or trans artist, and bought Tourmaline's revealing self-portrait *Swallowtail* (2020; p. 101) for the collection.

Reflecting the collegial and community energy that galvanized around the project, LACMA staff played an important role in *Black American Portraits*. The American Art department galvanized around the acquisition of Meta Vaux Warrick Fuller's *The Dancer* (cast c. 1902; p. 72), spending limited departmental funds to bring the work into the collection. A large group of LACMA employees volunteered to make personal donations to help purchase *Just How I Feel* (1972; p. 53), a self-portrait by Cedric Adams, an artist who worked as an art preparator at LACMA for nearly twenty-five years. As some personal collections focus on specific media, we reached out to photography collectors including Alice and Nahum Lainer, who purchased four images from Lorraine O'Grady's seminal *Art Is...* series (1983; pp. 102–3) for LACMA, adding to the vast selection of photography in the exhibition. These examples represent just a handful of the ways in which we prioritized acquisitions and devised creative ways to connect curatorial priorities with support from collectors and patrons, friends and colleagues, employing many possible channels to acquire work.

Many artists expressed serious interest in LACMA's project to acquire Black American works and helped put pressure on their dealers to either purchase and gift work themselves or reach out to collectors to support an acquisition for LACMA. Finally, representatives for artists including Amoako Boafo, rafa esparza, Genevieve Gaignard, Charles Gaines, and Deana Lawson were vital in connecting us with collectors who supported purchases and gifts. Normally, artists would be the last individuals we would ask for gifts, but a number of artists whose work is already in LACMA's collection—such as Isaac Julien, Glenn Kaino, Catherine Opie, Shinique Smith, Hank Willis Thomas, and Deborah Willis—donated their own work. By discussing the narrative of the exhibition, the importance of collecting, LACMA's history, and the museum's next chapter with a diverse range of trustees, patrons, supporters, friends, collectors, and artists and their representatives, we achieved dynamic results.

## Establishing a Counternarrative

Through this concerted effort over nearly three years, LACMA has acquired more than sixty-five works of art. Thanks to intense discussions with curators across

departments, who helped identify priority works for LACMA's encyclopedic collection, the selection is robust, grounded, and designed for diverse opportunities for future display. The inclusion of several non-Black artists strongly allied with Black and marginalized artists and communities in their own art practices and lives—such as Laura Aguilar, Edward Biberman, Bruce Davidson, rafa esparza, Lee Jaffe, Glenn Kaino, Consuelo Kanaga, Alice Neel, and Catherine Opie—indicated that supporters of different races and backgrounds were invited to play a role in the effort to elevate Blackness and Black subjectivities in the exhibition, and in LACMA's collection and community more broadly.

In the *Black American Portraits* planning process, we highlighted what could be considered some of LACMA's most egregious omissions from past decades. At the top of the list was the museum's failure to acquire work by Samella Lewis, an art historian, activist, former LACMA educator, and co-founder of the Museum of African American Art, the California African American Museum, several galleries, and numerous art journals; her painting *Bag Man* (1996; p. 66) was acquired by newer LACMA patrons Jen Rubio and Stewart Butterfield, indicating the need for LACMA to continue to expand its efforts and discourse. Perhaps the most meaningful acquisition for LACMA was *Jazz Singer (Lady of Leisure, Fox)* (1974; p. 139) by David C. Driskell, who died of complications related to COVID early in the pandemic. Through this joint purchase with the Lucas Museum of Narrative Art, accomplished thanks to Darren Walker of the Ford Foundation—who understood the importance of this addition to the collection—LACMA honors the legendary artist, art historian, and curator of *Two Centuries of Black American Art*.

*Black American Portraits* is not a comprehensive survey, and gaps in the collection will remain. At this moment, pre–World War II works continue to be the most rare and difficult to fundraise for, and this effort, led by the Modern and American Art curators, will take many years. It is also no simple task to find and acquire works by artists such as Archibald Motley, James Porter, and Laura Wheeler Waring; to include these artists in the exhibition, we had to borrow from the National Portrait Gallery and private collections. Early photographs of Frederick Douglass, Harriet Tubman, and other historic figures are similarly difficult to find on the market or in collections willing to part with them. Artist by artist, curators at LACMA are looking back in time, using the tools of the moment to build a future collection designed to stand out as a premier assembly of African American portraiture for the current and next generation of Los Angeles County and beyond. The groundwork has been laid, and the depth of possibilities seems infinite.

A museum's collection is never simply a reflection of the world as it exists, nor is it an definitive representation of important artistic movements and moments. A collection is always necessarily a statement about the work a community feels compelled to recognize, elevate, and celebrate, and it therefore gives us a window into the museum's commitments. By putting much of its energy into collecting works of and by Black Americans, LACMA has publicly displayed its intention to recognize a more complete, inclusive version of art and American history.

To express the meaning of this project as a learning and living experience that extended beyond the art on view, the museum also planned a celebratory series of public programs and events that took place alongside the show. Instead of holding a private reception for trustees, supporters, artists, and other VIPs—as is typical for museums—LACMA organized a public, outdoor open house for all, complete with a floral photo booth inspired by the Obama portraits and designed by world-renowned florist Maurice Harris of Bloom & Plume. Children's and family activities were on offer during the open house and throughout the run of the exhibition. Thanks to Naima J. Keith, LACMA's vice president of Education and Public Programs, and her team, viewers were able to see both exhibitions free of charge on multiple days and evenings. Visitors were also invited to a series of live virtual talks with dozens of the artists included in *Black American Portraits*, as well as live programs such as Kyle Abraham and A.I.M's exquisite performance *Our Indigo: If We Were a Love Song*, which conveyed much of the joy and emotion of the exhibition through choreography, dance, and the music of Nina Simone (figs. 8, 9).

Internally, the African American staff members who make up the museum's (B)LACMA resource group were given a safe space to discuss and guide LACMA's direction over the two years of exhibition planning. And, thanks to close partnership with curator Jennifer King, who serves as a liaison to the museum's Development department, the fundraising model was reconstructed, with adjusted thresholds for crediting and a culture of "friendraising" in order to offer more first-time supporters of color greater agency, collaboration, and self-determined investment and involvement. This approach allowed us to meet our fundraising goal nearly three times over. I hope and expect that we will see these efforts replicated in the museum's fundraising, curation, public programming, staffing, and leadership in the years to come.

As numerous participating artists have emphasized, *Black American Portraits* was a triumph and an unambiguous acknowledgment of how important it is for Black folks to see themselves on museum walls. From Kerry James Marshall to Amy Sherald, many artists have been vocal about how visiting museums in their youths and seldom seeing any faces that resembled their own prompted them to dedicate their careers to rectifying that absence. In response, LACMA decided not simply to mount one exhibition and move on, but to bring more works into its collection, using all its tools, support structures, and contacts—as well as new models—to ensure that the works could be seen over and over in new ways, and to inspire the artists of the Trayvon generation. The breadth of the counternarrative is vast and promising.

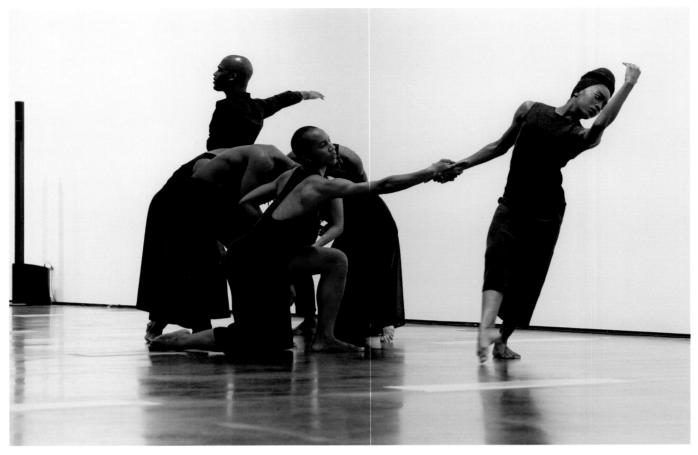

Figs. 8, 9. Kyle Abraham and A.I.M performing *Our Indigo: If We Were a Love Song*, Los Angeles County Museum of Art, February 15, 2022

## Notes

1   Malik Gaines, "Fade (1990–2003)," in *African American Artists in Los Angeles: A Survey Exhibition*, ed. Cece Sims (Los Angeles: City of Los Angeles, Department of Cultural Affairs, 2009), 59.

2   For more on this process, see the introduction to this volume on p. 11.

3   *The Obama Portraits Tour*, organized by the National Portrait Gallery, ran at LACMA from November 7, 2021, to January 2, 2022; the *Black American Portraits* exhibition ran from November 7, 2021, to April 17, 2022.

4   Toni Morrison on *Charlie Rose*, "Toni Morrison," aired January 19, 1998, https://charlierose.com/videos/17664.

5   See Jeffrey Stewart's essay in this volume, p. 172.

6   For more on LACMA's history of collecting work by Black artists, see Ilene Susan Fort's essay in this volume, p. 162.

7   Nearly four decades later, in 2019, LACMA acquired Maren Hassinger's *Untitled (Sea Anemone)* (1971).

8   Elizabeth Alexander, "The Trayvon Generation," *New Yorker*, June 22, 2020, https://www.newyorker.com/magazine/2020/06/22/the-trayvon-generation. Alexander has since published a book on this subject: Elizabeth Alexander, *The Trayvon Generation* (New York: Grand Central Publishing, 2022).

9   This two-century span was determined by the earliest collection work in the exhibition, *Portrait of a Sailor (Paul Cuffe?)* (c. 1800), and by David C. Driskell's 1976 exhibition *Two Centuries of Black American Art*, which in part inspired *Black American Portraits*.

10  It was still necessary to borrow work from the National Portrait Gallery and private collections to supplement works that were not available on the market.

11  Creative Growth is an Oakland, California, gallery and studio for unrepresented artists with developmental disabilities.

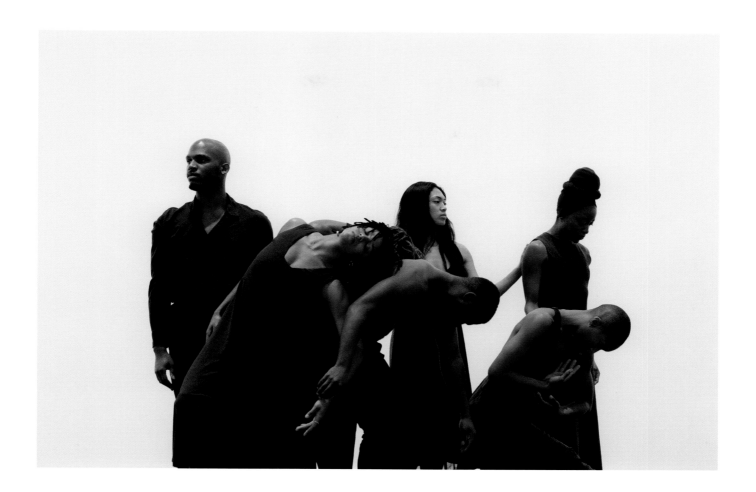

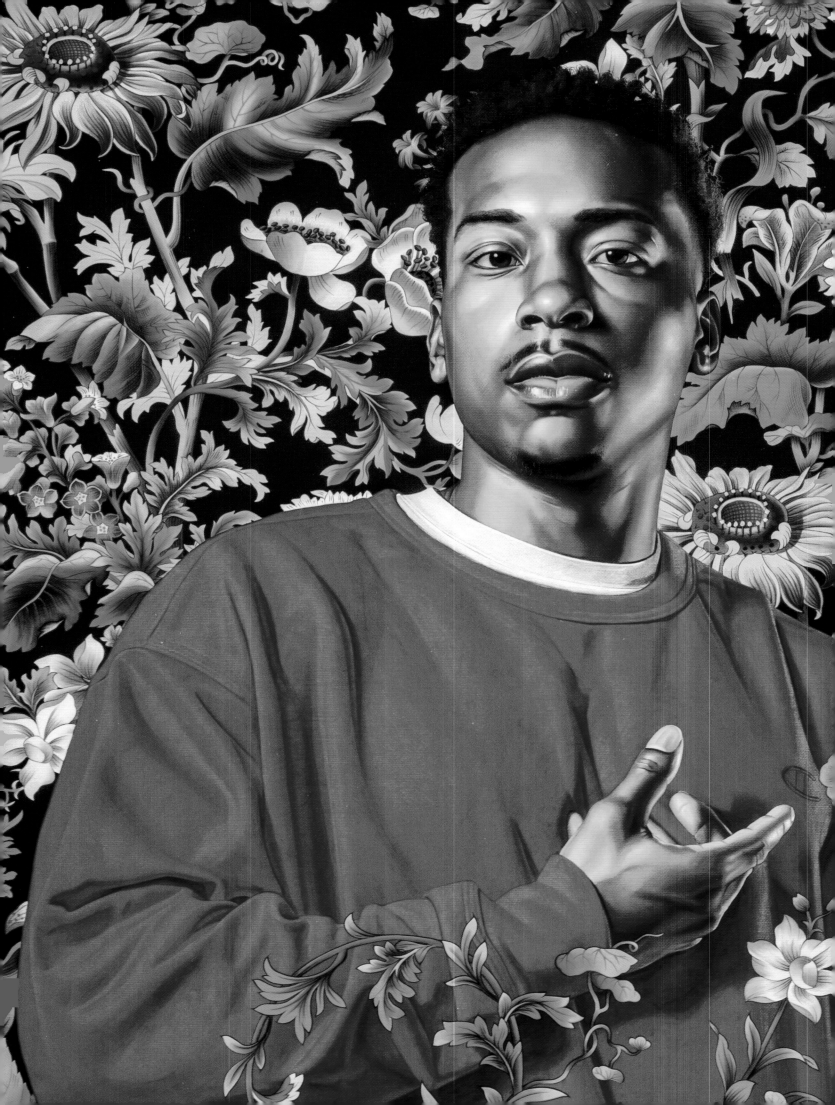

# Black American Art
# at LACMA: A History

Ilene Susan Fort

The Los Angeles Museum of History, Science and Art opened in 1913 without an art collection. The institution eventually began amassing its own holdings through purchase and donation, activities that accelerated when the art division separated in 1961 to become the Los Angeles County Museum of Art (LACMA). Yet throughout its history—and despite its location in Los Angeles, long home to a large population of African Americans—LACMA has never had a formal policy of acquiring Black American art. Although the museum made some overtures to the Black community during the late 1960s and early 1970s, its collection of Black art has, until recently, been built piecemeal, primarily through sporadic donations.

In 1983, I was hired as a curator at LACMA to research the holdings of American paintings and sculptures for a forthcoming catalogue. In the process, I became familiar with the collections of related departments, as well as with the acquisition procedure: some works are given to the museum by collectors or their estates; others are purchased using museum funds; still others are acquired through museum patron groups using member contributions.

LACMA's collection now includes hundreds of works by Black American artists in various media made over the past 173 years, although contemporary art dominates and represents the pluralism of the present age. The works in the collection are heavily representational, focusing primarily on the figure, with an occasional still life, landscape, or abstraction; the contemporary pieces include symbolic imagery and conceptual projects. Within the figurative representations there are historical and contemporary scenes, portraits, genre, and political commentary. The latter appears throughout the holdings, and ranges from gentle pathos to strident military attacks. Women artists are well represented. The artists often have California regional associations: a significant number of selections are by those who were born, studied, or resided in the state. Today, LACMA is the steward of a robust and generally representative group of artworks made by Black Americans, but a look back at the museum's acquisition history reveals the many coincidences, oversights, and omissions that underlie this collection.

## Early Acquisitions

Opened at the end of the first wave of museum-building in this country, the Los Angeles Museum of History, Science and Art typified many of the urban American museums of the time: a place to see great art from all over the world that also served a pedagogic purpose. In the museum's first year, curator Everett C. Maxwell began sending letters to various local art teachers encouraging them to bring public school students to visit.[1] Despite its didactic aim, however, the museum remained a basically white elite cultural institution in terms of administration, staffing, collections, programming, and attendance for most of its first century.

The museum received its first donations of Black American art fortuitously, in 1922 and 1948, from William Preston Harrison, who collected turn-of-the-century American paintings and owned two oils by Henry Ossawa Tanner, including *Daniel in the Lions' Den* (1907–18; fig. 1).[2] Tanner's paintings remained the only Black art owned by the institution until the late 1960s, after it became LACMA. Surprisingly, the museum presented its first solo exhibition devoted to a Black sculptor, *African Masks by Beulah Woodard*, quite early, in 1935, but it had no impact on the institution's policies.[3]

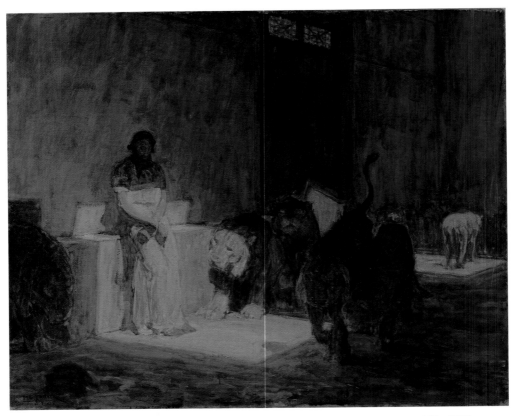

Fig. 1. Henry Ossawa Tanner, *Daniel in the Lions' Den*, 1907–18. Oil on paper mounted on canvas; 41⅛ × 49⅞ in. (104.5 × 126.8 cm). Los Angeles County Museum of Art, Mr. and Mrs. William Preston Harrison Collection, 22.6.3

The museum's Black art holdings now date primarily from two periods of cultural, social, and political change: the Civil Rights and Black Lives Matter eras. In 1965, the year the Los Angeles County Museum of Art opened its doors as a standalone building on Wilshire Boulevard, the Watts Rebellion erupted in South Los Angeles. The physical debris that participants left behind—broken concrete, pipes, and fencing— became the material for assemblages that Black artists such as Noah Purifoy and John Outterbridge created to express their anger; their commentaries would enter LACMA's holdings only decades later. Art-related changes also occurred around this time: Golden State Mutual Life Insurance Company, a Black-owned national enterprise headquartered in Los Angeles, began collecting African American art; Otis Art Institute hired Charles White, the first non-white member of the faculty; and LACMA awarded its New Talent Purchase Award to young artist Melvin Edwards, whose abstract steel sculpture *The Fourth Circle* (1966), which entered the collection in 1967, was the first piece of Black art the museum bought with its own funds (fig. 2).[4]

In 1968, the year Martin Luther King Jr. and Robert F. Kennedy were assassinated and the Fair Housing Act became law, museums became sites of racial contention, with grassroots activists decrying the absence of non-white American art in exhibitions and collections.[5] In 1963, LACMA refused to commemorate the hundredth anniversary of the end of enslavement with a juried exhibition for Black artists.[6]

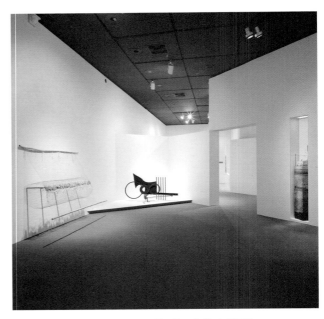

Fig. 2. Melvin Edwards's *The Fourth Circle* (1966) (center) in *Young Talent Awards: 1963–1983*, Los Angeles County Museum of Art, 1983

In 1968, Samella Lewis, the first academically trained Black professional to work at LACMA, was hired as an educator, but she resigned in 1970 due to her frustration over the slow pace

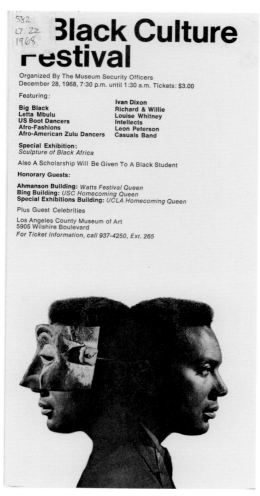

Fig. 3. Flyer for *A Black Culture Festival*, 1968

Fig. 4. Timothy Washington with his work *Raw Truth* (1970), in *Three Graphic Artists: Charles White, David Hammons, Timothy Washington*, Los Angeles County Museum of Art, 1971

Black professionals and presented by a major art museum. The show and tour, and the accompanying catalogue—written by David C. Driskell and Leonard Simon—transformed Black Studies and were landmarks for the museum's reputation.

Charles White's presence in Los Angeles was instrumental to these transformations. White was already well known when he settled in Southern California in 1956, and his actions and art encouraged the emergence of a nationally recognized Black art community in the region.[9] He lectured at LACMA, advised the museum's administration on several matters,

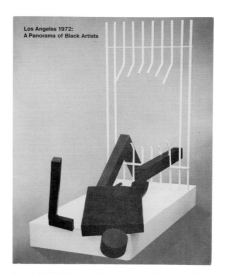

Fig. 5. Exhibition brochure for *Los Angeles 1972: A Panorama of Black Artists*, 1972

of change. Also in 1968, Claude Booker and Cecil Fergerson, two Black staff members at the museum, formed the Black Arts Council to campaign for the inclusion of Black artists in LACMA's exhibitions, collection, and programming. Their efforts slowly began to yield some results: by 1971, two Black trustees, Charles C. Wilson and Robert Wilson, had been added to the board, and museum administrators allowed the Black Arts Council and others to begin to organize cultural festivals, lectures, exhibitions, and activities in which Black Angelenos could learn about and express pride in their cultural heritage and contemporary community (fig. 3). Three crucial exhibitions were held at the museum as a result: *Three Graphic Artists: Charles White, David Hammons, Timothy Washington* in 1971 (fig. 4), the group exhibition *Los Angeles 1972: A Panorama of Black Artists* in 1972 (fig. 5), and *Two Centuries of Black American Art: 1750–1950* in 1976.[7] The museum bought three works from *Three Graphic Artists*, two of which were searing attacks on the American justice system: Hammons's early body print *Injustice Case* (1970; p. 68) and Washington's *One Nation Under God* (1970; p. 69).[8] *Los Angeles 1972*, organized by the Black Arts Council, surveyed local Black artists. *Two Centuries of Black American Art*, a bicentennial celebration, was the first large historical survey on the topic curated by

and was the person who recommended Driskell to organize the bicentennial exhibition. In 1967, Robert C. Maynard of the *Washington Post* deemed White the foremost artist of the Black Arts Movement, the aesthetic counterpart to Black Power.[10] Reflecting the preference for figurative representation among

Black artists at this time, White depicted Black men and women, past and present, underscoring their humanity, dignity, and right of self-determination. Exemplars of Black pride and identity, his images became emblems of the slogan "Black is Beautiful." In 1970, LACMA's curators astutely began purchasing his prints with county funds, acquiring seven lithographs from his acclaimed *Wanted Poster Series* (1969–71; fig. 6), in which he conveyed, through facial expressions and text, the agony enslaved people experienced under white ownership.[11]

In 1971, Los Angeles artist Joe Ray won LACMA's Young Talent Award; the following year, an untitled work comprising thirty-one photographs of people and places in his neighborhood became part of the museum's holdings. LACMA purchased its first work by a Harlem Renaissance master in 1975: Jacob Lawrence's *The 1920's...The Migrants Arrive and Cast Their Ballots* (1974), from the *Kent Bicentennial Portfolio: Spirit of Independence*. The museum was not able to afford an early painting by Lawrence until 2019, when its purchase of *Woman with Groceries* (1942; p. 77) was funded through the generosity of the estate of Julius Bernard Kester, a beloved installation designer at the institution, with additional funds from the American, Modern, and Contemporary Art departments and other sources.[12] In 1978, funding from the National Endowment for the Arts supplemented by local collectors enabled the purchase of *Walnut Tree Orchard* (1977) by Charles Gaines, his first work to enter the collection. The decade ended with an acquisition of historic Black art: a rare still life from 1849 by Robert S. Duncanson, the earliest painting by a Black artist at LACMA (fig. 7).[13]

Fig. 7. Robert S. Duncanson, *Still Life*, 1849. Oil on canvas; 16¼ × 20¼ in. (41 × 51.3 cm). Los Angeles County Museum of Art, gift of Mr. and Mrs. Robert B. Honeyman, Jr., M.78.98

## Slow Progress

In the 1980s LACMA's holdings of Black art grew only slightly. Daniel LaRue Johnson's *The Big Steal #1* (1962–63), a black-painted assemblage of broken found objects referencing the systemic racism and violence of the era, entered the museum's holdings in 1983 as part of the Michael and Dorothy Blankfort Collection; it thereby became the first Civil Rights commentary acquired since White's prints. Other significant acquisitions occurred through museum support groups. In 1981, the museum organized what it claimed to be its first solo exhibition of a Black artist, Maren Hassinger, as part of its *Gallery Six* series documenting emerging artists (fig. 8)—yet

Fig. 6. Charles White, *Wanted Poster Series #11*, 1970. Lithograph; 22½ × 16 in. (57.2 × 40.6 cm). Los Angeles County Museum of Art, Museum Purchase with County Funds, 70.4.143

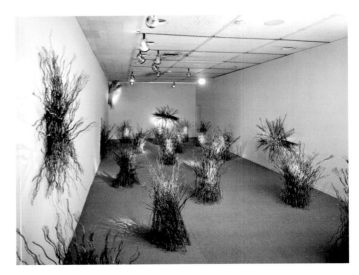

Fig. 8. Installation view in *Gallery Six: Maren Hassinger*, Los Angeles County Museum of Art, 1981

the institution did not then acquire a Hassinger work.[14] In 1986, the Director's Roundtable, organized a few years earlier to support administration initiatives, purchased prints produced by Cirrus Editions, a major lithographic workshop based in Los Angeles; this acquisition included LACMA's first work by Betye Saar, as well as one version of White's famed *I Have a Dream* print (1976; p. 143). In 1989, the museum's Collectors Committee, a group that meets annually to vote on new acquisitions, purchased Richmond Barthé's bronze figurative sculpture *Inner Music* (1956; p. 73). In the following decades, museum groups would continue to underwrite acquisitions, often correcting lacunae in LACMA's holdings: in 2016 the Director's Discretionary Fund, supplemented by additional individual donations, purchased a re-creation of Senga Nengudi's 1976 mesh-and-sand installation *Swing Low*, and in 2019 the Modern and Contemporary Art Council purchased a 1971 Hassinger hanging wire sculpture.

Many museums began to make concerted efforts to acquire Black art in the 1990s, with largely white curatorial staffs endeavoring to remedy their institutions' exclusion, marginalization, and distorted interpretation of Black artists.[15] Curator Robert A. Sobieszek became the head of LACMA's Photography department in 1990 after a notable career at the George Eastman House, where he had amassed one of the finest historical collections of photography. At LACMA Sobieszek focused on contemporary trends, as California was strong with schools emphasizing photography, film, and new media. Almost simultaneously with his arrival, the local Ralph M. Parsons Foundation—whose aim is to improve the lives of Angelenos through civic and cultural services—established a fund that underwrote the cost of new acquisitions while allowing LACMA curators full control over their selection.[16] Many of Sobieszek's choices were by women who made serial or conceptual photographs, including Black artists Carrie Mae Weems and Lorna Simpson. In 1991, three of Weems's gelatin silver prints from her landmark 1990 Kitchen Table Series entered the holdings (pp. 74–76), and five of Simpson's photogravures followed a few years later. Weems cast women, often herself, as the main protagonists of domestic life, while Simpson emphasized the anonymity of her subjects through body parts. These artists' focus on everyday life echoed historical images by noted Harlem photographer James Van Der Zee that had been given to the museum in 1983 (see p. 80), and the theme became a significant canonical determinant for LACMA's future purchases of Black art.[17]

In 1993, the museum made a major purchase, buying Kerry James Marshall's *De Style* (1993; pp. 86–87) from a local gallery, and thus becoming the first major institution to acquire one of the large figurative paintings that would establish Marshall's reputation as a leading American artist. In *De Style*, Marshall reflects the scale and subject matter of history painting, bringing Black life—in this case, a barbershop scene that reflects the artist's youth in Los Angeles—into the mainstream narrative of Western art. Four years later, the museum made two significant acquisitions also by Black artists associated with California. Gabriella K. Robertson, the daughter of antiques dealer Adolph Loewi, gifted the

museum *Chester* (1930; p. 29), a small ceramic head of a young boy by Bay Area sculptor Sargent Claude Johnson that Robertson's father had purchased from a William E. Harmon Foundation exhibition.[18] Known primarily for his African masks and Art Deco drawings, Johnson created few ceramic heads. *Chester* became a popular addition to gallery displays, and by 2007 it appeared as the banner image for the American Art department listing on LACMA's website; the work was soon an icon in American art history, thereby demonstrating the role museums serve in the process of canonization.[19] Also in 1997, the Eli Broad Family Foundation funded the purchase of Kara Walker's frieze-like paper cutout *And Thus...(present tense)* (1996); the first of several of her works to enter LACMA's collection, it was created the year Walker won the MacArthur Foundation "genius grant." Deriving her imagery from enslavement-era stereotypes but using silhouettes in a nod to a technique typically associated with white gentility, the artist confronted both past and present racism.

## The Collection Expands

In the twenty-first century, as Black lives and Black art have become more visible across the country, museums have attempted to rectify their previously exclusionary practices.[20] In a 2015 *New York Times* article, Randy Kennedy noted that institutions were presenting Black culture in a more "meaningful way than ever before," thereby distinguishing the present from periods in the 1970s and 1990s "when heightened awareness of art by African-Americans failed to gain widespread traction."[21] Black artists have achieved newfound visibility in popular culture, on the internet, and through social media, and are, as Tina M. Campt writes, "shifting the very nature of our interactions with the visual through their creation and quite literal curation of a distinctively Black gaze."[22] During this time, the Black art holdings at LACMA have grown substantially, as demonstrated by the early purchase of a large Mark Bradford collage, *Biggie, Biggie, Biggie* (2002), through the Modern and Contemporary Art Council's Art Here and Now acquisition program. Today one of the country's most acclaimed artists, Bradford is influenced by the Los Angeles Black assemblage movement of the 1960s, and the salvaged posters he sources and layers in his aerial abstractions are rich in connotations of the presence and erasure of the Black Angeleno experience.[23]

Occasionally, large historically and ethnically diverse collections amassed by local residents have been given to the museum, supplementing LACMA's own acquisition program. In 2008 the museum acquired seven genre scenes by Roy DeCarava through the Marjorie and Leonard Vernon Collection; the first Black photographer to receive a Guggenheim Fellowship, DeCarava used the award to create a photographic portrait of Harlem. Although the Vernons typically acquired historical images, they sometimes bought work by contemporary artists, and established a correspondence with DeCarava.[24] In 2011 the museum received ten Lorna Simpson photographs as part of the Audrey and Sydney Irmas Collection, a group of works that demonstrate the expansion

of the term "self-portraiture" among contemporary artists. The collection also included the photograph *The Child* (1994; p. 90) by Lyle Ashton Harris and Renee Cox, both of whom question and complicate issues of race, gender, and sexual orientation through masquerade and staging.[25] The museum acquired the archives of two Southern California print studios, Edition Jacob Samuel and Hamilton Press, in 2012 and 2017, respectively, and both contained works by local Black artists: the former included a portfolio of etchings by Marvin Harden, while the latter included lithographs by Gregory Wiley Edwards (the brother of Melvin Edwards) and Outterbridge.

In 2010, Franklin Sirmans was hired as head of LACMA's Contemporary Art department, marking a significant moment in the institution's history: he was the first Black person the museum had invited into the top echelon of its curatorial staff. During his tenure, Sirmans organized a Purifoy retrospective, increased the presence of Black artists in group shows such as *Fútbol: The Beautiful Game* (2014), and together with Christine Y. Kim added many works to the museum's collection through both purchase and donation, some in his honor. The 2010 Collectors Committee selected Glenn Ligon's major neon work *Rückenfigur* (2009) after Sirmans's persuasive presentation, and a large collage by Bradford and art by Theaster Gates and Mickalene Thomas were given or promised. In 2010, curators in the Modern and Contemporary Art departments worked together to purchase Outterbridge's *Asafetida Yoke* (2008), a simple yet powerful attack on the slave trade.

In 2011 Associate Curator of American Art Austen Bailly, with the assistance of Sirmans, brought in the museum's largest single acquisition of African American art: the Ruth Waddy Sketchbook (fig. 9).[26] Waddy was a Los Angeles printmaker who founded Art West Associated in 1962 to encourage Black youth to become involved in cultural activities.[27] Her sketchbook includes 122 drawings dating from 1968 to 1983 by up-and-coming artists and those with national and local reputations, including Cedric Adams, Herman "Kofi" Bailey, Romare Bearden, Margaret Burroughs, Lady Bird Cleveland, Alonzo Davis, David Hammons, Varnette P. Honeywood, Suzanne Jackson, Marie Johnson-Calloway, Loïs Mailou Jones, Samella Lewis, William Pajaud, and John T. Riddle Jr. The sketchbook also includes Edmund Barry Gaither's draft for a statement issued by the New York–based African American collective Spiral Group (1963–65), which explored the relationship of art and activism and debated whether abstraction was a politically radical art practice at a time when most Black artists remained tied to representation.

Beginning in 2008, the collection expanded in new directions. The museum acquired ceramics by Doyle Lane and jewelry by Vaughn Stubbs. In 2011, Gordon W. Bailey, a white Southern transplant to Los Angeles, began donating art by Black Southerners. Carvings made by Sulton Rogers and paintings made by Purvis Young were joined five years later by a 1940s painting by Clementine Hunter and modern and contemporary objects by Sam Doyle, Josephus Farmer, and Herbert Singleton in honor of the museum's fiftieth anniversary, for a total of twenty-six works. Also in 2016, Auldlyn Higgins Williams and E. T. Williams Jr., collectors of African American art, gave LACMA five paintings by jazz musician Claude Lawrence, whose expressionist imagery suggests his improvisational music; the donation was in honor of Angeleno Dale Mason Cochran and in memory of local attorney Johnnie L. Cochran Jr. In 2017 LACMA's Decorative Arts and Design Council supplemented the museum's Civil Rights–era holdings with another kind of protest art created in California: Emory Douglas's militaristic 1969 illustrations for the *Black Panther* publication (p. 92).

Acquisitions have continued apace in recent years; these numerous additions include works by Fred Eversley, Betye Saar and her daughters Alison and Lezley, and a promised gift of Kerry James Marshall's *A Portrait of the Artist as a Shadow of His Former Self* (1980; p. 21). LACMA's collection now includes more than 450 works by Black American artists. In addition to collecting, the museum has been devoting increased attention to Black art through exhibitions (fig. 10), permanent collection displays, online posts, and publications; the *Black American Portraits* show, featuring primarily LACMA holdings, including over sixty new acquisitions, is evidence of this effort. The future seems promising, much altered from two generations ago, but there is work yet to be done.

Fig. 9. Loïs Mailou Jones, *Haiti Vodou*, 1968, from the Ruth Waddy Sketchbook. Ink on paper; 10½ × 8¼ in. (26.7 × 21 cm). Los Angeles County Museum of Art, gift of the Azzi-Lusenhop Black Arts Movement Collection and purchased with funds provided by Robert and Kelly Day, the Modern and Contemporary Art Council, and the Elliot and Kimberly Perry Collection, M.2011.33.11

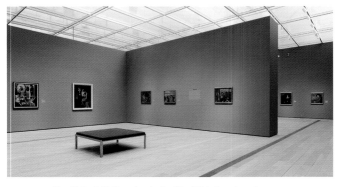

Fig. 10. Installation view in *Archibald Motley: Jazz Age Modernist*, Los Angeles County Museum of Art, 2014

I would like to thank the following past and present members of LACMA's curatorial staff for their assistance with information for this essay: Austen Bailly, Stephanie Barron, Claudine Dixon, Carol Eliel, Devi Noor, Eve Schillo, and Franklin Sirmans.

1   Maxwell correspondence, 1913–1914, box 7, folder A, Art Department of LAMHSA, Correspondence General, Archive, Balch Art Research Library, Los Angeles County Museum of Art. The first publication other than a checklist the museum issued was the *Bulletin*, beginning in 1919. An unattributed article explains that a lack of funds and the war delayed developments, but that, postwar, the institution was turning to one of its main functions beyond the care of objects—that is, education: "its duties do not cease with the mere presentation of the material deposited…an active system of education must be maintained in order to carry that education to those who are not able or not yet sufficiently roused in interest to seek it." "The Art Department," *Bulletin of the Museum of History, Science and Art, Department of Fine and Applied Arts* 1, no. 1 (October 1919): 3.

2   A recent transplant from Chicago, Harrison became the most significant donor of American paintings to the new museum, from his first donations to his wife's bequest of the remainder of their collection after his death. In 1922 he donated Tanner's *Daniel in the Lions' Den* (1907–18), with a second canvas from the Life of Job hidden beneath it, along with paintings by the New York Ashcan School, and in 1948 he gave Tanner's *Moonlight: Walls of Tangiers* (c. 1913–14).

3   No catalogue or brochure was printed.

4   LACMA began giving out the New Talent Purchase Award in 1963. In the early years it was also referred to as the Young Talent Award, and beginning in 1986 it became the Art Here and Now (AHAN) program.

5   Grassroots protests occurred in 1968 at the Whitney Museum of American Art and the following year at the Museum of Modern Art, both in New York. See Moira Simpson, *Making Representations: Museums in the Post-Colonial Era* (New York: Routledge, 1996), 9–10.

6   See Kellie Jones, *South of Pico : African American Artists in Los Angeles in the 1960s and 1970s* (Durham, NC: Duke University Press, 2017), 143.

7   For more details, see Bridget R. Cooks, *Exhibiting Blackness: African Americans and the American Art Museum* (Amherst: University of Massachusetts Press, 2011), 86–109; Suzanne Muchnic, *LACMA So Far: Portrait of a Museum in the Making* (San Marino, CA: Huntington Library, 2015), 92–93; and Jones, *South of Pico*, 162–72.

8   The museum also bought White's large *Seed of Love* (1969; p. 124), the only drawing by the artist in the collection.

9   White's relationship to the Los Angeles community, and especially LACMA, is discussed in more detail in Ilene Susan Fort, "Charles White's Art and Activism in Southern California," in *Charles White: A Retrospective*, ed. Sarah Kelly Oehler and Esther Adler (New Haven: Yale University Press, 2018), especially 128–30 and 134.

10  Robert C. Maynard, "The Black Revolutionaries VI: Black Nationalist Movement Spawns Cultural Revival," *Washington Post and Times-Herald*, September 30, 1967, A4.

11  The first print by White to enter the collection had come in two years earlier, as a gift of David Gensburg. In the early years of the twenty-first century, I discovered a rare early oil by White, *The Embrace* (1942), which was later bequeathed to the museum by the collectors Fannie and Alan Leslie. LACMA now owns fifteen works by the artist, the most by any single African American artist.

12  Of the Harlem Renaissance artists, the museum also owns three prints by Romare Bearden and two oils by Palmer C. Hayden in addition to drawings in the Ruth Waddy Sketchbook. The late Joan Palevsky, who supported the Balch Art Research Library at the museum, was responsible for three of these donations.

13  *Portrait of a Sailor (Paul Cuffe?)* (c. 1800; p. 20) was included as the earliest painting in the exhibition *Black American Portraits*, as it is thought to be by an American artist. However, neither the nationality nor the ethnicity of the artist has been verified, despite research that was done when the painting entered LACMA's collection.

14  See Katherine Hart, *Maren Hassinger on Dangerous Ground* (Los Angeles: Los Angeles County Museum of Art, 1981). It is worth noting that the two "first" solo exhibitions of Black artists, in 1935 and 1981, were both devoted to female sculptors.

15  The Poetics and Politics of Representation, an unprecedented conference of anthropologists, cultural historians, and museum professionals, held in 1988 at the Smithsonian Institution, Washington, D.C., examined this discrimination in museums. See Patricia Failing, "Black Artists Today: A Case of Exclusion," *Artnews*, March 1989, 124–31.

16  The foundation's website states that its grants emphasize "support for low-income children and families." "About Us," Ralph M. Parsons Foundation, accessed February 1, 2022, https://rmpf.org.

17  Patricia Banks has suggested that images of single figures and groups are popular with Black artists as they can be perceived as family portraits since creator, subject, and Black viewer belong to the same racial group. See Banks, *Represent*, 26.

18  This sculpture was brought to my attention through a circuitous route: LACMA's assistant curator of Costume and Textiles, Sandra Rosenbaum, was working with Robertson, a textile dealer living in Los Angeles. Robertson mentioned she had a Johnson ceramic after seeing *The Figure in American Sculpture: A Question of Modernity*, an exhibition I organized at LACMA in 1995.

19  Bruce Robertson explains this process in his article "The Tipping Point: Museum Collecting and the Canon," *American Art* 17, no. 3 (Fall 2003): 2–11.

20  See, for instance, Barbara Delatiner, "Interest in Black Art Just Grew and Grew," *New York Times*, January 30, 2000, https://www.nytimes.com/2000/01/30/nyregion/interest-in-black-art-just-grew-and-grew.html; Randy Kennedy, "Black Artists, and the March into the Museum," *New York Times*, November 28, 2015, https://www.nytimes.com/2015/11/29/arts/design/black-artists-and-the-march-into-the-museum.html; and Shantay Robinson, "Putting Their Money Where the Black Art Is: Museums Collect African American Art," *Black Art in America*, December 14, 2018, https://www.blackartinamerica.com/index.php/2018/12/14/putting-their-money-where-the-black-art-is-museums-collect-african-american-art/. Robinson cites numerous other examples.

21  Kennedy, "Black Artists, and the March into the Museum."

22  Tina M. Campt, "How Black Artists Are Shaping a Distinctly Black Gaze," *Hyperallergic*, August 22, 2021, https://hyperallergic.com/671547/how-black-artists-are-shaping-a-distinctly-black-gaze-tina-m-campt/, excerpted from Campt, *A Black Gaze: Artists Changing How We See* (Cambridge, MA: MIT Press, 2021).

23  See Dhyandra Lawson's text in this volume, p. 200, and Sebastian Smee, "Mark Bradford's Art Sees All the Broken Places That Led to This Moment of Protest," *Washington Post*, June 9, 2020, https://www.washingtonpost.com/entertainment/museums/mark-bradfords-art-sees-all-the-broken-places-that-led-to-this-moment-of-protest/2020/06/08/28c88e2e-a6a6-11ea-bb20-ebf0921f3bbd_story.html.

24  In 2008 Carol Vernon and Robert Turbin donated a massive collection of an internationally diverse character that had been quietly compiled by Vernon's parents, Marjorie and Leonard Vernon, since the 1970s. See Roy DeCarava to the Vernons, November 1, 1979, to April 12, 1982, the Marjorie and Leonard Vernon Collection artist files, Los Angeles County Museum of Art, Wallis Annenberg Photography Department, unprocessed 2015.026. I would like to thank Eve Schillo for bringing these letters to my attention.

25  See Dhyandra Lawson, *The Child* entry, in *This Is Not a Selfie: Photographic Self-Portraits from the Audrey and Sydney Irmas Collection* (Los Angeles: Los Angeles County Museum of Art, 2016), 50.

26  Austen Bailly, "The Ruth Waddy Sketchbook," Unframed, Los Angeles County Museum of Art, July 12, 2011, https://unframed.lacma.org/2011/07/12/the-ruth-waddy-sketchbook. Chicago art dealers David Lusenhop and Melissa Azzie, along with LACMA's American, Modern, and Contemporary Art departments, donated funds to purchase the sketchbook. As the museum was increasing its programming to attract minority visitors, it held a one-day conference to mark the thirty-fifth anniversary of the *Two Centuries* exhibition.

27  Waddy was also the artist who petitioned to have LACMA hold a commemorative exhibition commemorating emancipation.

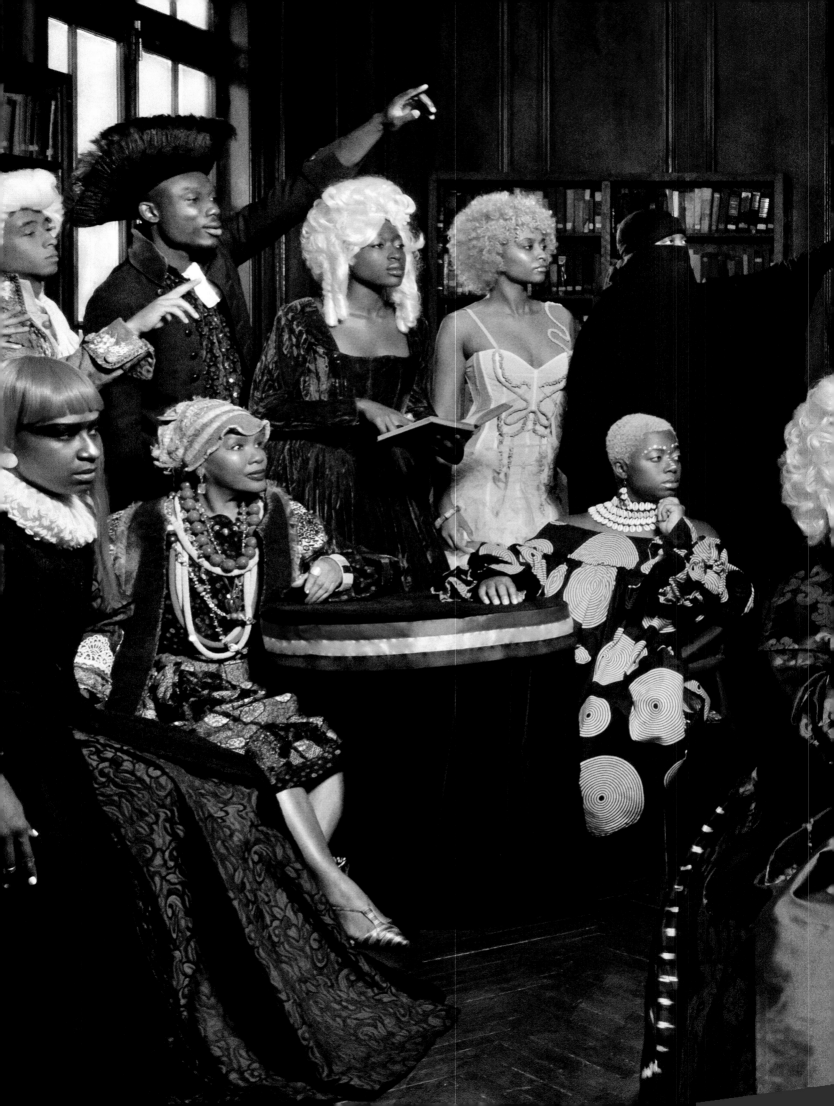

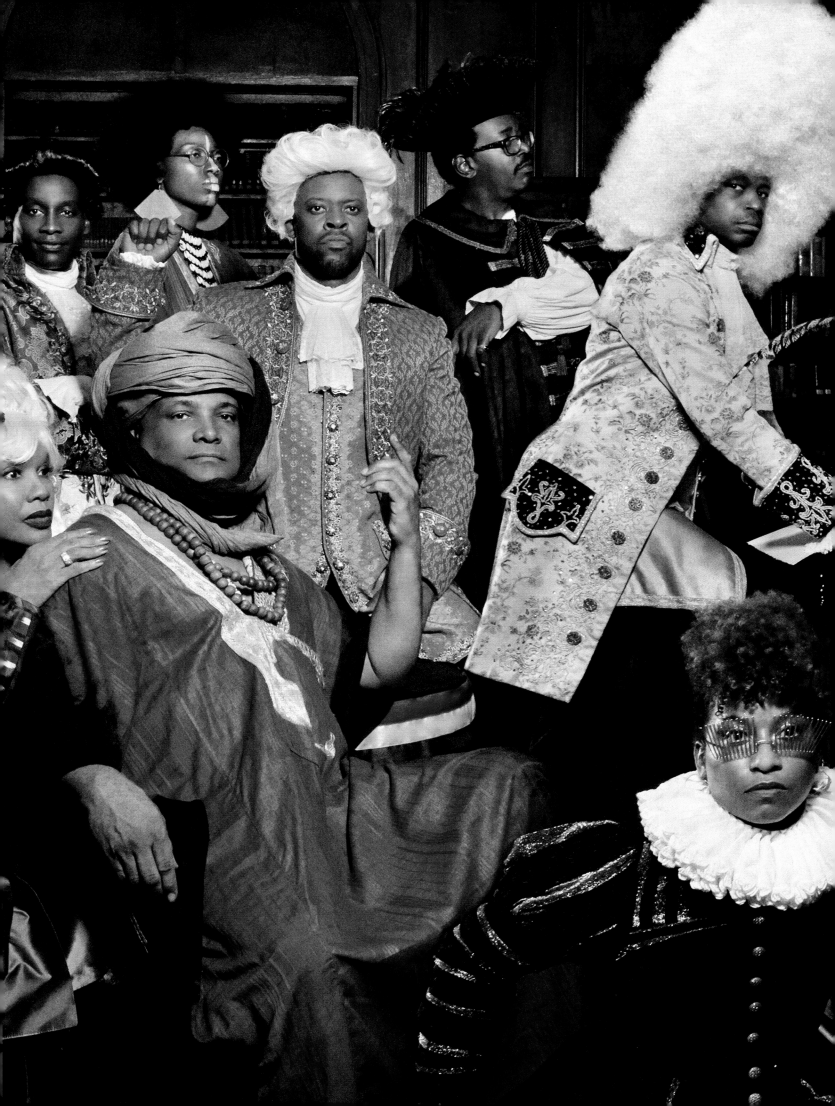

# Beyond the Master

Jeffrey C. Stewart

The visit of the Obama portraits to Los Angeles and the exhibition *Black American Portraits*, held by the Los Angeles County Museum of Art (LACMA) to accompany these presidential portraits, allow us to explore the meaning of portraiture in a nation that seldom exhibits the likenesses of African-descended people in our museums. Barack Obama's historic election to the presidency was quickly followed by the emergence of the Black Lives Matter movement in the wake of the unpunished killing of Trayvon Martin by a law-enforcement wannabe. What does it mean to mount a portrait show in the age of Black Lives Matter?

The absence of portraits reveals the absence of value. Of course, millions live and die in America without being immortalized in a portrait—and especially one that hangs in a museum. Some lives don't matter, the tradition of portraiture tells us, and many of those ignored are not Black. What, then, do we make of the special avoidance of Black faces and figures in the American canon of portraiture?

## Founding Fathers

Something is revealed every time we view a portrait in a museum. The portrait asks—or, more precisely, whispers—a question: Who is *not* here? The casual visitor to *America's Presidents*, a permanent exhibition of presidential portraits at the National Portrait Gallery, may not ask that question, may not see those portraits with what W. E. B. Du Bois called the Negro's "second-sight in this American world."[1] Before Kehinde Wiley's portrait of President Barack Obama was unveiled in 2018, no portrait of an African American hung in that exhibition. Yet the portraits of their masters do, because the first presidents of this nation—the majority of

the "Founding Fathers"—owned slaves. When one enters the first galleries of American presidents, one enters a hall of the slaveowner, for, with the exception of one—John Adams, elected in 1796—the first six presidents of the United States were owners of human beings.

These were not middling slaveowners. George Washington, our first president, owned more than six hundred enslaved people. Thomas Jefferson, our third president and the principal author of the Declaration of Independence, owned over six hundred human beings. James Madison, our fourth president, renowned for his authorship of the Federalist Papers, owned more than one hundred people. James Monroe, creator of the Monroe Doctrine, owned seventy-five enslaved people. Andrew Jackson, celebrated for bringing true democracy into American life, owned more than two hundred slaves and was also infamous for being a slave trader. Martin Van Buren, perhaps the most liberal of the group, owned one enslaved person, while William Henry Harrison owned eleven enslaved people and lobbied for the expansion of slavery into Indiana. John Tyler owned twenty-nine people and consistently advocated for slaveowners' rights after becoming president in 1841. James K. Polk, who owned fifty-six people, became president in part because he supported slavery at a time when the abolitionist movement at home and abroad was pressuring the United States government to end the practice. Even our twelfth president, Zachary Taylor, who resisted attempts to expand slavery, could not bring himself to free any of his three hundred enslaved human beings. The election of Abraham Lincoln in 1860 brought an anti-slavery president into office, but his second vice president, Andrew Johnson—who would serve as the seventeenth president of the United States after Lincoln's death—did not free his enslaved people until 1864.[2]

Why were so many slaveowners presidents of a republic founded on the principles articulated by Jefferson in the Declaration, that "all men are created equal with an equal right to life, liberty, and the pursuit of happiness?" The answer, though complex, boils down to this: the people who owned other people were the wealthiest individuals in America on the eve of and throughout the entire early republic called the United States. The enslaved people they owned constituted a huge percentage of their wealth, both in terms of the goods they produced for market, and in terms of their beings—which were capital in the American jurisprudence system. And then, as now, the quickest route to political power in the United States was through a great accumulation of capital. In short, the reason these men became presidents is because they were the most successful slaveowners in America at the time. In that sense, the enslaved *are* in the portraits that hang in the National Portrait Gallery, for without those enslaved humans laboring for them, or being traded like cattle by the likes of Andrew Jackson, these individuals would never have had the networks, resources, or platforms to become presidents.

In "The Uses of Portraiture," art historian Susan Tallman puts it this way: "The Medici bought their space on canvas, like most of those whose faces line museum walls."[3] As Tallman points out, portraiture is an elitist institution, where the rich and famous hang and the ordinary and laboring folk fail to exist. But in the case of American portraiture, the Black enslaved have a special—some might say unique—claim to being included in the frames with their elevated and celebrated masters: America is the first and only nation whose independence was purchased by the crops grown by enslaved African Americans.

In 1778, the colonies were deeply immersed in a war against Great Britain and not doing so well. Historian Curtis P. Nettles asks the key question about Black people's relationship to American freedom at this critical moment, before there were any American presidents: "How did the states find the means for paying for a large inflow of imports during the war?"[4] Much of what the colonies had produced in the past—masts for ships, tar, pitch, other naval stores, furs, whalebone, fish, and so on—had been purchased by the British. During the Revolutionary War, Britain not only refused to buy those goods from the colonies, but also carried out raids on land and sea to destroy the colonies' ships, often seizing their goods. There was only one commodity the colonies produced that brought good value on the international market: tobacco. The governments of both Virginia and Maryland exported the staple in order to buy arms and powder, and access to the tobacco trade was one of the main reasons France entered the war in 1778. Who planted, cultivated, harvested, bound, shipped, and delivered the "one American export" that "towered over all others" and brought the colonists the ally critical to their victory in the Revolutionary War?[5]

Washington knew. Jefferson knew. Madison and Monroe knew. Without the enslaved, there would be no American victory and no American presidents. There would be no portraits of "founders" hanging in the National Portrait Gallery, no American National Portrait Gallery itself. The

millions of African women and men whose labor created the platform for the presidency are also founders of the nation. They are the invisible heroes of America.

The Black portrait signifies absence, for each is haunted by the millions of Africans who came to America beginning in 1619, labored their entire lives, and died without anyone thinking to commission a portrait of them. We have no portrait of Anthony Johnson, the enslaved man who rose to become one of the most successful landowners in seventeenth-century Virginia. No portrait survives of Benjamin Banneker, a Black mathematician, one of America's earliest astronomers, and a human rights advocate; only an anonymous engraving exists of him. Only an anonymous engraving exists of the great Phillis Wheatley, one of the first published poets in America. Even singular accomplishment was not enough to break through what Thomas Jefferson called the "immoveable veil of black," which allowed him to say: We don't need to remember you.[6] No portrait exists of Sally Hemings, the enslaved woman with whom Jefferson had six children.

Why is this important? Because, in the West, the portrait carries powerful meanings. In a 2021 lecture, artist and historian Vincent Johnson showed a photograph of the head of seventeenth-century French clergyman Cardinal Richelieu, dug up by the Sorbonne in 1895, next to many beautiful portraits of the celebrated cardinal in flowing robes. "The skull looked like dirt shaped into a skull with pitiful teeth," Johnson said. The purpose of royal portraiture, he concluded, was "to extend the life image of the powerful versus showing they're just as dead as everyone else."[7] Having one's portrait made in the West means one's life *matters* more than others'.

## Breaking Through

In many of the portraits of the first presidents, the men are standing, as in Gilbert Stuart's portrait of George Washington (fig. 1). The image exudes power. Even the seated presidential portraits, such as those of Thomas Jefferson (fig. 2), James Madison (fig. 3), and William Henry Harrison (fig. 4), convey their subjects' ominous strength: I am the master and the decider of fates, the images suggest.

Remarkably—but also unsurprisingly—these postures resemble those often seen in portraits of slaveowners. Junius Brutus Stearns may have accidentally alluded to the intersectional nature of the pose in his *Life of George Washington—The Farmer* (c. 1853; fig. 5). In Stearns's portrait, Washington holds a stick in his hand, as if ready to use it on the enslaved people shown working on his farm; this gesture echoes Washington's extended right arm in Stuart's presidential portrait, a motion the president supposedly made while delivering the State of the Union address. The idea conveyed in most of the early presidential portraits is that in an America without a king, the president must exude a kind of dominance over the contradictions of a young republic.

Kehinde Wiley's presidential portrait of Barack Obama (fig. 6) interrupts this visual narrative decisively. Obama is seated in a chair and almost leaning forward into a space that he seems to share with us. His portrait suggests that he

Fig. 1. Gilbert Stuart, *George Washington (Lansdowne Portrait)*, 1796. Oil on canvas; 97½ × 62½ in. (247.6 × 158.7 cm). National Portrait Gallery, Smithsonian Institution; acquired as a gift to the nation through the generosity of the Donald W. Reynolds Foundation

Fig. 2. Gilbert Stuart, *Thomas Jefferson*, 1805/1821. Oil on mahogany panel; 26⅛ × 21 in. (66.4 × 53.3 cm). National Portrait Gallery, Smithsonian Institution; owned jointly with Monticello, Thomas Jefferson Foundation, Incorporated, Charlottesville, Virginia; purchase funds provided by the Regents of the Smithsonian Institution, the Trustees of the Thomas Jefferson Foundation, Incorporated, and the Enid and Crosby Kemper Foundation

Fig. 3. Chester Harding, *James Madison*, c. 1829–30. Oil on canvas; 36½ × 31½ in. (92.7 × 80 cm). National Portrait Gallery, Smithsonian Institution

Fig. 4. Rembrandt Peale, *William Henry Harrison*, c. 1813. Oil on canvas; 28½ × 23¾ in. (72.4 × 60.3 cm). National Portrait Gallery, Smithsonian Institution; gift of Mrs. Herbert Lee Pratt, Jr.

175

Fig. 5. Junius Brutus Stearns, *Life of George Washington—The Farmer*, c. 1853. Lithograph; 21¾ × 26⅝ in. (55.2 × 67.5 cm). Library of Congress Prints and Photographs Division Washington, D.C.

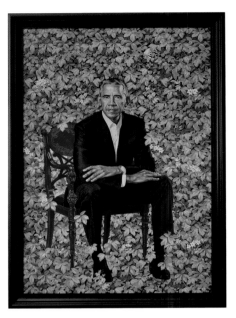

Fig. 6. Kehinde Wiley, *Barack Obama*, 2018. Oil on canvas; 92¼ × 65⅞ × 5⅜ in. (234.3 × 167.2 × 13.7 cm). National Portrait Gallery, Smithsonian Institution

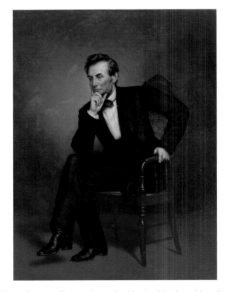

Fig. 7. George Peter Alexander Healy, *Abraham Lincoln, 12 Feb 1809–15 Apr 1865*, 1877. Oil on canvas; 74 × 54 in. (188 × 137 cm). National Portrait Gallery, Smithsonian Institution; transfer from the National Gallery of Art; gift of the A. W. Mellon Educational and Charitable Trust, 1942

has little desire to be in command of us: a counternarrative to critiques during his tenure that his was an "imperial presidency."[8] Rather, in Wiley's painting, President Obama emerges out of the background as someone willing, seriously, to engage with us and listen to us. The figure almost seems to hear our complaints and to be willing to act on them. There is sternness here, reflecting not only the terrifying responsibilities of the office, but also the complicated history and struggle Obama faced as the first African American president. The portrait conveys a sense of the outsider, which signifies that Obama could never be the master that many of his predecessors were. A similar visual politics is suggested by George Peter Alexander Healy's presidential portrait of Abraham Lincoln (fig. 7): sitting, head on hand, even more relaxed than Obama in his portrait, but similarly conveying—I'm not your master. Both portraits suggest the possibility of a presidency beyond the visual and political rituals of domination. The portrait of Obama, in particular, defines the ideal role of the president: the sensitive representative of the people, not their authoritarian master.

Michelle Obama is also seated in her portrait (fig. 8). Again, we see a politics of arrival that is also an aesthetic of disruption: we will not simply be a Black presidential couple that fits within the mold that others have carved out, seemingly grateful that we have been let into the citadel of the presidency and first ladyship. Indeed, Amy Sherald captures Michelle Obama's courage in this portrait, a courage exemplified by the First Lady's decision to acknowledge publicly that the White House in which she and her husband lived was built by the Black enslaved. The First Lady likely knew she would be criticized for uttering that fact—and she was—but her statement was an intervention, of the type that is also captured visually in her portrait: her presence, and power, was a form of representation of those not in the frame. A descendant of the enslaved, Michelle Obama chose to represent the enslaved as "founders" of the nation's heralded

institutions, like the White House. Correcting the invisibility of their names, images, and agency in the narrative of the White House—and in her portrait—Michelle Obama redefined the First Lady as a representative of the unseen masses who labor and die, like the rest of us, but who were heretofore unheralded and unremembered in their nation's grand house.

Though having one's portrait made traditionally suggested that one's life matters more than others', the por-

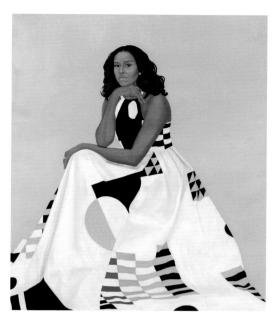

Fig. 8. Amy Sherald, *Michelle LaVaughn Robinson Obama*, 2018. Oil on linen; 72⅛ × 60⅛ in. (183.2 × 152.7 cm). National Portrait Gallery, Smithsonian Institution

trait can also be transformative. The portrait can be a form of "breaking through," as curator Wendy Wick Reaves suggests, "in the sense of penetrating the outward surface of a recognizable likeness." In this sense, portraitists can use "a variety of aesthetic references and choices, definitions of truth, political and social motivations, religious and economic implications, conceptual tools, and modes of disseminating their imagery" to create an experimental portraiture, one that breaks through the politics of the genre.[9] Such a breakthrough occurred when Barack and Michelle Obama chose contemporary Black artists to render their portraits.

## The Talented Tenth and the Minstrel

Something of that feeling of disruption of the grand narratives of the presidency—which means, really, the grand narratives of America—was captured in *Black American Portraits*, the show Christine Y. Kim and Myrtle Elizabeth Andrews organized to accompany the exhibition of the Obama portraits at LACMA. In a sense, *Black American Portraits* was an answer to the absence of robust Black representation in the galleries at LACMA and other American museums, especially at a time of an upsurge in protests and rebellions against the inhuman way Black people are often treated by the police in custody, during traffic stops, or even in their homes—the proverbial castle or fort that is never a bastion for Black people in America. Looking at the works featured in *Black American Portraits*, I see the relative absence of Black portraits in major museums in America captured in the furtive presence on these subjects' faces, which is emblematic of our furtive presence in America as a whole.

The very first work, chronologically, in the *Black American Portraits* exhibition was *Portrait of a Sailor (Paul*

*Cuffe?)* (c. 1800; p. 20). It is a portrait possibly of Paul Cuffe, a mixed Black and Indigenous freeman born in New England in 1759 who amassed a fleet of ships and sailed nine Black families to Africa after the War of 1812. Cuffe's eyes look back at us with a question: Why am I here? This question takes on added meaning when we realize that when this portrait was painted, the slave trade was still going on; it was officially outlawed by England in 1807, and by America a year later.[10] Even though a war for colonial freedom from England had just been won, enslavement was on the rise in the United States of America, eventually expanding into large-scale plantations in Alabama, Mississippi, Georgia, Louisiana, and other Southern states. Cotton would soon be king and fuel the economic surge of the new United States into a global trading nation. So the short answer to Cuffe's question is easy: You're here because you are the most important source of capital in the Americas.

One would think, therefore, that Cuffe and others like him would be esteemed in American portraiture, since the presence of Black people—their bodies, minds, and families— was key to America's economic ascent from the seventeenth to the nineteenth century, and our ability to become independent from England and have a nation at all. But Cuffe's look tells a different story, one of being hounded and hated in the eighteenth century as much as George Floyd and Sandra Bland were hounded and ultimately killed in the twenty-first. The unanswered question, the real question, is: Why?

That this could be a portrait of Paul Cuffe provides us with a different answer to a different question. What to do about it, this ungratefulness, this lack of humanity in how one is treated in the only home one has really known. Cuffe decided to leave, to reverse his path, and lead an expedition that would lay the groundwork for a mass emigration Back-to-Africa, back to the ancestral homeland. But as Cuffe and countless others found out, the practical obstacles—not the least of which were massively financial—made such a mass exodus impossible. The Door of No Return was just that.[11] Black people who had come to America, no less than those born here, were a new people, a modern people, whose tearing from their homelands actually symbolized the modern condition more existentially than that of the Europeans who wrote about alienation so compellingly after World War II. But what Cuffe also represents, and one can glimpse it in this portrait, is an incredible resolve, a piercing sense of power to shape one's future despite the constraints imposed on it by conditions and other men—white men, at that. His Blackness comes through in this portrait as an assertion of humanity in the face of dehumanization, regardless of the politics of the viewer. He is here, whether you like it or him at all.

Thus the works in the exhibition convey resoluteness inside of tragedy. To be hated in the land of one's birth is a tragedy. But the countervailing psychic and personal pain of this predicament, captured in paintings, photographs, daguerreotypes, and other media in this show, is the power of self-love in the face of social alienation from one's fellow citizens. Each portrait has some of that self-love sprinkled in it, despite the loneliness that is evident. A group portrait

of three Black men from the late nineteenth or possibly the early twentieth century conveys this duality (fig. 9). Perhaps a portrait of a father standing behind his two sons, the image embodies Du Bois's other signature concept, the "talented tenth."[12] The men stare back at us with resoluteness in the face of challenges that lie ahead for the sons. And yet the standing figure's arms are draped across the shoulders of the younger men, a visual laying on of the hands, to suggest the love that has been transferred from older to younger, to carry on the struggle for dignity and beauty. The elder figure's face reflects a sternness that suggests what he has, as my mother used to say, "gone through," and what the younger men will continue to go through just to be considered human beings in the first decades of the American century.

Du Bois was among the first to try to deal with this problem of the visual absence of Black people as human beings in the West. He helped to organize an exhibition of African American materials at the 1900 Exposition Universelle in Paris, and used the occasion to bring the existence of successful Black citizens into the frame of international attention. As sociologist Aldon Morris puts it, at the exposition, "African Americans were displayed in a series of photographs and artifacts as a proud people, dressed in splendor as accomplished scholars and intellectuals studying the world with as much competence as one imagine students of Plato, Copernicus, Alexander Crummel, and Frederick Douglass."[13] Du Bois's target was not the absence of the enslaved but the invisibility of the free and successful post-emancipation people, who often referred to themselves as the "New Negro," people proud of their race, undeterred by white supremacy, and unbowed by the challenge of making it in an unforgiving world.

Artist Joyce Owens did a painting of one of the photographs from the exposition, bringing out the portrait power of representing the turn-of-the-century people often called "colored Americans" at the time: *Out of the Box: Woman in Shirtdress* (2005–14; fig. 10). The rich folds of the subject's dress complement with elegance the power of her face. Her gaze is averted, almost as if she dares not confront the viewer with a frontal stare that might, given the racist etiquette of Jim Crow, be termed "uppity" and occasion violence.

The talented tenth of women was breaking through in more than racial ways, since to be a Black woman of intellectual and moral substance was an intersectional anomaly in Jim Crow America. Artist Henry Taylor provides a powerful visual notation of this reality in his 2005 painting *She is not a ho* (p. 98), brutally confronting the tendency in white supremacist policy narratives, no less than in daily American media, to further a particular form of absence: a refusal to see Black women as respectable and beautiful. Du Bois hoped that from the talented tenth would emerge a cadre of Black visual artists who would counter racist propaganda with powerful visual narratives of Black worth. In that sense, Du Bois would, I believe, be heartened that since 1900 a large body of Black visual artists has arrived whose art provides a liberationist aesthetic of Black agency.

We cannot ignore, however, a tradition that has existed and flourished in America alongside that of the

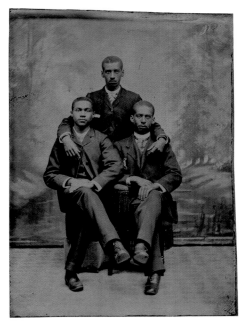

Fig. 9. Artist not recorded, *Untitled*, late 19th century. Tintype; 3½ × 2¼ in. (8.9 × 5.7 cm). Ron Finley Midnight Matinee Collection

talented tenth: the minstrel tradition of the jiving, laughing, happy-go-lucky but also potentially menacing Negro, which began in the 1830s and has extended well into the 2020s. As literary theorist Houston A. Baker has noted, the key to the minstrel shows that entertained whites in the nineteenth century and the blaxploitation films that entertained Blacks in the twentieth is the minstrel mask: an invented, contorted, fabricated face turned toward whites to, in essence, give them what they want to see—and hear—and believe about Black people.[14]

Obviously, the mask could also be internalized. We see echoes, to continue the double metaphor of the minstrel mask as a sounding, in Kerry James Marshall's *A Portrait of the Artist as a Shadow of His Former Self* (1980; p. 21). In the art world constructed in the West, and especially in America, the Black artist is as suspect as the Black woman in Henry Taylor's painting. Donning the minstrel mask becomes the "mastery of form," as Baker calls it, by which the artist references the guise through which white America has most consumed Black creativity: the performance of demeaning self-parody. Here, the minstrel mask signals the terrifying "symbolizing fluidity" by which an artist engages the reality of being Black and "bid to paint," to paraphrase Countee Cullen.[15] Black artists, no less than the Black actors in blaxploitation films, are haunted by having to provide a caricatured version of themselves in order to enter the citadel of "art." Marshall's "mask" is an updated minstrel weapon, whose teeth are deliberately, shockingly white—to entertain, to jive, or to prepare to attack—playing on all the fears and confusions inherent in the audience of the minstrel performer.

By contrast, *Portrait of a Sailor*, the portrait of the three Black men, and *Out of the Box* all suggest the seriousness with which their subjects face the coming struggle. Though separated by time, gender, and circumstance, these portraits convey a common devotion to character and ele-

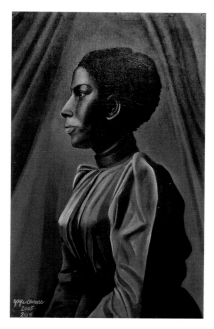

Fig. 10. Joyce Owens, *Out of the Box: Woman in Shirtdress*, 2005–14. Acrylic on wood; 20½ × 12½ in. (52.1 × 31.8 cm). Collection of the artist

gance in bearing that is an armor against the terror of being Black in their times. The portraits are aesthetic Rorschach tests of their subjects' experiences as Black people in a racially weaponized America. Each of these figures would have known someone who had been a slave. They would have known someone who had been lynched or someone who had witnessed a lynching, in an era without cell phone cameras to record such events. Each would have experienced a personal humiliation or attack simply because they were a Black man or Black woman dressed in nice clothes walking down the street in a city like Atlanta, New Orleans, or Boston. Hounded, perhaps even beaten, by those who took their appearance as an affront to the racial codes of white supremacy and its reputed aspersions of Black barbarism, they would have found their very existences viewed as crimes by some whose eyes fell on them in real life or in these images.

Is these individuals' forthrightness in the face of hate any different from that captured in *Swallowtail* (2020; p. 101), a self-portrait by Black trans artist Tourmaline? How different is this subject's experience of demeaning non-tolerance of their very being on the street or in the gallery? Are not the unsolved murders of Black trans people our twenty-first century lynchings? But in *Swallowtail* one also finds that resoluteness sutured with self-love evident in the portrait of three men from the end of the nineteenth century, and in the likely Cuffe portrait from that century's beginning.

## Beyond the Garden

Such resoluteness characterizes the portraits of President and First Lady Obama, with an additional element—a sense of play. This playfulness is captured in the green, verdant background of President Obama's portrait, a motif also seen in Tourmaline's self-portrait. Placing the Black subject in the *garden*, so to speak, inserts something of the ideology of

America into these portraits. The garden is also a metaphor for Eden and the desire to see America as a kind of second Eden. The nation, of course, never lives up to that metaphor, because someone was needed to till the American garden, which is why the African was brought to America in the first place. The Negro in the garden signifies to most of American history the conflict of race, exploitation, and death that is the counter-narrative of Eden in America. But these and other portraits suggest something else: the longing, perhaps captured in the visual metaphor of sitting in the garden, to belong, wanting to be included in the American garden. Even though the Black enslaved tilled this garden from 1619 forward, seldom did they have permission to take the fruit they'd grown. That is the Black story of America.

Michelle Obama's portrait—and many of the images of and by other Black women in the exhibition—suggests that she does not want to be invited into the garden. Sherald's ethereal blue background intimates that the First Lady has, perhaps, transcended the politics of inclusion in favor of another, almost Afrofuturist aesthetic, to fashion another world, a post-garden. The stark contrast of bold black and white creates a staccato cadence of jazz sound heard coming from this portrait. Michelle Obama seems to have turned away from the garden, to something in the land of Pop art imagination, a future that is immaterial and free to all those who can see what she sees—a future unbounded by the past though coming out of it with beauty and self-love.

Indeed, many of the portraits created by Black women artists in the exhibition, such as Lorraine O'Grady's *Art Is... (Man With Rings and Child)* (1983; p. 102) and Deborah Willis's *Living Room Picture Stories* (1994; p. 134), consistently assert the joy of the Black experience for those who turn away from the desire for inclusion in a place that excludes us. This is what these portraits of the excluded really say about how we tell the story of portraiture, which is to say the story of America. Our task, should we decide to shoulder it, is to avoid relaying to our next generation the old story of how one gets "remembered" in the gallery of the anointed, and instead find new visual narratives to represent real and lived inclusion as a process of both redress and amelioration.

The Obama portraits open a door to an integrated national portraiture, one that goes beyond the master to include the people who made the president and the presidency possible. Another kind of museum is possible, one that features as exemplary the people whose sacrifice created the conditions for the esteemed and highly regarded to ascend. That museum would exhibit the exemplary without preference to those who exercised dominating, often destructive power, or those with the money to pay to hang their images on museum walls. A truly American portraiture would give space alongside the famous to those who "represent" the selfless virtues of the American, even before an America existed. Rather than distract us from the reality of death through royal-like imagery, this new portraiture, gestured to in *Black American Portraits*, would help us reckon with who we really are as a people—warts, dirt, pitiful teeth, and all.

## Notes

1    W. E. B. Du Bois, "The Strivings of the Negro People," *Atlantic* (August 1897), https://www.theatlantic.com/magazine/archive/1897/08/strivings-of-the-negro-people/305446/.

2    See Wikipedia contributors, "List of Presidents of the United States Who Owned Slaves," Wikipedia, accessed February 8, 2022, https://en.wikipedia.org/w/index.php?title=List_of_presidents_of_the_United_States_who_owned._slaves&oldid=1069528786.

3    Susan Tallman, "The Uses of Portraiture," *New York Review of Books* 68, no. 15 (October 7, 2021): 14.

4    Curtis P. Nettles, *The Emergence of a National Economy, 1775–1815* (New York: M. E. Sharpe 1962), 19. Also see Merrill Jensen, "The American Revolution and American Agriculture," *Agricultural History* 43 (1969): 107–24.

5    Nettles, *The Emergence of a National Economy*, 15. Nettles writes, "One American export—tobacco—towered over all others. Prewar shipments to Britain had amounted annually to about 100,00,00 pounds, four fifths of which was re-exported, mainly to Europe. To wrest this lucrative trade from Britain was an impelling commercial ambition of France: its conduct in foreign affairs might be called 'King Tobacco Diplomacy.'"

6    Thomas Jefferson, *Notes on the State of Virginia* (Philadelphia: Pritchard and Hall, 1788), 148. See https://docsouth.unc.edu/southlit/jefferson/jefferson.html.

7    Vincent Johnson, "The Black History of Art History" (lecture, City University of New York, New York, October 7, 2021).

8    See Linda Feldmann, "Is Barack Obama an Imperial President?," *Christian Science Monitor*, January 26, 2014, https://www.csmonitor.com/USA/Politics/2014/0126/Is-Barack-Obama-an-imperial-president.

9    Wendy Wick Reaves, "Introduction," in *Beyond the Face: New Perspectives on Portraiture*, ed. Wendy Wick Reaves (Washington, D.C.: National Portrait Gallery, 2018), 23.

10   See ABC News, "Timeline of the Atlantic Slave Trade," January 7, 2006, https://abcnews.go.com/US/story?id=96659&page=1#:~:text=1860s%20The%20Atlantic%20slave%20trade,1836%20ban%20on%20slave%20trading.

11   See Orla Ryan, "Door of No Return Opens Up Ghana's Slave Past," Reuters, March 20, 2007, https://www.reuters.com/article/us-slavery-ghana/door-of-no-return-opens-up-ghanas-slave-past-idUSL2121456420070320.

12   W. E. B. Du Bois, "The Talented Tenth," in *The Negro Problem: A Series of Articles by Representative American Negroes of Today* (New York: James Pott & Co., 1903), 33–75.

13   Aldon Morris, "American Negro at Paris, 1900," in *W. E. B. Du Bois's Data Portraits: Visualizing Black America: The Color Line at the Turn of the Twentieth Century*, ed. Whitney Battle-Baptiste and Britt Rusert (New York: Princeton University Press, 2018), 23–24.

14   Houston A. Baker Jr., *Modernism and the Harlem Renaissance* (Chicago: University of Chicago Press, 1987), 15–24.

15   "Yet do I marvel at this curious thing: To make a poet black, and bid him sing!" Countee Cullen, "Yet Do I Marvel," in *Color* (New York: Harper & Brothers, 1925). See https://www.poetryfoundation.org/poems/42611/yet-do-i-marvel.

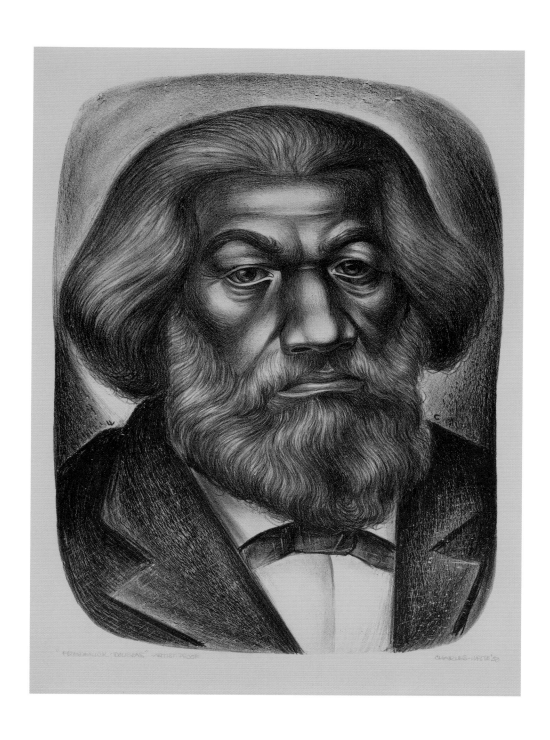

Charles White, *Frederick Douglass*, 1950

# Proof of Life

## Bridget R. Cooks

Within the history of Black survey exhibitions, *Black American Portraits* appeared at a momentous time. At the Los Angeles County Museum of Art (LACMA) it was a companion show to *The Obama Portraits Tour*, featuring *Barack Obama* (2018; p. 176) by Kehinde Wiley and *Michelle LaVaughn Robinson Obama* (2018; p. 177) by Amy Sherald. In 2021 these two exhibitions signaled the desire for community, connection, communion, fellowship, and the acknowledgment of the vitality of Black life. The masked exhibition visitors were the survivors of at least two simultaneous and ongoing catastrophes: the spectacular display of anti-Black violence in America and the COVID-19 pandemic (fig. 1). Viewers decided to witness the portraits as a way to press on, quite literally risking their lives to see the exhibition while virus variants and anti-vaxxers posed a continual threat to their well-being. To refer back to the joyously defiant Tool song that provides the epigraph for this essay, the exhibition provided a special opportunity to "celebrate this chance to be alive and breathing," particularly in a time of loss. In the celebration, Black viewers rejected the isolation we struggled with for many months while embracing our right to opacity on display: the endless diversity of Black life, survival, and the sheer will to persist through, watch, and help shape what happens next.

The LACMA presentation of *Black American Portraits* comprised images of Black people made by Black and non-Black artists over more than two hundred years. It felt overwhelming to walk along nearly a dozen walls and pedestals displaying artworks in different styles and media. The works were installed in a quasi-salon style: some were provided a singular space of focus, while others were hung in vertical stacks of two or three, making it a challenge to see each one without stretching up or bending down. What this large survey offered—even for visitors well-versed in African American art history—was a chance to learn from the juxtapositions of artworks made in different time periods and styles. To encourage social distancing during the pandemic, extended labels that would have provided information about the unique story of each artwork were not allowed. By looking more closely at just two artists whose work was featured in this wide-ranging exhibition, we uncover frameworks through which to understand some of the narratives that underlie *Black American Portraits*.

At LACMA, the title wall for *Black American Portraits* displayed images of both notable public figures and unnamed Black models rendered by a tour de force of American artists (p. 189). Placed as a poetic bookend at the far left of

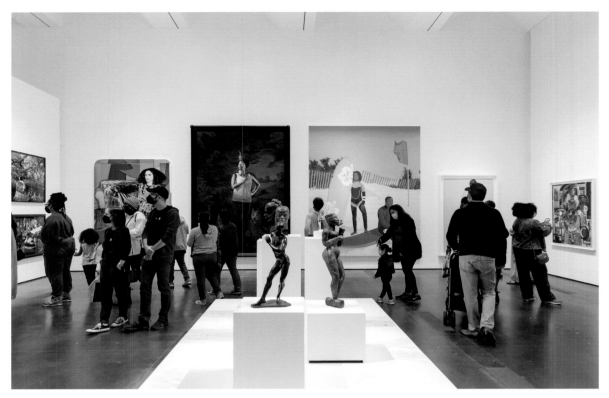

Fig. 1. Visitors in *Black American Portraits*, Los Angeles County Museum of Art, November 7, 2021

this wall was the collage and oil painting *Jazz Singer (Lady of Leisure, Fox)* by David C. Driskell (1974; p. 139). Fabulously dressed in an eclectic spectrum of colorful patterned fabrics, feathers, gold jewelry, and precious stones, the beautiful diva takes center stage in the middle of the canvas and looks confidently at the viewer. Beneath her flowered, wide-brimmed, floppy hat, her face is bisymmetrically split: painted with a serious expression on the left side and composed of a color photograph of a smiling face on the right. The different faces hint at the range of performative possibilities she offers, from the melancholy blues to songs of celebration. With her reading glasses in her hand, she pauses to see her spectators more clearly. She is an observer and a storyteller who knows how to command an audience.

To the right of her hat is the iconic facade of New York's famed Lincoln Center, indicating the venue for her concert. To the left are torn paper fragments and a sepia-toned painting of a little girl, which allude to another place and time. Through this painting, Driskell offers an homage to Black women who fill many different roles. As a single figure composed of many parts, her creative construction is a metaphor for Driskell's own wide-ranging artistic influences and skills. Metaphorically speaking, Driskell, like the *Jazz Singer*, wore multiple hats: those of artist, curator, scholar, institution builder, and mentor. The presence of his painting in the exhibition honored his multifaceted legacy, which includes the groundbreaking exhibition *Two Centuries of Black American Art: 1750–1950* that debuted at LACMA in 1976. Driskell helps to illuminate the context for *Black American Portraits*; indeed, there would not be an exhibition of Black portraits to witness if it were not for his work.

*Two Centuries* was part of America's bicentennial celebration of the nation. Many Black people organized to bring the exhibition to fruition. Most notable were members of the museum's security staff and the Black Arts Council, led by art preparator Claude Booker and curatorial assistant Cecil Fergerson. The Black Arts Council included Black LACMA staff, artists, and citizens who advocated for the support of Black artists in the city. Black Angelenos who attended the exhibition and its programs in the thousands—breaking all previous attendance records at the museum—made the council and security staff's efforts a success.[1] *Two Centuries* traveled to the Dallas Museum of Fine Arts, the Brooklyn Museum, and the High Museum in Atlanta through 1977. Five thousand copies of the catalogue (fig. 2) were printed, exceeding the usual run of one thousand produced for the museum's art exhibitions.[2] Driskell explained, "The catalogue became a textbook or resource...like an encyclopedia or some sort of reference book...proof that we could have this enormous exhibition and here is the record of it."[3] The exhibition and its catalogue served as evidence that Black creativity has been an American tradition for hundreds of years.

Another contextual framework that helps us to understand the journey to—and through—*Black American Portraits* is offered by artist, curator, scholar, and educator Deborah Willis. Since 2013, she has co-organized a series of Black Portraiture[s] convenings, international meetings where artists, curators, scholars, and collectors share their contributions toward an informed, global understanding of images of Black people. The meetings have foregrounded any serious attention paid to images of the Black body by constructing thematic approaches for vision, with the subtitles

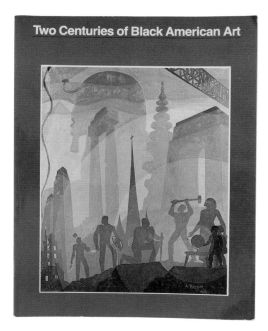

Fig. 2. Cover of *Two Centuries of Black American Art* (1976), showing Aaron Douglas's *Building More Stately Mansions* (1944)

Fig. 3. Detail of Deborah Willis's *Living Room Picture Stories* (1994)

The Black Body in the West (2013), Imaging the Black Body and Re-staging Histories (2015), Reinventions: Strains of Histories and Cultures (2016), The Color of Silence (2018), Memory and the Archive Past. Present. Future (2019), Absent/ed Presence (2021), and Play and Performance (2022).

In addition to providing an interdisciplinary structure for understanding *Black American Portraits*, Willis is represented by three works in the exhibition. For *Living Room Picture Stories* (1994; p. 134), she took photographs of domestic scenes in her hometown of Philadelphia and her father's hometown of Orange, Virginia. She then reproduced these images of common spaces of safety, fellowship, and ritual and incorporated them into a quilt made of cotton and lace. In one photograph, we see Willis reflected in a large mirror mounted above a fireplace mantel covered with Victorian-style vases, candle holders, and a clock; her face is illuminated by the glow of a chandelier (fig. 3). A calendar tacked high on a closet door and photographs on the wall of a young girl and an embracing couple mark the passing of time. In another photograph, Willis's nieces Kalia and Medea dance in their living room in front of a wall of family portraits. Displayed in a salon-like style not unlike the works in *Black American Portraits*, these groups of personal photographs form what cultural theorist bell hooks calls sites of resistance and contestation; it is "possible to see walls of photographs in black homes as a critical intervention, a disruption of white control of black images."[4] Additionally, for hooks, these sites are performative spaces where knowledge about family history and identity can be acquired:

*We would stand before the walls of images and learn the importance of the arrangement, why a certain photo was placed here and not there. The walls were fundamentally different from photo albums. Rather than shutting images away, where they could be seen only by request, the walls were a public announcement of the primacy of the image, the joy of image making. To enter black homes in my childhood was to enter a world that valued the visual, that asserted our collective will to participate in a noninstitutionalized curatorial process. For black folks constructing our identities within the culture of apartheid, these walls were essential to the process of decolonization.*

Willis's transformation of photographs into the quilt format demonstrates the comfort offered through the intimate scenes of family, memories of quality time, and feelings of home. Translating the images into an object that offers warmth and protection provides an everyday context in which to understand the value of relationships in pictures.

In *Thomas and Thomas* (2008; p. 111) and *Sometimes I See Myself in You* (2008; p. 142), Willis collaborated with her son, Hank Willis Thomas, to look across three generations of her family. At first glance, *Thomas and Thomas* appears to be an oversize stereo card of a handsome man elegantly dressed in a tuxedo. With a closer look, viewers notice differences between

187

Notes

1    See Bridget R. Cooks, *Exhibiting Blackness: African Americans and the American Art Museum* (Amherst: University of Massachusetts, 2001), 102.
2    Cooks, *Exhibiting Blackness*, 105.
3    David C. Driskell, interview with author, March 17, 2007, Santa Monica, CA.
4    bell hooks, "In Our Glory: Photography and Black Life," in *The Photography Reader*, ed. Liz Wells (New York: Routledge Press, 2003), 390–91.
5    hooks, "In Our Glory," 392.

the buildings in the pictures and see that although the men are standing on the same street corner and are dressed in the same clothes, their individual features make them distinct. One photograph shows Willis's father on the day her sister was born. Dressed in a white tie and tails to take part in a chorale performance, he stands proudly in front of the first home he ever purchased. His cousin, studio photographer Alphonso Willis, captured this historic moment of celebration. The second photograph, taken by Deborah Willis, depicts her son in the position her father assumed over fifty years earlier. The remade photograph reveals the men's visual resemblance and serves as Willis's homage to her past and future through two of the most important people in her life.

With *Sometimes I See Myself in You*, created the same year as *Thomas and Thomas*, Willis explores her maternal connection with her son through three portraits: one of Hank, one of her, and one showing half of each of their faces between the other two. The visual likeness between the two individuals is striking, but the three-part photograph speaks to more than just genetic similarity. Like *Thomas and Thomas*, the triptych attests to the substantive influence that one life has on another: mother to son, artist to artist, soul to soul. The alignment of the faces in the center portrait also recalls Driskell's *Jazz Singer*—two stories, two journeys, two lives brought together in one.

At a time when we are looking to artists to imagine the world as equitable, to provide wonder, to inspire the living, to honor the dead, to validate artistic intelligence and the experiences of survivors, *Black American Portraits* has provided an opportunity to show proof of life: the object, the evidence, the thing that proves that the collective and individual Black body in all of its forms is something worth fighting for. It gives the family hope that their loved one still exists.

As the tradition of American violence continues, the Black body belongs in places of reverence. The existence of the Black figure in American art is as charged as it ever was. To represent the Black figure now is to show that the fullness of our presence is necessary. The space for Black portraiture does not come as a criticism of or replacement for abstraction. Instead, it is a revival of our presence in a widely legible form, one that seeks to counter normalized systems of Black denigration. *Black American Portraits* made space to support the fact that Black lives should matter in an anti-Black world.

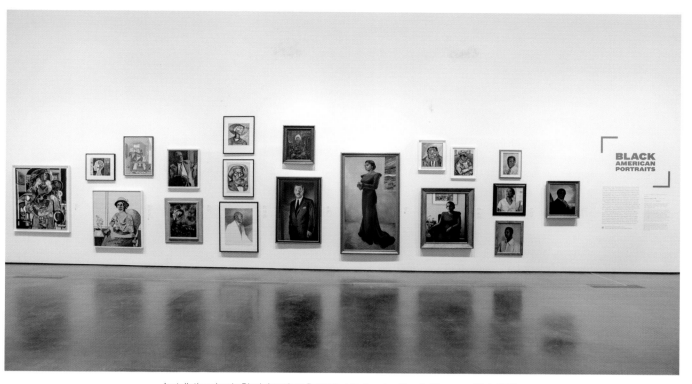

Installation view in *Black American Portraits*, Los Angeles County Museum of Art, 2021

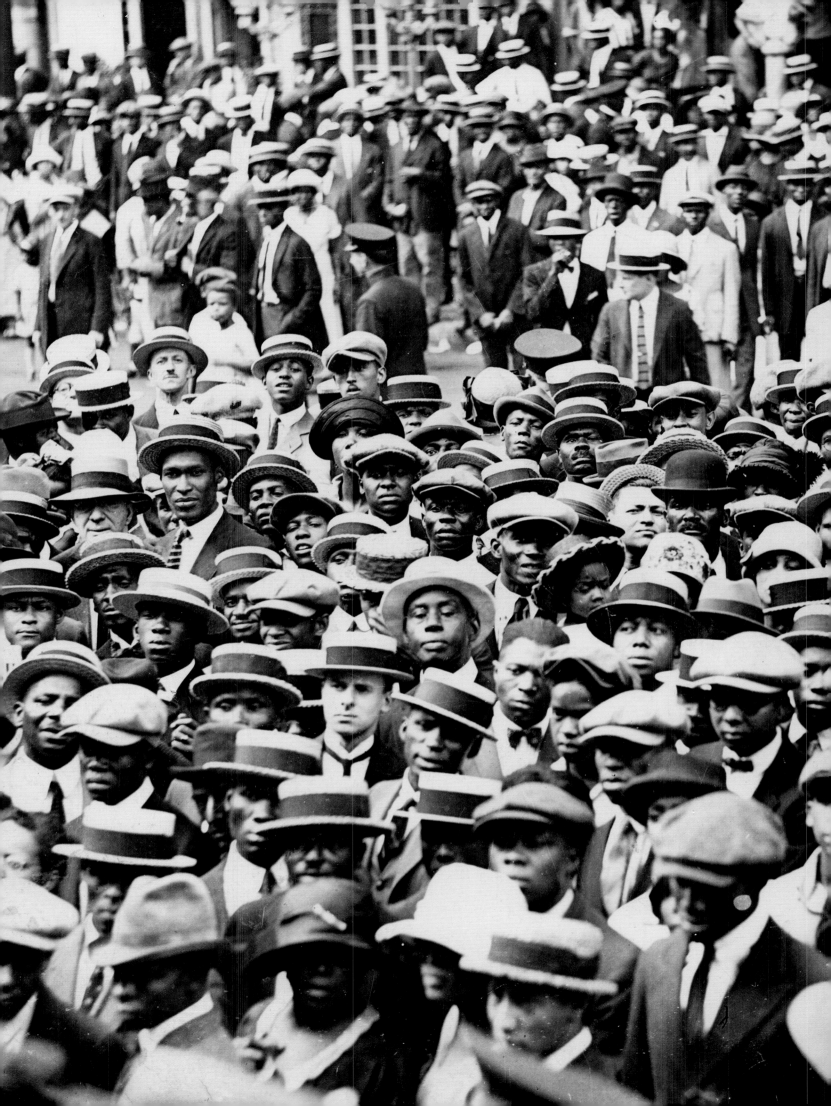

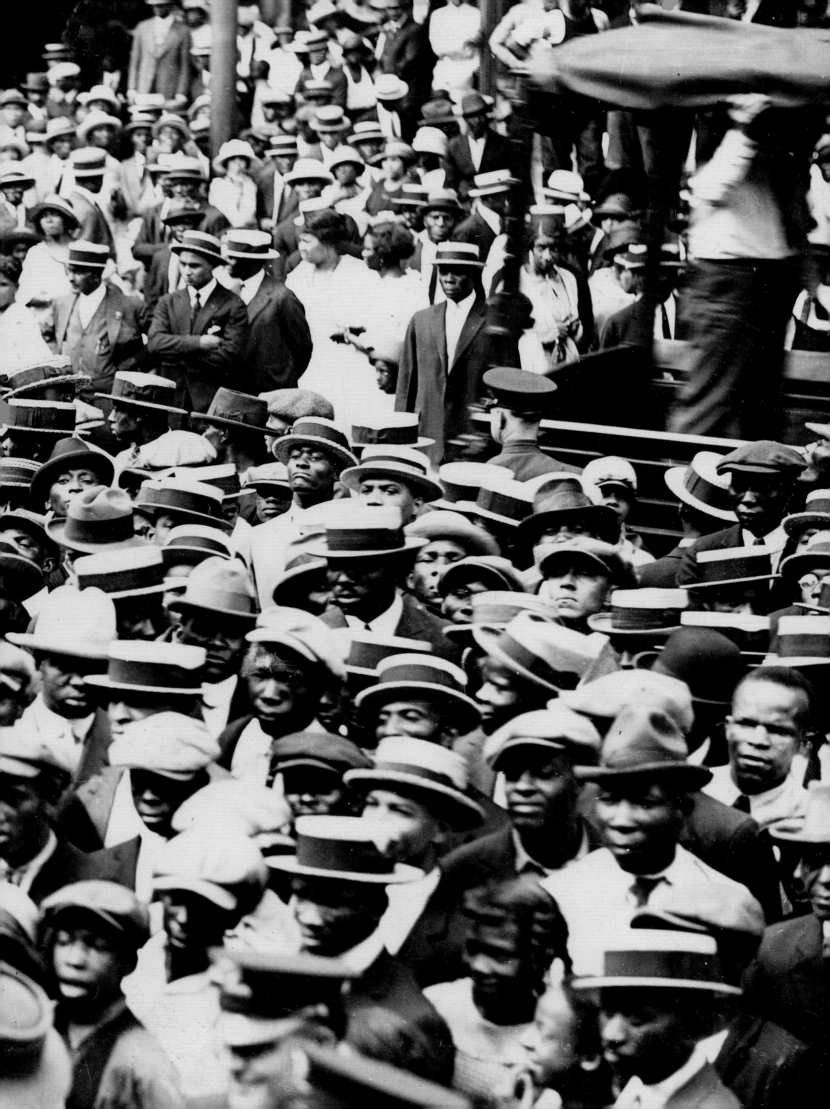

# A Lil' History of Photography:
# Black American Photography
# before Barack Obama

Myrtle Elizabeth Andrews

In a black-and-white photograph in the collection of the Los Angeles County Museum of Art (LACMA), President Barack Obama is pictured from behind and in double (p. 145). The viewer sees the back of Obama's head and his reflection in the mirror; his eyes are closed. In 2009, when Ralph Nelson made this image, Obama was a new president. The years and work that would define him were yet to come, but his likeness was already solidified in the American imaginary as iconic.

The *Black American Portraits* exhibition—and, by extension, this book—came about because of the extraordinary popularity of *The Obama Portraits Tour*, organized by the National Portrait Gallery (p. 151). People have been taken with images of Obama since he first appeared on the national political scene, and photography helped frame him both as presidential and as an everyman. Images of Obama enabled many people to see themselves and their hopes for our democracy represented in the presidency for the first time.

Though Obama himself is a singular Black figure, the innumerable pictures in which he appears are part of a long legacy of Black American photographic portraiture. Obama became an icon and the first Black president in part because generations of Black Americans before him had snapped family photographs, sat for portraits, and created artworks showing beauty, respect, community, and hope. Through photographic works in LACMA's collection, we can trace some of the key moments in the history of American photography, witnessing how the medium intersects with and facilitates evolving expressions of Black subjectivity.

Photography was invented in France in 1839 and became commercially available worldwide in the following decade. It grew especially popular in the United States, with photography studios opening up around the country in the mid-nineteenth century. Photographic technologies quickly changed the way people and societies saw themselves and others, helping to solidify a dominant white lens as the ideal way of seeing. In the United States, in particular, photography has been used since its inception to justify racism and enslavement. At the same time, certain image makers—including approximately fifty Black American photographers in the medium's first decade in the U.S.—have always trained our collective vision beyond dominant, degrading modes of picturing Black people.[1]

As photographer and photography historian Deborah Willis documents in several books, the arrival of photography in the United States coincided with emancipation and offered Black Americans a way to imagine themselves through their own eyes for the first time. In her book *Envisioning Emancipation: Black Americans and the End of Slavery*, co-authored with Barbara Krauthamer, Willis argues that photographs were key to the transition from enslavement to freedom. For example, abolitionists such as Harriet Tubman, Sojourner Truth, and Frederick Douglass commissioned portraits to present themselves as dignified, countering the prevailing depictions of Black people as lazy, stupid, and ugly. In the mid- to late nineteenth century, Civil War soldiers and other newly freed Black citizens also began to construct thoughtful studio portraits of themselves. As Willis writes, "Photography documented the promise and hope of emancipation through the subjects' framing, poses, and dress."[2]

A strong proponent of the power of photography to uplift the newly freed Black population was Frederick Douglass (fig. 1). Having escaped slavery, Douglass became an abolitionist and lectured widely about the evils

of enslavement and the ability of photographic portraits to empower Black people to project images of freedom into the world. Douglass sat for more than 150 portraits in the first five decades of photography's existence, with the express intention of publicizing those images; more photographs were made of him than of any other American of his time, including President Abraham Lincoln.[3]

One late-nineteenth-century studio portrait illustrates Black Americans' understanding of the power of photography to counter the dominant visual culture. An

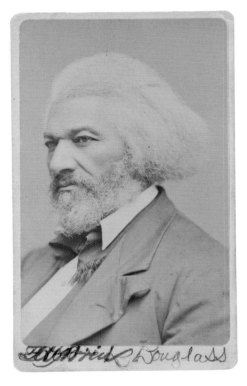

Fig. 1. George Kendall Warren, *Frederick Douglass*, 1876. Albumen silver print; 3⅞ × 2¼ in. (9.7 × 5.7 cm). National Portrait Gallery, Smithsonian Institution

unidentified woman wears fine clothing, including a polka-dot skirt and a collared blouse with a bow (p. 104). She is adorned in jewelry and her hair is pulled back neatly. Looking away from the camera, she holds up a book in her lap. This is a picture of a woman who wants the viewer to know that she has style, class, and education—a powerful statement at a moment when the nation was steeped in anti-Black imagery, and the ban on Black literacy under slavery had just recently been lifted. Early photographic practices paved the way for future generations of Black Americans to document and celebrate themselves and their communities.

By the early twentieth century, Black Americans were making their way from across the South to Northern cities in search of new opportunities and ways of existing. James Van Der Zee documented Harlem, New York, for over fifty years, especially during the Harlem Renaissance of the 1920s and 1930s. Along with the poetry, sculpture, and painting that blossomed during the renaissance, a new urban class of Black

Americans rooted in cosmopolitanism and the arts emerged, and Van Der Zee captured its evolution. In a circa 1925 self-portrait, he poses for the camera wearing a suit, tie, and boater hat (p. 31). His stance and stylish clothing exude the new sense of class and pride that characterized Harlem and other Black urban centers in the first part of the twentieth century.

While the word "portrait" usually refers to a picture of a person or people, it can also denote a document of a particular place or moment in time, and Van Der Zee made both kinds of portraits (fig. 2).[4] In addition to producing studio photographs of celebrities, preachers such as "Sweet Daddy" Grace (p. 78), and paying customers, Van Der Zee brought his large cameras into the streets. He took pictures of the middle-class life and community that flourished both in New York and a short train ride away in Atlantic City, as seen in a photograph of women in bathing suits on the beach (p. 80). A picture made in 1920 teems with people wearing hats gathered on a Harlem street, capturing the liveliness of the neighborhood (p. 81). A double image shows a parade for Black nationalist Marcus Garvey, documenting a new sense of power and pride in Blackness (p. 79).

Photography has been used by scientists, journalists, and politicians as visual evidence throughout its history. As part of the New Deal, the U.S. government created the Farm Security Administration (FSA) in 1937 and tasked photographers with documenting the lives of poor farmers across the nation. Gordon Parks began working as a photojournalist for the FSA in 1941, intending to show the plight of Black Americans in the nation's capital. His FSA

Fig. 2. Installation view in *Black American Portraits*, Los Angeles County Museum of Art, 2021, including works by Roy DeCarava and James Van Der Zee

images reveal the contradiction of Washington, D.C.: both the seat of power of the national government and home to an impoverished Black population. In a photograph made in 1942, Parks shows a woman fetching water outdoors (p. 107). While the image is meant to expose poverty, it is also a portrait that makes the domestic, life-giving labor of Black women visible. Parks would go on to become the first Black photographer for *Life* magazine, a national periodical that helped define the visual culture of the nation for a generation. While Parks's

magazine images included photographs of models, celebrities, and politicians, his picture making was rooted in a desire to expose the evils of segregation and racism.

The Civil Rights and Black Power movements brought about a new generation of activists and artists determined to show the world that Black is Beautiful. A student of jazz and Pan-Africanist thought, Brooklyn-based photographer Kwame Brathwaite established a photography studio for a group of Black women models in 1962 (fig. 3). While the history of photography is filled with images in which brown skin tones are unflatteringly lit, Brathwaite excelled at creating fashion-forward studio portraits of his models in both color and black and white. In one photograph, Brathwaite uses his signature head-on composition to capture model Clara Lewis Buggs (p. 118). She has a bold hairstyle and big jewelry, and stands in front of a bright yellow backdrop holding an even brighter yellow flower. In a black-and-white portrait of Carolee Prince, the model wears clothing she has designed and poses with her eyes closed (p. 64). Prince tilts her head to the side, creating playful angles that contrast with the perfect symmetry of her parted hairstyle. At a moment when Black Americans

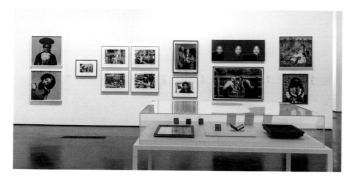

Fig. 3. Installation view in *Black American Portraits*, Los Angeles County Museum of Art, 2021, including works by Kwame Brathwaite, Lorraine O'Grady, and Lyle Ashton Harris and Renee Cox

were marching in the streets to petition for representation and creating institutions of their own, Brathwaite's photographs provided visual affirmations of pride in Blackness.

Roy DeCarava came of age in postwar New York and trained as a painter and printmaker at Harlem School of the Arts and Cooper Union. He took up photography in the mid-1940s after a brief time with the Works Progress Administration. Less interested in the technological and documentary features of the medium, DeCarava made expressly aesthetic photographs, using a 35mm camera and the printing process to create art. He argued that photography—and especially the silver gelatin print—is an artistic medium, if the practitioner is so engaged. In 1952 DeCarava became the first Black photographer to receive a Guggenheim Fellowship, which allowed him to spend a year photographing without the demands of full-time employment. He founded the first fine-art photography gallery in the U.S. in 1954 and in 1955 he published *The Sweet Flypaper of Life* with writer and poet Langston Hughes. The book features 140 of DeCarava's images accompanied by a narrative written by

Hughes and remains a foundational photography publication of the twentieth century. The photograph *Image/eye, Sherry* (p. 36) is a close-up half-portrait of DeCarava's wife. He took the picture in 1970 and printed it in 1981, yet the work is timeless. In this silver gelatin photograph, DeCarava explores the relationship, framed in delicacy and proximity, to an almost invisible expression where intimacy resides.

Lorraine O'Grady has combined photography and performance in her work in order to grapple with issues of identity, gender, and beauty standards. Photographs from her *Art Is...* project show an enormous gold frame atop a float at the 1983 Harlem African American Day Parade, along with performers carrying smaller gold frames (pp. 102–3). The performers placed the frames in front of the joyful attendees of the event to compose portraits within the photographs. In one image, a young girl carries a drink and smiles for the camera as someone holds a gold frame around her. In another, we see a man with a child on his shoulders as another performer frames him in gold. And in yet another, the enormous antique-style frame shows the scene along Adam Clayton Powell Jr. Boulevard, complete with a "Unisex Barber Salon." The images harken back to Van Der Zee's pictures of the Harlem Renaissance but exude a new vitality and sense of purpose; these are portraits of Black people reveling in family, community, and celebration in public.

In the 1990s, many artists, academics, and scholars insisted on the importance of positioning oneself in regard to gender, race, and sexuality. In a 1990 project focused on the domestic space of the kitchen table, Carrie Mae Weems used her own body to create scenes that conjure an air of intimacy (fig. 4). Each image in her Kitchen Table Series consists of a text panel and a portrait in which Weems is pictured in character, either alone or with others. In one Kitchen Table photograph, Weems and a man are seated at a table for a meal and a game of cards (p. 76). The man has finished his lobster and she has barely touched her plate. He is surrounded by several beer cans and an empty wineglass, while her glass of wine is still full. In the background, there is a picture on the wall and a bird in a cage. Weems holds a cigarette in one hand and gently touches the side of the man's head as he plays the harmonica. The text panel is playful and sultry:

> *Looking her up, down, sideways, he said, "So tell me baby, what do you know about this great big world of ours?" Smiling she said, "Not a damn thang sugar...but with conviction I can tell you I'm nobody's fool. So a better question might be: what can you teach me?"*

This work, like many other photographs, installations, performances, and videos by Weems, centers a Black woman subject and poses questions about relationships, love, and family.

Photographer Lyle Ashton Harris and artist Renee Cox also explore Black family dynamics in *The Child* (1994; p. 90), in which they pose for a fictional family photograph. Harris tackles issues of gender, sexuality, masculinity, and spirituality in his artistic practice, often picturing himself, his lovers, his friends, and his family. In *The Child*, as in many of

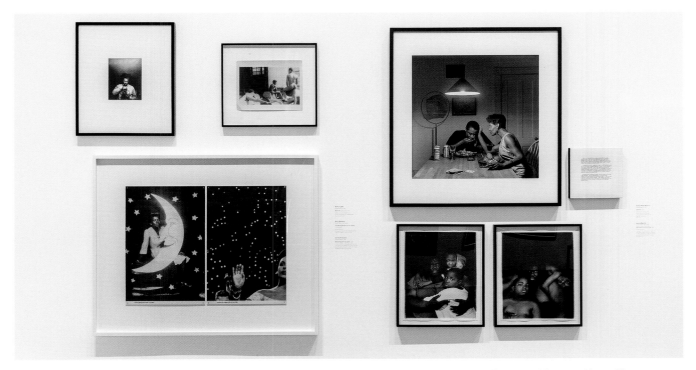

Fig. 4. Installation view in *Black American Portraits*, Los Angeles County Museum of Art, 2021, including works by Carrie Mae Weems and Lorna Simpson

his photographic works, Harris recasts gender roles in order to make them strange: here, he poses as the mother, wearing red lipstick and a red headband and holding a baby, while Cox portrays the father with a fake mustache and goatee, a suit, a collared shirt, and a tie. The two artists, who look straight into the camera with serious expressions, stand in front of a red, black, and green background. These colors allude to Black nationalism and the flags of many African nations. With this fabricated family photograph, Harris and Cox declare that queer brothers, sisters, and those across the gender spectrum are part of the Black family: both the nuclear family and the larger family of the African diaspora.

Lorna Simpson, who is known for paintings, installations, and photography-based works that often center Black women subjects, also tackles gender dynamics in *Backdrops, Circa 1940s* (1998; p. 117) by appropriating two images of Black women in front of Hollywood backdrops. On the left is a somewhat blurry photograph of an unidentified Black woman who poses with a smiling moon against a background of stars. On the right, we see part of an image of Lena Horne, one of the few Black actresses to play leading roles in early Hollywood. Both photographs show Black women depicted yet obscured in front of starry backdrops. The pairing alludes to the ways Black women in Hollywood have traditionally been relegated to the background—playing nannies and maids in the movies of the 1940s—rather than appearing as the stars of American cinema. The racial and gender dynamics visible in movies, television, and photography have helped teach Americans how to see.

In 2017, the year Obama finished his final term as president, Renee Cox made *The Signing*, a photograph that uses the medium to look back into American history with

a new vision (pp. 62–63). The large-scale image restages a 1940 painting by Howard Chandler Christy titled *Signing of the Constitution* (fig. 5). Cox recasts Black characters in a moment from which Black people were decidedly excluded. The signing of the U.S. Constitution was a momentous occasion: a country was formed not out of a monarchical divine right to rule, as with European nations, but through an agreement between the rulers and "the people." Of course, personhood—the way citizenship in this new nation was measured—was reserved for white men only. In this re-envisioned version of the founding, Black people occupy all the seats at the table, and Cox has cast herself as the main character. Afrofuturist in aesthetic, *The Signing* is a colorful digital reimagining of history, in which Black subjects and citizens are at the center of the national origin story.

For as long as photography has existed in the United States, Black Americans have used the medium to interrogate dominant ways of seeing and to offer alternate visions of the past and future. With its unique ability to simultaneously represent and construct, reflect and create, photography has enabled Black Americans to tell their stories as they are and as they would like them to be. In this small sample of images from LACMA's collection, Black figures are centered as the protagonists in an evolving American story.

It is from this deep well of imagery that *Untitled (Obama in Mirror, B&W)* and its iconic subject emerge. When Barack Obama looks into the mirror, he sees a single man who made history. But when he closes his eyes, he sees images and figures that came before him and paved the way for us to see him. In a nation that is built upon anti-Blackness, seeing Black people through their own eyes helped make it possible for us to envision and elect the first Black President of the United States.

Fig. 5. Howard Chandler Christy, *Signing of the Constitution*, 1940. Oil on canvas; 20 × 30 ft. (6.1 × 9.1 m). Architect of the Capitol, Washington, D.C.

## Notes

1    Deborah Willis, *Reflections in Black: A History of Black Photographers, 1840 to the Present* (New York: W. W. Norton, 2000), 4.
2    Deborah Willis and Barbara Krauthamer, *Envisioning Emancipation: Black Americans and the End of Slavery* (Philadelphia: Temple University Press, 2013), 23
3    See John Stauffer, Zoe Trodd, Henry Louis Gates, Jr., Kenneth B. Morris Jr., and Celeste-Marie Bernier, *Picturing Frederick Douglass: An Illustrated Biography of the Nineteenth Century's Most Photographed American* (New York: Liveright Publishing), 2015.
4    For older definitions of "portrait," see Marcia R. Pointon, *Hanging the Head: Portraiture and Social Formation in Eighteenth-Century England* (New Haven: Yale University Press, 1993), 8.

# The Elusive Body: Mark Bradford and David Hammons

Dhyandra Lawson

We make portraits because people elude us. People move. People die. People enter our lives and leave them. Portraits encapsulate the mortal and moving body.

When visitors walk into the Resnick Pavilion at the Los Angeles County Museum of Art (LACMA), the first artwork they see is *150 Portrait Tone* by Mark Bradford (fig. 1). Layers of paper Bradford ripped and collaged culminate in a mural that reaches twenty feet high and spans twenty-five feet. The museum commissioned the work and presented it in 2017. It has been on view ever since—a permanent fixture in the Resnick Pavilion and a definitive work in the collection. The work frames every exhibition and human interaction around it.

"...Oh my God please don't tell me he's dead..."

"...Please Jesus don't tell me that he's gone..."

"...Please officer don't tell me that you just did this..."

"...Stay with me..."

Bradford stenciled the transcript of Diamond Reynolds's cries for her boyfriend, Philando Castile, across the mural (fig. 2). In 2016, Castile, thirty-two, was driving with his girlfriend and her four-year-old daughter in Saint Paul, Minnesota, when police officer Jeronimo Yanez pulled him over. The officer told Castile he had stopped him for a broken taillight. Dashboard camera footage shows that Yanez pulled over Castile because he "look[ed] like people" that were involved in a local robbery.[1] Yanez asked for Castile's license and insurance. Castile said he had a firearm he was licensed to carry. Yanez replied, "Don't reach for it then." Castile assured him, "I'm not pulling it out." Yanez fired seven shots through Castile's car window, killing him. Yanez was charged with second-degree manslaughter and two counts of dangerous discharge of a firearm. On June 16, 2017, after five days of

deliberation, a Minnesota jury acquitted him of all charges. LACMA presented *150 Portrait Tone* four months later.

Bradford rarely shows the human form in his work. Rather, he reveals traces of the body.[2] From Philando Castile to the Africans who were sold on auction blocks, Black people have been distinctly visible in the Americas. Bradford's choice is, as he has described, political.[3]

The artist uses urban debris. He collects posters and paper from around his South Los Angeles neighborhood. With water, glue, and a process of sanding, he builds up and tears the paper, then transforms the rigid layers into seamless compositions (figs. 3–5). Bradford's laborious process implicates his body in his work. The papers the artist recovers from city streets are vestiges of the people who left them there.

The physicality of Bradford's practice recalls David Hammons's Body Prints series. Hammons moved to Los Angeles in 1963 from Springfield, Illinois, to study art. He began making body impressions in 1968, just after he graduated from the Chouinard Art Institute (now the California Institute of the Arts). After that, he studied drawing with social realist artist and activist Charles White at Otis Art Institute.

For his Body Prints series, Hammons coated himself in margarine, Crisco, and baby oil. He then pressed his body onto paper and sprinkled the impression with charcoal or graphite to reveal a positive image. Some of his compositions depict figures socializing or involved in intimate exchanges. Other works express political commentary. Eventually, he applied his body prints onto other surfaces. *The Door (Admissions Office)* (1969), a glass door featuring two Black figures facing each other, alludes to segregation.

In *Injustice Case*, arguably the most famous print from the series, Hammons portrays a man gagged, chained,

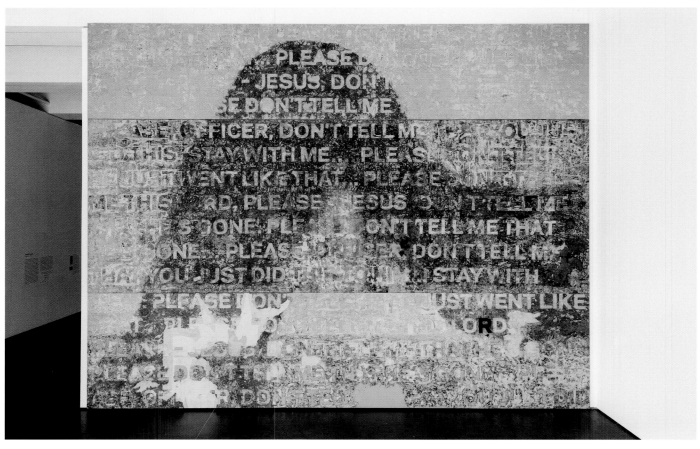

Fig. 1. Installation view of Mark Bradford, *150 Portrait Tone*, 2017. Mixed media on canvas; 240 × 310 in. (304.8 × 788.7 cm). Los Angeles County Museum of Art, purchased with funds provided by Jimmy Iovine, Liberty Ross, and Family, M.2018.11

Fig. 2. Mark Bradford's *150 Portrait Tone* (2017) in progress, as shown in the film *Wild Wild West: A Beautiful Rant by Mark Bradford* (2018)

and lashed to a chair (p. 68). The image references Black Panther Party leader Bobby Seale's treatment during the trial of the Chicago Eight in 1969. The eight defendants were charged with having incited civil unrest at the Democratic National Convention the year before. During the trial, Seale, a co-defendant, repeatedly objected to not having legal representation. Judge Julius Hoffman ordered police to gag and bind Seale in the courtroom. Seale's case was declared a mistrial and never retried.

Hammons impressed his body onto paper in the shape of bound Seale. He framed the image with an actual American flag; stars and stripes occupy the border of the work. The image amplifies a Black artist's voice speaking out against his nation's mistreatment of Black people.

Hammons was immersed in a community of Black artists and activists in Los Angeles in the 1960s. They established exhibition opportunities and support networks for Black Angelenos in churches, libraries, and civic centers.[4] Black-owned galleries like Brockman Gallery dedicated their efforts to fostering the careers of artists of color; *Injustice Case* debuted there in April 1970.[5] LACMA acquired the piece and presented it in *Three Graphic Artists: Charles White, Timothy Washington, David Hammons* the next year (fig. 6). The exhibition featured works by Charles White and then-emerging artists Hammons and Timothy Washington. The three artists were also members of LACMA's Black Arts Council; founded by LACMA staff members Claude Booker and Cecil Fergerson in the wake of the Watts Rebellion, the group sought to promote the work of African American artists and engage more diverse audiences at the museum. *Injustice Case* is one of three works by Hammons in LACMA's collection.

Scholars often compare Hammons's Body Prints to X-rays. The contrast between black and white, and the indexical impressions Hammons makes, recall photographs. Unlike an X-ray, however, his monoprints emphasize the body's exterior. In *Injustice Case*, Hammons's jeans, hair, and fingernails have marked the paper. The print reveals the fibers of the rope around his knees and the bind yanking his neck back on his shoulders (fig. 7).

Hammons's work accentuates the fundamental physical difference Europeans used to justify African peoples' subjugation: their skin. The charcoal Hammons applies to pa-

Figs. 3–5. Mark Bradford's *150 Portrait Tone* (2017) in progress, as shown in the film *Wild Wild West: A Beautiful Rant by Mark Bradford* (2018)

per materializes his Blackness. A slippage emerges between artist and subject—as Hammons takes on Seale's physicality, he renders not only his social position but the social position of all Black Americans.

Hammons moved to New York in 1974. There, he began his career-long practice of repurposing everyday objects like liquor bottles and human hair into sculpture. This seemed to reflect his time in Los Angeles, where many Black artists, including John Outterbridge, Noah Purifoy, and Betye Saar practiced assemblage, and where Hammons encountered—and admired—Watts Towers, Simon Rodia's huge outdoor tiled sculptures in South L.A.[6] "I like doing stuff better on the street," Hammons has reflected. "The art becomes just one of the objects that's in the path of your everyday existence. It's what you move through, and it doesn't have any seniority over anything else."[7]

Like Hammons, Bradford looks beyond the walls of his studio. He continues to practice in Leimert Park, where he grew up working in his mother's hair salon. "I was born on the fringe," he has said. "I knew where I came from, but I was only interested in where I was going. It's the same with materials. They come from merchants and the streets. I'm interested in where they're going…. Taking humble stuff and demanding they have access to anything they want."[8]

Whereas Hammons uses charcoal, Bradford uses the color pink to evoke flesh in *150 Portrait Tone.* The title references the name and color code of the acrylic medium prominent in the piece. Recalling the now-obsolete "Flesh" crayon in the Crayola box, "portrait tone" carries assumptions about who is depicted.[9] A dark, serpentine form undulates through the composition, disrupting the pink panels. The form bends upward from the bottom of the piece and curves at the apex. The abstraction implicates Castile's body—perhaps his twisted arm, his Black skin, or his shadow.

In *150 Portrait Tone*, layers of torn paper resemble weathered plaster walls. Five decades separate Hammons's and Bradford's work. Hammons made *Injustice Case* in the wake of the 1965 Watts Rebellion. Bradford's work anticipated the protests that ensued after George Floyd's murder in 2020—four years after Castile's death. In each instance, police brutality toward Black people prompted social upheaval.

Traditional portraits function like biographies, with artists simulating the likenesses of their subjects by depicting the features of their faces, wardrobes, and surroundings. Hammons and Bradford expand traditional figuration. In *150 Portrait Tone* and *Injustice Case*, the artists conjure a visceral

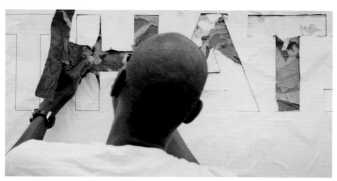

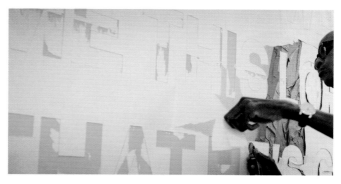

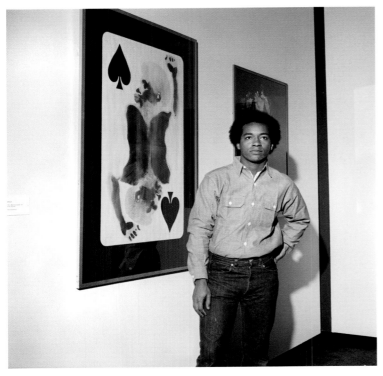

Fig. 6. David Hammons with his work *Spade* (1970), in *Three Graphic Artists: Charles White, David Hammons, Timothy Washington*, Los Angeles County Museum of Art, 1971

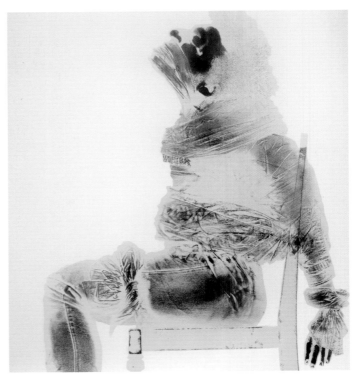

Fig. 7. Detail of David Hammons's *Injustice Case* (1970)

sense of their subjects. Bradford transcribes Reynolds's words to evoke the cadence and sentiment of her pleas (fig. 8). Those who stand in front of *150 Portrait Tone* take Diamond Reynolds's point of view as she watched her boyfriend die; the sound of her voice echoes in viewers' minds. Seale couldn't speak. Hammons wrapped his own mouth and pressed it onto paper, enacting the moment of Seale's silence to provoke viewers to respond. History perpetuates racism and imperialism when it does not report oppressed peoples' points of view. Hammons and Bradford offer complex pictures of African American experience—an existence defined by the spectrum of human emotion, including love and joy, like any other— but also an existence marked by one's place in history and in American society.

"...Stay with me..." Reynolds pled.

Bradford and Hammons do not simply simulate the likenesses of their subjects. The physicality of the artists' processes reinforces the sensation of their subjects' humanity. They implicate themselves, and the viewer, in their works. The physicality of Bradford's process, and of Hammons's skin, is on view.

Bradford and Hammons grasp for a visceral sense of the elusive body—its utterance and its texture. They reinforce the humanity of Castile and Seale in situations where they were denied it.

## Notes

1    "Dash Camera Shows Moment Philando Castile Is Shot," *New York Times*, June 20, 2017, https://www.nytimes.com/video/us/100000005176538/dash-camera-shows -moment-philando-castile-is-killed.html.

2    Huey Copeland, "Painting After All: A Conversation with Mark Bradford," *Callaloo* 37, no. 4 (2014): 817.

3    Copeland, "Painting After All," 817.

4    Connie Rogers Tilton, "Introduction," in *L.A. Object & David Hammons Body Prints*, ed. Connie Rogers Tilton and Lindsay Charlwood (New York: Tilton Gallery, 2006), 16.

5    Kellie Jones, "In Motion: The Performative Impulse," in *South of Pico: African American Artists in Los Angeles in the 1960s and 1970s* (Durham, NC: Duke University Press, 2017), 228.

6    Kellie Jones, "Interview: David Hammons," *ART PAPERS*, July/August 1988, 42.

7    David Hammons in Jones, "Interview," 40.

8    Mark Bradford in *Wild Wild West: A Beautiful Rant by Mark Bradford*, directed by Dime Davis, produced by Elle Lorraine and Erin Wright (Los Angeles: Los Angeles County Museum of Art, November 29, 2018), https://www.youtube .com/watch?v=HCEILH01--s.

9    Michael Govan, "Mark Bradford's '150 Portrait Tone,'" YouTube video, January 18, 2021, https://www.youtube.com/watch?v=-RqgXLI6K-I.

Fig. 8. Detail of Mark Bradford's *150 Portrait Tone* (2017)

# Afterword

Naima J. Keith

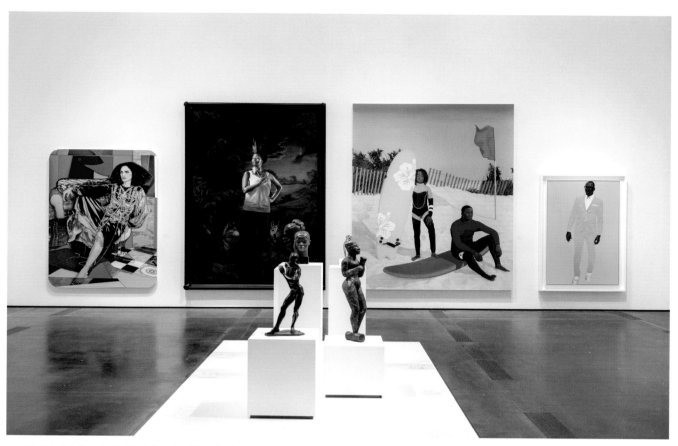

Fig. 1. Installation view in *Black American Portraits*, Los Angeles County Museum of Art, 2021, with Barkley Hendricks's *Photo Bloke* (2016) at far right

On May 25, 2020, George Floyd was murdered at the hands of Minneapolis police officers. In the months since, Black death and violence have been featured on major news outlets nearly daily, and more than eleven thousand demonstrations in support of Black Lives Matters have been held at over three thousand locations across the country.[1] Cries for justice for Elijah McClain, Breonna Taylor, Philando Castile, and countless other victims of police violence have echoed from the streets. Major corporations and institutions have followed suit, issuing public statements in which they commit to racial equity.

The *Black American Portraits* exhibition at the Los Angeles County Museum of Art (LACMA) was also a response to this moment, an artistic contribution to a racial reckoning. The show created a space for the elevation of Black artists, the contemplation of Black representation, and the celebration of Black joy. The nuanced and diverse offerings in the exhibition contrasted with the images of Black pain that had flooded our news channels and social media feeds for eighteen months. The exhibition gave audiences a chance to see Black bodies at ease, at leisure, in love—a type of portrayal that was intended for all viewers but may have been especially resonant for viewers of color, who might recognize themselves, their family members and friends, and their experiences in these images.

This diversity of representation helps expand the idea of what portraiture can mean, especially for Black people. Notably, the exhibition also helped contextualize Amy Sherald's portrait of Michelle Obama (p. 177). When the portrait was first revealed, there was a mixed reception due to its unconventional nature—the first lady is painted in gray tones (a style Sherald employs to ask her audience to move beyond racial stereotypes) and sits in a comfortable yet assured posture. Presented adjacent to the varied works in *Black American Portraits*, Michelle Obama's portrait was validated as an artistic representation of Black confidence, joy, and security.

The representation of Black style and joyfulness is central to Barkley Hendricks's realist and postmodern oil paintings of Black Americans. After visiting Europe in the mid-1960s and experiencing dismay at the lack of art featuring Black people in most of the museums, Hendricks began to capture and elevate Black Americans through photography and painting. In *Photo Bloke* (2016; fig. 1), he shows a Black man in a vibrant pink suit striding confidently toward the viewer. The subject's ease and assurance, as well as his distinct style, can be thought of as a prototype for what is known today as Black boy (and man) joy. Black visitors to *Black American Portraits* likely had an experience diametrically opposed to Hendricks's discomfiting trips to

European museums: during the run of the exhibition, there were more images of Black people on LACMA's walls than ever before in the museum's fifty-six-year history.

Black love is readily apparent in *The Inversion of Racquel* (2021; p. 127), a painting by Mickalene Thomas. A portrait of Racquel Chevremont, Thomas's life partner and muse, the piece is a powerful image of Black femininity, a staple of the artist's work. Such displays of Black love and power are increasingly necessary to reconcile images of Black pain. In 2020, analyses of Gallup COVID-19 panel surveys found that reports of sadness among Black Americans increased dramatically—2.1-fold—after George Floyd was murdered by police officer Derek Chauvin; it can be reasonably assumed that the constant press coverage of Black death and violence contributed to this increase.[2] *Black American Portraits* functioned as an oasis, providing viewers with at least momentary solace from the inundation of painful imagery.

Amy Sherald's portraiture provides a similar type of relief, as she paints "the things [she] wants to see by depicting Black Americans in scenes of leisure and centered in stillness."[3] Her work *An Ocean Away* (2020; p. 49) features a Black father and son—again painted in her signature grayscale—wearing wetsuits, holding surfboards, and gazing out onto the horizon. This painting asserts that Black people belong by the water, in nature, at the beach, and in outdoor sports—places that still lack adequate representation of people of color and are often unfairly thought of as "white." Sherald and other artists featured in the exhibition use their art to reclaim and reimagine the world to be more hospitable to Black people.

*Black American Portraits* answered protesters' calls to imagine a joyful and viable future for Black people, inviting visitors—Black people and allies alike—to experience Blackness as powerful, beautiful, abundant, nuanced, and jubilant. The reception of the show by children, teachers, and community members was a testament to the ability of representative art to transform and create space for the imagination of Black resilience and joy. LACMA invested in its public programming for the exhibition in order to reach the widest audience possible and offer multiple avenues for engagement with the work. Making good on its Policy on Diversity commitment to ensure community members, particularly those of color, from across L.A. have more access to art, LACMA hosted an opening event on November 7, 2021, and more than five thousand people attended.[4] Reactions reflected the variety of emotion in the work itself: from tears to joy, we were moved to see such an authentic embodiment of Blackness (figs. 2–4).

Throughout the lifetime of the exhibition, LACMA offered nearly thirty public programs, ranging from film screenings to poetry slams to artist speaker series, providing necessary context for the powerful work. Beyond giving a space to the work itself, one of the most important functions of *Black American Portraits* was its ability to connect community members with art through targeted events and investments. We will ensure this practice continues beyond the life of the exhibition and prioritize finding more ways for Angelenos—

Fig. 2. Maurice Harris of Bloom & Plume pictured in one of his floral environments inspired by *The Obama Portraits Tour*. Los Angeles County Museum of Art, November 7, 2021

Fig. 3. A visitor with Kerry James Marshall's *A Portrait of the Artist as a Shadow of His Former Self* (1980) in *Black American Portraits*, Los Angeles County Museum of Art, November 7, 2021

especially those who might see themselves in the work of Black artists—to spend time with our growing collection.

The exhibition was an important step toward increasing and diversifying representation of Black artists and portraiture, but it was just that—a step. Author and activist Ta-Nehisi Coates has spoken directly to the need to couple art, representation, and action, stating:

> *Representation is not enough. You need actual structure. I mean...Georgia just passed this election law to really turn Black people in Georgia into second-class citizens.... There's nothing that "representation" could really do about that. Somebody headlining a film or some Black artist—that's not going to directly solve that problem. But having said that, I do think that we underestimate just how much of the power of white supremacy is actually symbolic. It lies within art, within culture, within totems and symbols.*[5]

Here at LACMA, through *Black American Portraits*, through investment in our collection of Black American art, through public programs, we are working to offer a rich

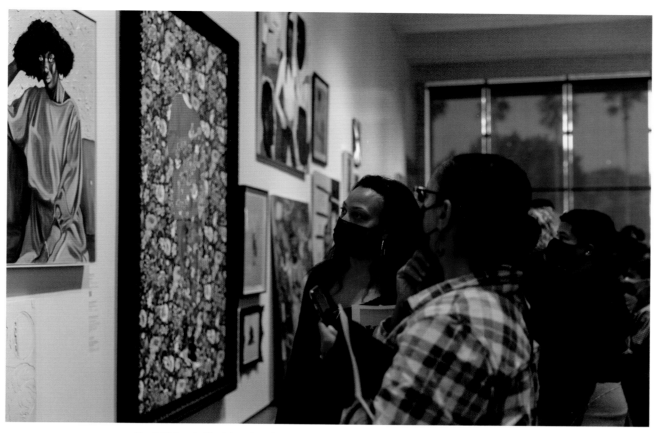

Fig. 4. Visitors in *Black American Portraits*, Los Angeles County Museum of Art, November 7, 2021

vocabulary of these totems and symbols. LACMA will continue to expand its holdings of work by Black artists and artists of color, ensuring the positive representation we saw over the course of *Black American Portraits* carries on far beyond the life of exhibition. LACMA's diversity aims cannot be accomplished by exhibitions alone, and will require a shift in the acquisition practices that build our permanent collection. Over the past three years, LACMA has acquired more than sixty-five works by African American artists. This is a promising step, but much work is left to be done at LACMA and in the museum field in general; research shows that less than 3 percent of museum acquisitions over the past decade have been of work by African American artists.[6]

Each time you return to this volume, we challenge you to interrogate the systems and injustices that have made—and continue to make—this work necessary and important. We hope the myriad of diverse and moving pieces allows you to imagine a future where Black excellence and joy are not simply responses to the brutal and needless murder of Black people, but standard features of our collective daily existence.

Notes

1    "Racial Justice Protests: Key Trends in Demonstrations Supporting the BLM Movement," Armed Conflict Location & Event Data Project (ACLED), May 2021, https://acleddata.com/2021/05/25/a-year-of-racial-justice-protests-key-trends-in-demonstrations-supporting-the-blm-movement/.

2    Melissa de Witte, "Anger and Sadness Soared Following George Floyd's Death, Particularly among Black Americans, Stanford Psychologists Find," *Stanford News*, September 20, 2021, https://news.stanford.edu/2021/09/20/psychological-toll -george-floyds-murder/.

3    Tom Teicholz, "Artist Amy Sherald Delivers 'The Great American Fact,'" *Forbes*, April 15, 2021, https://www.forbes.com/sites/tomteicholz/2021/04/15/painter-amy -sherald-deliversthe-great-american-fact/.

4    Los Angeles County Museum of Art Board of Trustees, "Policy on Diversity," June 7, 2017, https://www.lacma.org/sites/default/files/file-attachments/Board_Diversity_Policy.pdf.

5    Ta-Nehisi Coates quoted in "Calida Rawles, Amy Sherald, and Ta-Nehisi Coates Find Freedom in Belonging," *Harper's Bazaar*, June 14, 2021, https://www.harpersbazaar.com /culture/features/a36577372/calida-rawles-amy-sherald-ta-nehisi-coates-conversation/.

6    Julia Halperin and Charlotte Burns, "African American Artists Are More Visible Than Ever. So Why Are Museums Giving Them Short Shrift?," *Artnet News*, September 20, 2018, https://news.artnet.com/the-long-road-for-african-american-artists/african -american-research-museums-1350362.

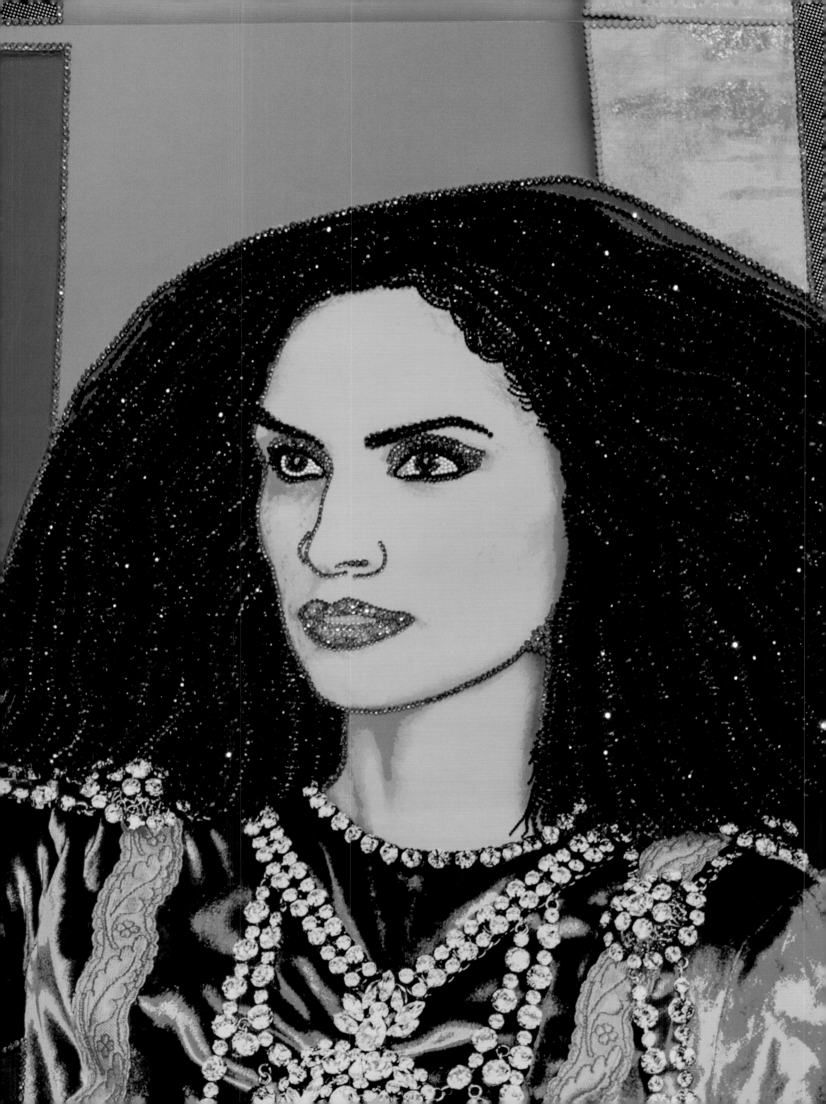

# List of Plates

Unless otherwise indicated, all works are in the collection of the Los Angeles County Museum of Art.

Artist not recorded
*Portrait of a Sailor (Paul Cuffe?)*, c. 1800
Oil on canvas
25¼ × 20½ in. (64.1 × 52.1 cm)
Purchased with funds provided by Cecile Bartman
M.2005.2
p. 20

William Armfield Hobday
England, 1771–1831
*Portrait of Prince Saunders*, c. 1815
Oil on canvas
28½ × 22 in. (72.4 × 55.9 cm)
Los Angeles County Museum of Art, gift of the 2022 Collectors Committee
pp. 7, 132

Artist not recorded
*Untitled*, late 19th century
Daguerreotype
3⅞ × 3½ × ¾ in. (9.8 × 8.9 × 1.9 cm)
Ralph M. Parsons Fund
M.2021.132
pp. 8, 104

Meta Vaux Warrick Fuller
United States, 1877–1968
*The Dancer*, cast c. 1902
Bronze
Height: 7 in. (18 cm)
American Art Acquisition and Deaccession funds
M.2022.55
p. 72

James Van Der Zee
United States, 1886–1983
*Crowd in Harlem*, 1920
Gelatin silver print
Image: 3½ × 5⅝ in. (8.7 × 13.7 cm)
The Marjorie and Leonard Vernon Collection, gift of The Annenberg Foundation, acquired from Carol Vernon and Robert Turbin
M.2008.40.2286
pp. 81, 190–91

James Van Der Zee
United States, 1886–1983
*Marcus Garvey & Garvey Militia, Harlem*, 1924
Gelatin silver print
Image: 9¾ × 7¾ in. (24.6 × 19.7 cm)
Gift of Emerald and Harriet Merrill
M.83.315.3
p. 79

James Van Der Zee
United States, 1886–1983
*Self-Portrait in Boater Hat*, c. 1925
Gelatin silver print
Image: 9⅜ × 7 in. (23.7 × 17.7 cm)
The Audrey and Sydney Irmas Collection
AC1992.197.129
p. 31

Miki Hayakawa
Japan, 1988–1953, active United States
*Portrait of a Negro*, 1926
Oil on canvas
26 × 20 in. (66 × 50.8 cm)
Purchased with funds provided by Mrs. James D. Macneil
M.2004.27.2
p. 133

Sargent Claude Johnson
United States, 1888–1967
*Chester*, 1930
Painted terracotta
11½ × 4½ × 4¾ in. (29.2 × 11.4 × 12.1 cm)
Gift of Mrs. William J. Robertson in memory of her father Adolph Loewi
AC1997.71.1
p. 29

James Van Der Zee
United States, 1886–1983
*Atlantic City*, 1930
Gelatin silver print
Image: 6½ × 4 in. (16.35 × 10 cm)
Gift of Emerald and Harriet Merrill
M.83.315.5
pp. 10, 80

Edward Steichen
Luxembourg, 1879–1973, active United States
*Paul Robeson as "The Emperor Jones,"* 1933
Gelatin silver print
13⅛ × 10½ in. (33.3 × 26.7 cm)
Gift of Richard and Jackie Hollander in memory of Ellyn Lee Hollander
M.2019.398.10
p. 114

James Van Der Zee
United States, 1886–1983
*Daddy Grace, Harlem*, 1938
Gelatin silver print
Image: 9⅜ × 7½ in. (23.8 × 18.9 cm)
Gift of Emerald and Harriet Merrill
M.83.315.1
p. 78

Jacob Lawrence
United States, 1917–2000
*Woman with Groceries*, 1942
Gouache on paper
29¾ × 21 in. (75.6 × 53.3 cm)
Purchased with funds provided by the Julius Bernard Kester Trust with additional support from American Art Council, Robert H. Halff Endowment, Modern Art Acquisition Fund, Modern and Contemporary Art Council, Fannie and Alan Leslie Bequest, American Art Acquisition Fund, and American Art Deaccession Fund
M.2019.348
Back cover, p. 77

Gordon Parks
United States, 1912–2006
*Untitled, Washington, D.C.*, 1942
Gelatin silver print
Image: 4¾ × 3⅞ in. (11.9 × 9.7 cm)
Gift of Dan and Jeanne Fauci
M.2002.200.3
p. 107

Beauford Delaney
United States, 1901–1979
*Negro Man* [Claude McKay], 1944
Oil on canvas
19⅛ × 16¼ in. (48.6 × 41.3 cm)
Gift of the 2022 Collectors Committee with additional funds provided by the Robert H. Halff Endowment, the Modern and Contemporary Art Council, and The Buddy Taub Foundation, Jill and Dennis Roach, Directors
M.2022.44
p. 42

John Biggers
United States, 1924–2001
*Sharecropper*, 1945
Oil on canvas
24 × 18 in. (61 × 45.7 cm)
Purchased with funds provided by the Ducommun and Gross Endowment and Robert H. Halff Endowment
M.2022.41
p. 125

Alice Neel
United States, 1900–1984
*Horace Cayton*, 1949
Oil on canvas
30 × 24 in. (76.2 × 61 cm)
Promised gift of Mark Gordon Family Collection
p. 88

Consuelo Kanaga
United States, 1894–1978
*She is a Tree of Life to Them*, 1950
Gelatin silver print
Image: 12¾ × 9⅜ in. (32.4 × 23.7 cm)
Ralph M. Parsons Fund
M.2006.93
p. 147

Charles White
United States, 1918–1979
*Frederick Douglass*, 1950
Lithograph
Sheet: 26⅛ × 19⅞ in. (66.4 × 50.5 cm)
Gift of Sylvia and Frederick Reines
M.90.193
p. 181

Elizabeth Catlett
United States, 1915–2012, active Mexico
*Sharecropper*, 1952
Linocut
Sheet: 25½ × 19⅝ in. (64.8 × 49.9 cm)
Gift of the 2011 American
Art Acquisitions Group
M.2011.41
p. 30

Richmond Barthé
United States, 1901–1989
*Inner Music*, 1956
Bronze
Height: 24½ in. (62.2 cm)
Gift of the 1989 Collectors Committee
M.89.25
p. 73

Bruce Davidson
United States, b. 1933
*Untitled*, c. 1989
From the series Chicago
Dye coupler print
Primary support: 14 × 11 in. (35.6 × 27.9 cm)
Gift of an anonymous donor
M.2018.264.369
pp. 3, 93

Kwame Brathwaite
United States, b. 1938
*Untitled (Clara Lewis Buggs with Yellow
Flower)*, 1962, printed 2020
Pigment-based ink-jet print
30 × 30 in. (76.2 × 76.2 cm)
Promised gift of Kim and Keith Allen-Niesen
p. 118

Kwame Brathwaite
United States, b. 1938
*Untitled (Carolee Prince Wearing Her Own
Designs)*, 1964, printed 2018
Pigment-based ink-jet print
31 × 31 × 2 in. (78.7 × 78.7 × 5.1 cm)
Promised gift of Kim and Keith Allen-Niesen
p. 64

Betye Saar
United States, b. 1926
*Phrenology Man with Symbols*, 1966
Color etching with embossing printed from
three plates
Sheet: 16¼ × 18½ in. (41.3 × 47 cm)
Purchased with funds provided by Bruce
Davis
AC1996.102.1
p. 121

Edward Biberman
United States, 1904–1986
*I Have a Dream*, 1968
Oil on Masonite
24 × 30 × 3 in. (61 × 76.2 × 7.62 cm)
Purchased with funds provided by the
American Art Council
M.2011.42
p. 42

Emory Douglas
United States, b. 1943
*The Black Panther, vol. 2, no. 25*, March 9,
1969
Ink on paper
17½ × 11½ in. (44.5 × 29.4 cm)
Decorative Arts and Design Council
Acquisition Fund
M.2018.252.1a–b
p. 92

Charles White
United States, 1918–1979
*Seed of Love*, 1969
Ink on paper
Sheet: 51 × 36 in. (129.5 × 91.4 cm)
Museum Acquisition Fund
M.71.9
p. 124

Roy DeCarava
United States, 1919–2009
*Image/eye, Sherry*, 1970, printed 1981
Gelatin silver print
Image: 12 × 8 in. (30.5 × 20.5 cm)
The Marjorie and Leonard Vernon Collection,
gift of The Annenberg Foundation, acquired
from Carol Vernon and Robert Turbin
M.2008.40.638
p. 36

David Hammons
United States, b. 1943
*Injustice Case*, 1970
From the series Body Prints
Body print and American flag
Sheet: 63 × 40½ in. (160 × 102.9 cm)
Museum Acquisition Fund
M.71.7
pp. 68, 204

Timothy Washington
United States, b. 1946
*One Nation Under God*, 1970
Engraving on aluminum with added color
35 × 48 in. (88.9 × 121.9 cm)
Museum Purchase with Museum Associates
Funds
M.71.8
p. 69

Cedric Adams
United States, b. 1953
*Just How I Feel*, 1972
Graphite on paper
18 × 23⅞ in. (45.7 × 61 cm)
Purchased with funds provided by LACMA
colleagues: Liz Andrews, Stephanie Barron,
Timothy Benson, Julia Burtenshaw, Giorgio
Carlevaro, Claudine and Jim Dixon, Tom
Duffy, Carol S. Eliel, Ilene Susan Fort, Rita
Gonzalez, Hollis Goodall, Michael Govan,
Christine Y. Kim, Rachel Kaplan, Wendy
Kaplan, Ilona Katzew, Jennie King, Julia
Latané, Leah Lehmbeck, Devi Noor, David
Parker, Nancy Russell, Britt Salvesen, Lauren
Bergman Siegel, Staci Steinberger, Kristin
Strid, Nancy Thomas, and Kevin Goff, and
those who wish to remain anonymous
M.2021.128
p. 53

Charles White
United States, 1918–1979
Printed by Lloyd Bags, Cirrus Editions Ltd.
*Portrait of Tom Bradley*, 1974
Lithograph
Sheet: 30 × 22¼ in. (76.2 × 56.5 cm)
Gift of Mayor Tom Bradley
AC1992.283.1
p. 119

David C. Driskell
United States, 1931–2020
*Jazz Singer (Lady of Leisure, Fox)*, 1974
Oil and collage on canvas
52 × 44 in. (132.1 × 111.8 cm)
Jointly acquired by the Los Angeles County
Museum of Art, with funds provided by the
Ford Foundation in honor of David Driskell
and Christine Y. Kim on the occasion of *Black
American Portraits*; and the Lucas Museum of
Narrative Art, Museum Purchase, Los Angeles
p. 139

Alvin Baltrop
United States, 1948–2004
*The Piers (three men on dock)*, n.d. (1975–86)
Gelatin silver print
11 × 13¾ in. (27.8 × 34.9 cm)
Promised gift of Graham Steele and Ulysses
De Santi
p. 60

Charles White
United States, 1918–1979
Printed by Daniel Freeman, Cirrus Editions Ltd.
*I Have a Dream*, 1976
Lithograph
Sheet: 22½ × 30 in. (57.2 × 76.2 cm)
Cirrus Editions Archive. Purchased with funds
provided by the Director's Roundtable, and gift
of Cirrus Editions
M.86.2.495
p. 143

Kent Twitchell
United States, b. 1942
*Portrait of Charles White*, 1977
Graphite on paper
Sheet: 132 × 48 in. (335.3 × 121.9 cm)
Gift of Benjamin Horowitz
M.91.86
p. 137

Sam Doyle
United States, 1906–1985
*Jake, Our Best.*, 1978–83
House paint on metal
47 × 28 in. (119.4 × 71.1 cm)
Promised gift of Gordon W. Bailey in tribute to
Jackie and Rachel Robinson in honor of the
museum's 50th anniversary
p. 109

Ming Smith
United States, b. 1951
*Grace Jones, Studio 54 II*, 1979
Gelatin silver print
Sheet: 12 × 18 in. (30.5 × 45.7 cm)
Promised gift of Janine Sherman Barrois and
Lyndon J. Barrois, Sr.
p. 113

Kerry James Marshall
United States, b. 1955
*A Portrait of the Artist as a Shadow of His Former Self*, 1980
Egg tempera on paper
8 × 6½ in. (20.3 × 16.5 cm)
Promised gift of Steven and Deborah Lebowitz
p. 21

Frederick J. Brown
United States, 1945–2012
*Dr. Leon Banks (Study for Last Supper)*, 1982
Oil on linen
32 × 24¼ in. (81.3 × 61.6 cm)
Purchased with funds provided by the Modern and Contemporary Art Council Acquisitions Endowment
M.2022.50
p. 54

Lorraine O'Grady
United States, b. 1934
*Art Is... (Man with Baby)*, 1983, printed 2009
Chromogenic print
16 × 20 in. (40.6 × 50.8 cm)
Purchased with funds provided by Alice and Nahum Lainer
M.2021.144.3
p. 103

Lorraine O'Grady
United States, b. 1934
*Art Is... (Man with Rings and Child)*, 1983, printed 2009
Chromogenic print
16 × 20 in. (40.6 × 50.8 cm)
Purchased with funds provided by Alice and Nahum Lainer
M.2021.144.1
p. 102

Lorraine O'Grady
United States, b. 1934
*Art Is... (Nubians)*, 1983, printed 2009
Chromogenic print
16 × 20 in. (40.6 × 50.8 cm)
Purchased with funds provided by Alice and Nahum Lainer
M.2021.144.4
p. 103

Lorraine O'Grady
United States, b. 1934
*Art Is... (Unisex Barber Shop)*, 1983, printed 2009
Chromogenic print
16 × 20 in. (40.6 × 50.8 cm)
Purchased with funds provided by Alice and Nahum Lainer
M.2021.144.2
p. 102

Arthur Jafa
United States, b. 1960
*Monster*, 1988, printed 2017
Gelatin silver print
Image: 10 × 8 in. (25.4 × 20.3 cm)
Purchased with funds provided by Contemporary@LACMA, 2021
M.2022.43
p. 43

Isaac Julien
United Kingdom, b. 1960
*The Last Angel of History*, 1989/2016
Kodak Premier print, Diasec mounted on aluminum
71 × 102⅛ × 1¾ in. (180.3 × 259.4 × 4.5 cm)
Gift of the artist and Jessica Silverman Gallery
M.2021.27
pp. 126, 223

Carrie Mae Weems
United States, b. 1953
*Untitled*, 1990
From the Kitchen Table Series
Gelatin silver print and text panel
Image: 27 × 26⅞ in. (68.6 × 68.2 cm)
Ralph M. Parsons Fund
M.91.107.1
p. 74

Carrie Mae Weems
United States, b. 1953
*Untitled*, 1990
From the Kitchen Table Series
Gelatin silver print and text panel
Image: 27½ × 27⅛ in. (69.9 × 68.9 cm)
Ralph M. Parsons Fund
M.91.107.2
p. 75

Carrie Mae Weems
United States, b. 1953
*Untitled*, 1990
From the Kitchen Table Series
Gelatin silver print and text panel
Image: 27 × 27 in. (68.6 × 68.6 cm)
Ralph M. Parsons Fund Photography
M.91.107.3
p. 76

Willie Robert Middlebrook
United States, 1957–2012
*In His "Own" Image*, 1992
From the series *Portraits of My People*
Gelatin silver prints
Overall: 96 × 80 in. (243.8 × 203.2 cm)
Ralph M. Parsons Fund
AC1993.128.1.1–.16
p. 120

Kerry James Marshall
United States, b. 1955
*De Style*, 1993
Acrylic and collage on canvas
104 × 122 in. (264.2 × 309.9 cm)
Purchased with funds provided by Ruth and Jacob Bloom
AC1993.76.1
pp. 86–87

Laura Aguilar
United States, 1959–2018
*Clothed/Unclothed #34*, 1994
Gelatin silver prints
Each: 20 × 16 in. (50.8 × 40.6 cm)
Gift of the Laura Aguilar Trust of 2016, jointly acquired by the Los Angeles County Museum of Art and the Vincent Price Art Museum Foundation
M.2020.93.14a–b
pp. 50–51

Lyle Ashton Harris
United States, b. 1965
Renee Cox
Jamaica, b. 1960, active United States
*The Child*, 1994
Dye diffusion transfer print
Primary support: 30⅜ × 22 in. (77.2 × 55.8 cm)
The Audrey and Sydney Irmas Collection
AC1997.52.1
p. 90

Deborah Willis
United States, b. 1948
*Living Room Picture Stories*, 1994
Photo-quilt: fabric, hand-colored photosensitive cotton, and lace
46 × 43 in. (116.8 × 109.2 cm)
Ralph M. Parsons Fund
AC1995.17.1
pp. 134, 182–83, 187

Samella Lewis
United States, 1923–2022
*Bag Man*, 1996
Oil on canvas
51½ × 32¾ in. (130.8 × 83.2 cm)
Purchased with funds provided by Jen Rubio and Stewart Butterfield
M.2022.56
p. 66

Alison Saar
United States, b. 1956
*Sledge Hammer Mamma*, 1996
Ceiling tin on wood with nails and sledgehammer
32 × 7 × 8 in. (81.3 × 17.8 × 20.3 cm)
Purchased with funds provided by Paul and Suzanne Muchnic and Reese and Linda M. Polesky in loving memory of Herbert V. Muchnic. Additional funds generously provided by Times Mirror
AC1996.161.1
p. 124

Lorna Simpson
United States, b. 1960
*Backdrops, Circa 1940s*, 1998
Screenprint diptych on felt panels
Overall: 26¼ × 33¾ in. (66.5 × 85.7 cm)
Ralph M. Parsons Fund, gift of Robert M. and Lynda Shapiro
M.2021.101a–b
p. 117

Lee Jaffe
United States, b. 1950
*Jean-Michel Basquiat*, 1983, printed 2005
Digital ink-jet print
15 × 22 in. (38.1 × 55.9 cm)
Gift of Fred and Winter Hoffman
M.2015.212.15
p. 100

Henry Taylor
United States, b. 1958
*She is not a ho*, 2005
Mixed media on canvas
64 × 78¼ × 1½ in. (162.6 × 198.8 × 3.8 cm)
Gift of Dean Valentine and Amy Adelson
M.2008.283.5
p. 98

Shinique Smith
United States, b. 1971
*Untitled (Rodeo Beach Bundle)*, 2007
Digital chromogenic print
30 × 20 in. (76.2 × 50.8 cm)
Gift of the artist and SAS Studio LLC,
in honor of Vernessia and
Lawrence H. Smith, Sr.
M.2021.75
p. 85

Shepard Fairey
United States, b. 1970
*Yes We Did*, November 7, 2008
Offset lithograph
36 × 24 in. (91.4 × 61 cm)
Gift of Shepard and Amanda Fairey
M.2019.254.4
p. 123

William Scott
United States, b. 1964
*Untitled*, c. 2008
Watercolor and acrylic on paper
24 × 18 in. (61 × 45.8 cm)
Gift of Burton Aaron
M.2021.98
p. 54

Deborah Willis
United States, b. 1948
Hank Willis Thomas
United States, b. 1976
*Sometimes I See Myself in You*, 2008
Dye coupler print
19¾ × 48⅝ in. (50.2 × 123.4 cm)
Gift of the artists
M.2021.67.1
p. 142

Deborah Willis
United States, b. 1948
Hank Willis Thomas
United States, b. 1976
*Thomas and Thomas*, 2008
Dye coupler print
19½ × 27⅛ in. (49.5 × 68.9 cm)
Gift of the artists
M.2021.67.2
p. 111

Whitfield Lovell
United States, b. 1959
*#3 (After the Card Series)*, 2009
Charcoal on paper
12¼ × 9 in. (31.1 × 22.9 cm)
Promised gift of Bruce and Donna Polichar
p. 28

Nicole Miller
United States, b. 1982
*The Conductor*, 2009
Digital film
Duration: 7 minutes, 13 seconds
Purchased with funds provided by Eduardo
Muller Contemporary Art
M.2013.50.1–.3
p. 67

Ralph Nelson
United States, b. 1946
*Untitled (Obama in Mirror, B&W)*, 2009
Archival ink-jet print
Image: 8 × 12 in. (20.3 × 30.5 cm)
Gift of Jeff Dunas and friends
M.2010.183.2.13
p. 145

Lorna Simpson
United States, b. 1960
*1957–2009 Interior Group 3*, 2009
Gelatin silver prints
Mat (each): 7 × 7 in. (17.8 × 17.8 cm)
The Audrey and Sydney Irmas Collection
M.2011.46.1–.10
pp. 32–34

Janna Ireland
United States, b. 1985
*The Black Suit*, 2012
Pigment-based ink-jet print
40 × 32 in. (101.6 × 81.3 cm)
Ralph M. Parsons Fund
M.2020.19.1
p. 91

Kerry James Marshall
United States, b. 1955
*Black Beauty (Tyla)*, 2012
Ink-jet print
31 × 23 in. (78.7 × 58.4 cm)
Promised gift of Sharyn and Bruce Charnas
p. 116

Stan Douglas
Canada, b. 1960
*Luanda-Kinshasa*, 2013
Single-channel video projection (color, sound)
Duration: 1 hour, 8 minutes, 34 seconds
Collection of the Los Angeles County Museum
of Art and Perez Art Museum Miami (PAMM),
purchased jointly with funds provided by
Viveca Paulin-Ferrell and Will Ferrell, Allison
and Larry Berg, Jeanne Williams and Jason
Greenman, Holly and Albert Baril, Katherine
Ross and Michael Govan, Shannon and Peter
Loughrey, Terri and Michael Smooke, Jennifer
Hawks and Ramin Djawadi, and Phil Mercado
and Todd Quinn through Contemporary
Friends, 2015 and PAMM's Collectors Council
M.2016.169.1–.2
pp. 148–49

Todd Gray
United States, b. 1954
*Mirror Mirror*, 2014
Archival pigment prints and found antique
frames
29½ × 23½ × 2 in. (74.9 × 59.7 × 5.1 cm)
Promised gift of the collection of Arthur Lewis
and Hau Nguyen
p. 47

Carrie Mae Weems
United States, b. 1953
*Untitled (Ella on silk)*, 2014
Diptych printed with fabric dye on silk
charmeuse
Left frame: 44½ × 34¼ × 2¼ in.
(113 × 87 × 5.7 cm)
Right frame: 15 × 12 × 2¼ in.
(38.1 × 30.5 × 5.7 cm)
Gift of Susan Brennan in honor of Franklin
Sirmans, Artistic Director of Prospect.3
M.2014.262a–b
p. 144

Njideka Akunyili Crosby
Nigeria, b. 1983, active United States
*I Still Face You*, 2015
Acrylic, colored pencil, charcoal, oil, and
transfers on paper
83 ¼ × 104¾ in. (211.5 × 266.1 cm)
Purchased with funds provided by Holly and
Albert Baril and AHAN: Studio Forum, 2015
Art Here and Now Purchase
M.2016.242.1b
pp. 38–39

Rico Gatson
United States, b. 1966
*Bird*, 2015
Colored pencil and gelatin silver print on
paper
22 × 30 in. (55.9 × 76.2 cm)
Gift of Marco Nocella
M.2021.28
p. 130

Genevieve Gaignard
United States, b. 1981
*Trailblazer (A Dream Deferred)*, 2015
Chromogenic print
40¾ × 60¾ × 2 in. (103.5 × 154.3 × 5.1 cm)
Purchased with funds provided by the Ruben
Family
M.2021.129
p. 96

Kambui Olujimi
United States, b. 1976
*Untitled*, 2015–20
From the series *Walk With Me*
Ink and graphite on paper
14 × 11 in. (35.6 × 27.9 cm)
Purchased with funds provided by Sally and
Ralph Tawil
M.2021.147.1
p. 52

Kambui Olujimi
United States, b. 1976
*Untitled*, 2015–20
From the series *Walk With Me*
Ink and graphite on paper
14 × 11 in. (35.6 × 27.9 cm)
Purchased with funds provided by Sally and
Ralph Tawil
M.2021.147.2
p. 52

Catherine Opie
United States, b. 1961
*Kamala Harris*, 2015
Pigment print
24 × 20 in. (61 × 50.8 cm)
Gift of the artist
p. 88

Umar Rashid
United States, b. 1976
*Yolanda, Lady of Yerba Buena*, 2015
Acrylic and ink transfer on wood
8 × 6 in. (20.3 × 15.2 cm)
Promised gift of the collection of Arthur
Lewis and Hau Nguyen
p. 46

Martine Syms
United States, b. 1988
*Notes on Gesture*, 2015
Single-channel video (color, sound)
Duration: 10 minutes, 33 seconds
Purchased with funds provided by AHAN:
Studio Forum, 2016 Art Here and Now
purchase
M.2016.248.2.2.LEXC
p. 37

Sadie Barnette
United States, b. 1984
*Untitled (Dad, 1966 and 1968)*, 2016
Digital chromogenic prints
45½ × 39½ in. (115.6 × 100.3 cm)
Anonymous gift
M.2018.234a–b
p. 35

Alison Saar
United States, b. 1956
*Breach*, 2016
Wood, ceiling tin, found trunks, washtubs,
and other objects
155 × 60 × 51 in. (393.7 × 152.4 × 129.5 cm)
Purchased with funds from an anonymous
donor
M.2018.74.1–.20
p. 95

Renee Cox
Jamaica, b. 1960, active United States
*The Signing*, 2017
Digital chromogenic print
36½ × 99¼ × 3 in. (92.7 × 252.1 × 7.6 cm)
Gift of Amar Singh
M.2021.59.2
pp. 62–63, 170–71

Paul Mpagi Sepuya
United States, b. 1982
*Darkroom Mirror Study (0X5A1525)*, 2017
Dye-based ink-jet print
Primary support: 51 × 34 in. (129.5 × 86.4 cm)
Purchased with funds provided by LENS:
Photography Council, 2018
M.2018.109
pp. 14, 135

Nathaniel Mary Quinn
United States, b. 1977
*Uncle Dope*, 2017
Charcoal, gouache, soft pastel, oil pastel, and
paint stick on paper
24 × 17½ in. (61 × 44.5 cm)
Promised gift of Heather and Theodore
Karatz
p. 138

Jonathan Lyndon Chase
United States, b. 1989
*butt naked dressed in nothing but pearls*, 2018
Marker, acrylic, oil, and spray paint on canvas
and Styrofoam heads
72 × 60 × 1½ in. (182.9 × 152.4 × 3.8 cm)
Purchased with funds provided by Joel Lubin
M.2019.31a–d
p. 61

Lauren Halsey
United States, b. 1987
*The Crenshaw Hieroglyphic Project: Exterior
Wall (Featuring Frankie Beverly)*, 2018
Carved gypsum on wood
24 × 24 in. (61 × 61 cm)
Promised gift of Janine Sherman Barrois and
Lyndon J. Barrois, Sr.
p. 44

Janna Ireland
United States, b. 1985
*Wife and Mother*, 2018
Pigment-based ink-jet prints
Each: 45 × 30 in. (114.3 × 76.2 cm)
Purchased with funds provided by the Ralph
M. Parsons Fund
M.2020.19.2.1–.2
p. 89

Glenn Kaino
United States, b. 1972
*Invisible Man (Salute)*, 2018
Aluminum and stainless steel
95 × 41¼ × 41¼ in. (241.3 × 104.8 × 104.8 cm)
Gift of the artist
M.2021.146
p. 94

Toyin Ojih Odutola
Nigeria, b. 1985, active United States
*Junior's Research*, 2018
Pastel, charcoal, and graphite on paper
70¾ × 41¾ in. (179.7 × 106.1 cm)
Gift of Steve and Lizzie Blatt
M.2020.210
p. 84

Deborah Roberts
United States, b. 1962
*Breaking ranks*, 2018
Paper collage, acrylic, and pigment
Sheet: 30¼ × 22 in. (76.8 × 55.9 cm)
Purchased with funds provided by Karen
R. Constine, the Ralph M. Parsons Fund,
George and Azita Fatheree, Nike O.
Opadiran, and Demetrio and Gianna Kerrison
M.2019.5
p. 105

Xaviera Simmons
United States, b. 1974
*Sundown (Number Twenty)*, 2018
Dye coupler print
46 × 38 in. (116.8 × 96.5 cm)
Gift of Sharyn and Bruce Charnas
M.2021.123
pp. 108, 220

Dannielle Bowman
United States, b. 1989
*Vision (Bump'N' Curl)*, 2019
Pigment-based ink-jet print
40 × 32 in. (101.6 × 81.3 cm)
Purchased with funds provided by the Ralph
M. Parsons Fund
M.2021.61.2
p. 45

Dannielle Bowman
United States, b. 1989
*Vision (Garage)*, 2019
Pigment-based ink-jet print
30 × 23 in. (76.2 × 58.4 cm)
Purchased with funds provided by LENS:
Photography Council, 2020
M.2021.169
p. 115

Diedrick Brackens
United States, b. 1989
*look spit out*, 2019
Cotton, nylon, acrylic yarn, and silk
72 × 72 in. (182.9 × 182.9 cm)
Purchased with funds provided by Allison
and Larry Berg
M.2019.220
p. 97

Mark Bradford
United States, b. 1961
*Dancing in the Street*, 2019
Single-channel video (color)
Duration: 2 minutes, 50 seconds
Gift of Andy Song
M.2020.223.1
p. 140

Reggie Burrows Hodges
United States, b. 1965
*Swimming in Compton: Auntie B*, 2019
Acrylic and pastel on canvas
60 × 60 in. (152.4 × 152.4 cm)
Gift of Laura and Stafford Broumand
M.2021.71
p. 99

Kenturah Davis
United States, b. 1984
*A Question Only Answered With Another
Question*, 2019
Oil applied with rubber stamp letters on
embossed and debossed Igarashi kozo
paper
39 × 58 in. (99.1 × 147.3 cm)
Promised gift of Chelsea and Ali Rana
p. 27

216

Amy Sherald
United States, b. 1973
*An Ocean Away*, 2020
Oil on canvas
130 × 108 × 2½ in. (330.2 × 274.3 × 6.4 cm)
Promised gift of Robert Iger and Willow Bay
p. 49

Tourmaline
United States, b. 1983
*Swallowtail*, 2020
Dye sublimation print
29½ × 30 in. (74.9 × 76.2 cm)
Purchased with funds provided
by Douglas Cordell
M.2021.130
p. 101

Fulton Leroy Washington (aka Mr. Wash)
United States, b. 1954
*Shattered Dreams*, 2020
Oil, acrylic, and glow-in-the-dark acrylic on
canvas
48 × 60 in. (121.9 × 152.4 cm)
Purchased with funds provided by Aubrey
Drake Graham
M.2021.131
pp. 56–57

rafa esparza
United States, b. 1981
*big chillin with Patrisse*, 2021
Acrylic on adobe
72 × 57 in. (182.9 × 144.8 cm)
Purchased with funds provided by Liana
Krupp
M.2021.127
p. 65

Deana Lawson
United States, b. 1979
*Barrington and Father*, 2021
Pigment print
73¾ × 57⅝ in. (187.3 × 146.4 cm)
Gift of Patricia and Rabie Ahmad
M.2021.120
pp. 110, 219

Ada Pinkston
United States, b. 1983
*The Open Hand is Blessed*, 2021
Augmented reality Snapchat lens
Commissioned by the Los Angeles County
Museum of Art and Snap Inc.
M.2021.148
pp. 24–25

Mickalene Thomas
United States, b. 1971
*The Inversion of Racquel*, 2021
Rhinestones, acrylic, and oil on canvas
mounted on wood panel
96 × 72 in. (243.8 × 182.9 cm)
Commissioned by the Los Angeles County
Museum of Art with funds provided by an
anonymous donor
M.2021.126
pp. 127, 210

Kehinde Wiley
United States, b. 1977
*Yachinboaz Ben Yisrael II*, 2021
Oil on linen
Canvas: 96 × 65 in. (243.8 × 165.1 cm)
Promised gift of Rich Paul
pp. 136, 160–61

To learn more about these works and the
sitters who appear in them, please visit
LACMA's Collections Online database at
https://collections.lacma.org/.

# Contributors

**Hilton Als** is a Pulitzer Prize–winning staff writer at *The New Yorker* magazine, and a curator. He lives in New York.

**Myrtle Elizabeth "Liz" Andrews** is an artist, curator, museum professional, and leader dedicated to the arts and social justice. From 2016 to 2021 she was Executive Administrator in the Director's Office at the Los Angeles County Museum of Art. She is now Executive Director of the Spelman College Museum of Fine Art, the only museum in the nation focused on art by and about women of the African diaspora.

**Bridget R. Cooks**, PhD, is Chancellor's Fellow and Professor in the Department of African American Studies and the Department of Art History at the University of California, Irvine. Her research focuses on African American artists, Black visual culture, and museum criticism. Her scholarship can be found in dozens of books, academic journals, and art exhibition catalogues.

**Ilene Susan Fort** is Curator Emerita of the American Art Department at the Los Angeles County Museum of Art. She is author of numerous articles, catalogues, and books on nineteenth- and twentieth-century art. She researched and co-wrote the museum's first collection catalogue on American art (1991), oversaw the Archibald Motley exhibition (2014), and contributed an essay for the Charles White retrospective catalogue (2018).

**Naima J. Keith** is the Vice President of Education and Public Programs at the Los Angeles County Museum of Art. Within her role, she oversees all aspects of and sets the vision for LACMA's innovative and exhibition-driven educational programming that serves more than 650,000 community members annually.

**Christine Y. Kim** is Britton Family Curator-at-Large of North American Art for Tate Modern. As Curator of Contemporary Art at the Los Angeles County Museum of Art from 2009 to 2021, Kim organized *Julie Mehretu* (2019), *Isaac Julien: Playtime* (2019), *James Turrell: A Retrospective* (2013), and *Human Nature: Contemporary Art from the Collection* (2011), among other exhibitions. Kim was a curator at the Studio Museum in Harlem from 2000 to 2008, and has contributed to numerous publications and co-curated international exhibitions such as the 12th Gwangju Biennial, South Korea (2018).

**Dhyandra Lawson** is Assistant Curator in the Wallis Annenberg Photography Department at the Los Angeles County Museum of Art. Her research interests include photography, performance, and media-based practice; contemporary African American and African diaspora artists; and rhetoric and contemporary art theory.

**Jeffrey C. Stewart**, PhD, is MacArthur Foundation Chair and Distinguished Professor in the Department of Black Studies at the University of California, Santa Barbara. His biography *The New Negro: The Life of Alain Locke* (2018) won the 2019 Pulitzer Prize for Biography, the 2018 National Book Award for Nonfiction, and the 2019 American Book Award. His most recent book is *The New Negro Aesthetic* (2022).

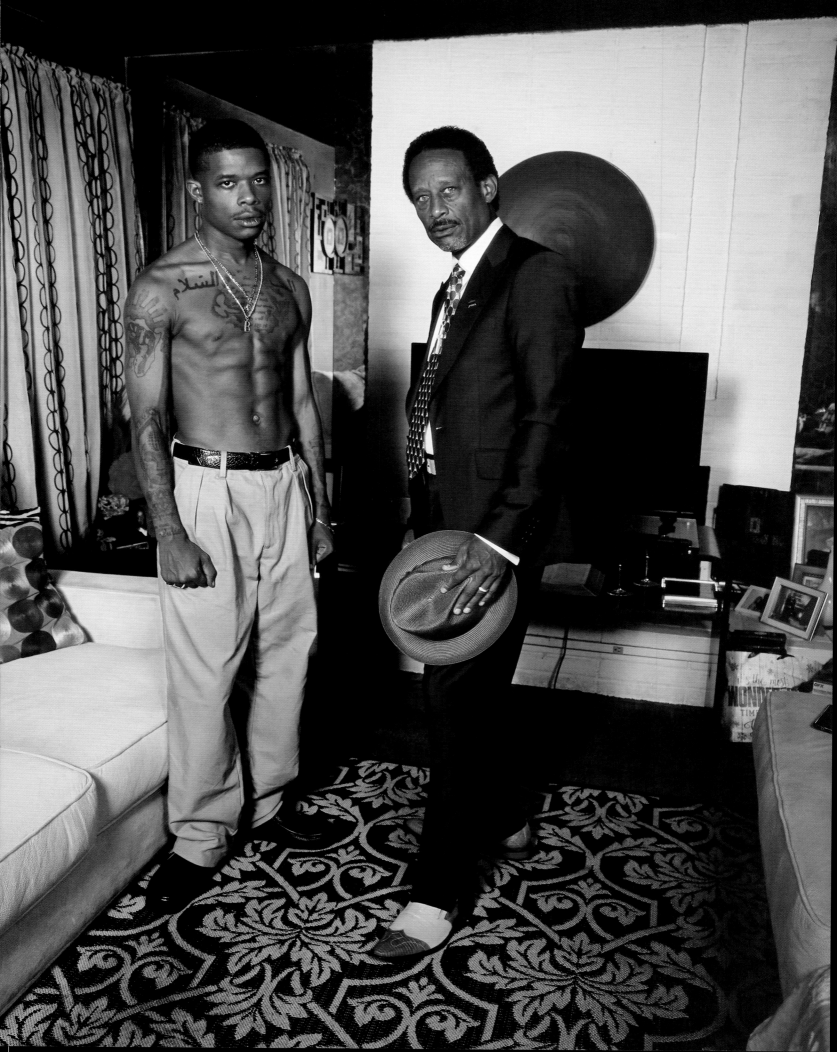

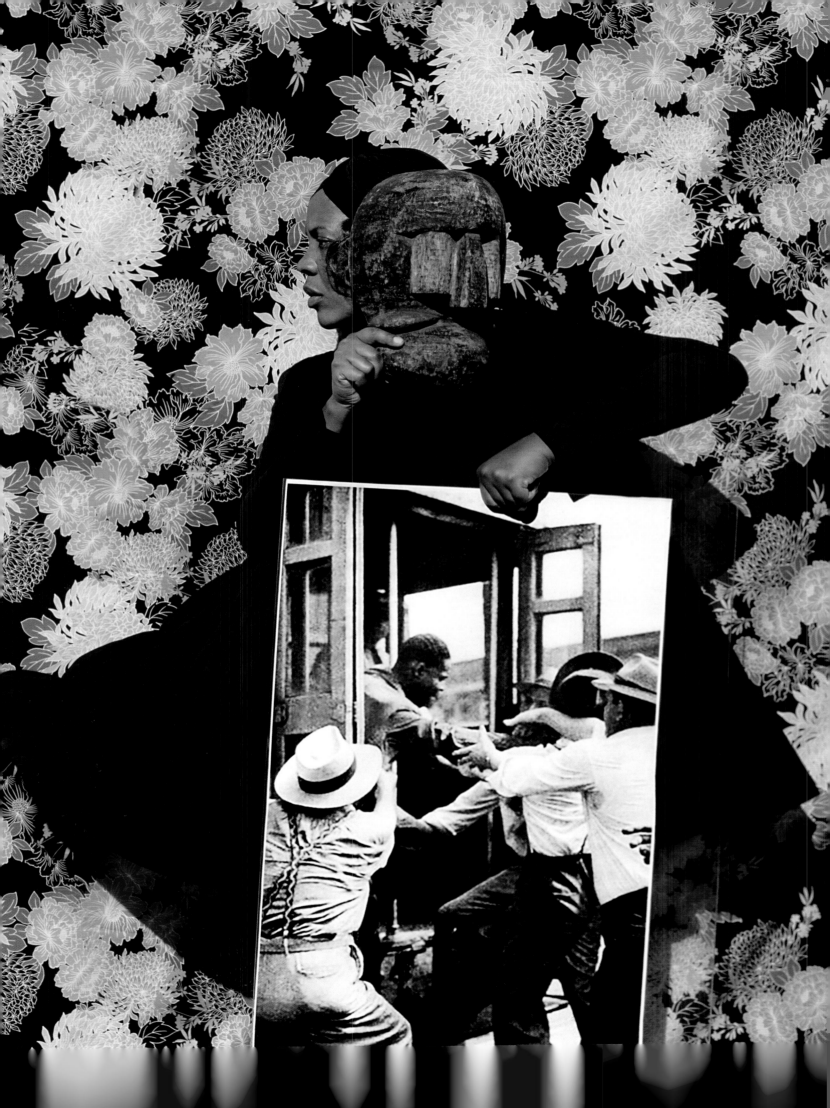

# Image Credits

Works and photographs are reproduced courtesy of the creators and lender of the materials depicted. The following images, keyed to page number, are those for which additional or separate credits are due. Unless otherwise noted, all photos are © 2023 Museum Associates/LACMA.

Cover, p. 58: © 2023 Bisa Butler; back cover, p. 77: © 2023 The Jacob and Gwendolyn Knight Lawrence Foundation, Seattle/Artists Rights Society (ARS), New York; pp. 3, 93: © 2023 Bruce Davidson; pp. 4, 106: © 2023 Zora J Murff, courtesy of Webber Gallery; pp. 7, 132: photo courtesy of Sotheby's; pp. 10, 31, 78, 79, 80, 81, 190–91: © 2023 James Van Der Zee Archive, The Metropolitan Museum of Art; pp. 14, 135: © 2023 Paul Mpagi Sepuya, digital image courtesy of the artist; pp. 21, 86–87, 116: © 2023 Kerry James Marshall, courtesy of the artist and David Zwirner; pp. 22, 126, 223: © 2023 Isaac Julien, courtesy of the artist and Victoria Miro; p. 23: © 2023 Lezley Saar; pp. 24–25: © 2023 Ada Pinkston, image courtesy of Snap Inc.; p. 26: © 2023 Kahlil Joseph; p. 27: © 2023 Kenturah Davis, photo courtesy of Matthew Brown, Los Angeles; p. 28: © 2023 Whitfield Lovell, courtesy of DC Moore Gallery, New York; p: 30: © 2023 Mora-Catlett Family/licensed by VAGA at Artists Rights Society (ARS), NY; pp. 32, 33, 34, 117: © 2023 Lorna Simpson, courtesy of the artist and Hauser & Wirth; p. 35: © 2023 Sadie Barnette, photo courtesy of Charlie James Gallery, Los Angeles; p. 36: © 2023 Estate of Roy DeCarava. All rights reserved. Courtesy of David Zwirner; p. 37: © 2023 Martine Syms, courtesy of the artist and Bridget Donahue, New York; pp. 38–39: © 2023 Njideka Akunyili Crosby, courtesy of the artist, Victoria Miro, and David Zwirner, photo by Joshua White Photography; p. 40: © 2023 Robert Pruitt; p. 41: © 2023 Woody De Othello, photo by John Wilson White, courtesy of Jessica Silverman, San Francisco; p. 42 top: © 2023 Estate of Beauford Delaney, by permission of Derek L. Spratley, Esquire, Court Appointed Administrator, courtesy of Michael Rosenfeld Gallery LLC, New York; p. 42 bottom: © 2023 Edward Biberman Estate; p. 43: © 2023 Arthur Jafa, courtesy of the artist and Gladstone Gallery; p. 44: © 2023 Lauren Halsey, courtesy of the artist and David Kordansky Gallery, Los Angeles and New York; pp. 45, 115: © 2023 Dannielle Bowman, digital images courtesy of the artist; p. 46: © 2023 Umar Rashid; p. 47: © 2023 Todd Gray, digital image courtesy of the artist; p. 48: © 2023 Kim Dacres, photography by Ed Mumford, courtesy of the artist and GAVLAK Los Angeles | Palm Beach; p. 49: © 2023 Amy Sherald, courtesy of the artist and Hauser & Wirth, photo by Joseph Hyde; pp. 50, 51: © 2023 Laura Aguilar Trust; p. 52: © 2023 Kambui Olujimi; p. 53: © 2023 Cedric Adams; p. 54 left: © 2023 Creative Growth Art Center, courtesy of Creative Growth and the artist; p. 54 right: © 2023 Frederick J. Brown Trust, digital image courtesy of Berry Campbell, New York; p. 55: © 2023 Chase Hall, courtesy of the artist and C L E A R I N G, New York/Brussels, photo by JSP Art Photography; pp. 56–57: © 2023 Fulton Leroy Washington, digital image courtesy of the artist; p. 59: © 2023 D'Angelo Lovell Williams, courtesy of the artist and Higher Pictures Generation; p. 60 top: © 2023 Clifford Prince King, digital image courtesy of the artist; p. 60 bottom: © 2023 Estate of Alvin Baltrop/Artists Rights Society (ARS), New York; p. 61: © 2023 Jonathan Lyndon Chase, courtesy of the artist and Kohn Gallery, Los Angeles, photo by Coke O'Neal; pp. 62–63, 170–71: © 2023 Renee Cox, digital image courtesy of the artist; pp. 64, 118: © 2023 Kwame Brathwaite, photos courtesy of the Kwame Brathwaite Archive and Philip Martin Gallery, Los Angeles; p. 65: © 2023 rafa esparza, photo by Ruben Diaz, courtesy of the artist and Commonwealth and Council, Los Angeles; p. 66: 2023 Estate of Samella Lewis, photo by Gene Ogami, courtesy of Stella Jones Gallery and the artist's estate; p. 67: © 2023 Nicole Miller, digital images courtesy of the artist and Kristina Kite Gallery, Los Angeles; p. 68, 204 right: © 2023 David Hammons; p. 69: © 2023 Timothy Washington; p. 70: © 2023 Micaiah Carter, photograph courtesy of the artist and Sarah Hasted/International Art Advisory; p. 71: © 2023 Jordan Casteel, courtesy of the artist and Casey Kaplan, New York, photo by David Schulze; p. 72: photo by Frédéric Uyttenhove, Brussels; p. 73: © 2023 Richmond Barthé Estate, courtesy of Stella Jones Gallery, New Orleans; pp. 74, 75, 76, 144: © 2023 Carrie Mae Weems, courtesy of the artist and Jack Shainman Gallery, New York; pp. 82–83: © 2023 Calida Rawles; p. 84: © 2023 Toyin Ojih Odutola, courtesy of the artist and Jack Shainman Gallery, New York; p. 85: © 2023 Shinique Smith, digital image courtesy of the artist; p. 88 left: © 2023 The Estate of Alice Neel, courtesy of The Estate of Alice Neel and David Zwirner; p. 88 right: © 2023 Catherine Opie, digital image courtesy of the artist and Regen Projects, Los Angeles; pp. 89, 91: © 2023 Janna Ireland, digital images courtesy of the artist; p. 90: © 2023 Lyle Ashton Harris; p. 92: © 2023 Emory Douglas/Artists Rights Society (ARS), New York; p. 94: © 2023 Glenn Kaino; p. 95, 124 left: © 2023 Alison Saar; p. 96: © 2023 Genevieve Gaignard, courtesy of the artist and Vielmetter Los Angeles; p. 97: © 2023 Diedrick Brackens, image courtesy of the artist and Various Small Fires, Los Angeles and Seoul; p. 98: © 2023 Henry Taylor, courtesy of the artist and Hauser & Wirth; p. 99: © 2023 Reggie Burrows Hodges, courtesy of the artist and Karma, New York; p. 100: © 2023 Lee Jaffe; p. 101: © 2023 Tourmaline, photo courtesy of the artist and Chapter NY; pp. 102, 103: © 2023 Lorraine O'Grady/Artists Rights Society (ARS), New York; p. 105: © 2023 Deborah Roberts, photo by Philip Rogers; p. 107: courtesy of and copyright © 2023 The Gordon Parks Foundation; pp. 108, 220: © 2023 Xaviera Simmons, digital image courtesy of the artist; p. 109: © 2023 Estate of Sam Doyle; pp. 110, 219: © 2023 Deana Lawson, courtesy of the artist, David Kordansky Gallery, Los Angeles and New York, and Sikkema Jenkins & Co., New York, digital image by Fredrik Nilsen Studio; pp. 111, 142: © 2023 Deborah Willis and Hank Willis Thomas, courtesy of the artists and Jack Shainman Gallery, New York; p. 112: © 2023 Jerrell Gibbs; p. 113: © 2023 Ming Smith, digital image courtesy of the artist; p. 114: © 2023 The Estate of Edward Steichen/Artists Rights Society (ARS), New York; pp. 119, 124 right, 143, 166 left, 181: © 2023 The Charles White Archives; p. 120: © 2023 Willie Robert Middlebrook Estate; p. 121: © 2023 Betye Saar; p. 122, 123: © 2023 Obey Giant Art, Inc., courtesy of Shepard Fairey/obeygiant.com; p. 125: © 2023 Estate of John Biggers, courtesy of Michael Rosenfeld Gallery LLC, New York; pp. 127, 210: © 2023 Mickalene Thomas; p. 128: © 2023 Otis Kwame Kye Quaicoe, image of painting by Robert Wedemeyer, courtesy of the artist and Roberts Projects Los Angeles; p. 129: © 2023 Charles Gaines, courtesy of the artist and Hauser & Wirth, photo by Fredrik Nilsen; p. 130: © 2023 Rico Gatson, photo courtesy of Ronald Feldman Gallery, New York; p. 131: © 2023 Glenn Kaino, photography by Glenn Kaino Studio; pp. 134, 182–83, 187 right: © 2023 Deborah Willis; pp. 136, 160–61: © 2023 Kehinde Wiley, courtesy of Roberts Projects, Los Angeles; p. 137: © 2023 Kent Twitchell; p. 138: © 2023 Nathaniel Mary Quinn, photo by Michael Tropea; p. 139: © 2023 Estate of David C. Driskell, courtesy of DC Moore Gallery, New York; pp. 140, 198–99, 202, 203, 205: Mark Bradford, courtesy of the artist and Hauser & Wirth; p. 141: © 2023 Wangari Mathenge, image of painting by Robert Wedemeyer, courtesy of the artist and Roberts Projects Los Angeles; p. 145: © 2023 Ralph Nelson; p. 146: © 2023 Kohshin Finley, photo courtesy of the artist; pp. 148, 149: © 2023 Stan Douglas, courtesy of the artist, Victoria Miro and David Zwirner; pp. 151 left, 176 top right: © 2023 Kehinde Wiley. The National Portrait Gallery is grateful to the following lead donors for their support of the Obama portraits: Kate Capshaw and Steven Spielberg; Judith Kern and Kent Whealy; Tommie L. Pegues and Donald A. Capoccia; Clarence, DeLoise and Brenda Gaines; The Stoneridge Fund of Amy and Marc Meadows; Robert E. Meyerhoff and Rheda Becker; and Catherine and Michael Podell pp. 151 right, 177: The National Portrait Gallery is grateful to the following lead donors for their support of the Obama portraits: Kate Capshaw and Steven Spielberg; Judith Kern and Kent Whealy; Tommie L. Pegues and Donald A. Capoccia; Clarence, DeLoise and Brenda Gaines; The Stoneridge Fund of Amy and Marc Meadows; Robert E. Meyerhoff and Rheda Becker; and Catherine and Michael Podell; p. 152 left: © 2023 Tavares Strachan; pp. 153, 168 right: © Chicago History Museum/© Estate of Archibald John Motley Jr. All reserved rights 2023/Bridgeman Images; pp. 154 left, 164 bottom, 165 top right, 204 left: LACMA Photographic Archives; p. 154 top right: © 2023 Zak Ové; p. 154 bottom right: © 2023 Cauleen Smith; pp. 158, 159, 186, 208, 209: photos by HRDWRKER; p. 166 bottom right: artworks © 2023 Maren Hassinger, photo: LACMA Photographic Archives; p. 168 left: © 2023 Loïs Mailou Jones Pierre-Noël Trust; pp. 175, 176 bottom right, 194 left: digital images courtesy of the Smithsonian Open Access Initiative; p. 176 left: digital image courtesy of the Library of Congress; p. 179: © 2023 Joyce Owens, photo courtesy of the artist; p. 197: photo courtesy of the Architect of the Capitol, Washington, D.C.; p. 224: photo by Yurin Mok

# Additional Captions

p. 3: Bruce Davidson, *Untitled*, c. 1989 (detail); p. 4: Zora J Murff, *American Mother*, 2019; p. 7: William Armfield Hobday, *Portrait of Prince Saunders*, c. 1815 (detail); p. 8: Artist not recorded, *Untitled*, late 19th century (detail); p. 10: James Van Der Zee, *Atlantic City*, 1930 (detail); p. 14: Paul Mpagi Sepuya, *Darkroom Mirror Study (0X5A1525)*, 2017 (detail); pp. 158–59: Kehinde Wiley, *Yachinboaz Ben Yisrael II*, 2021 (detail); pp. 170–71: Renee Cox, *The Signing*, 2017 (detail); pp. 182–83: Deborah Willis, *Living Room Picture Stories*, 1994 (detail); pp. 190–91: James Van Der Zee, *Crowd in Harlem*, 1920 (detail); pp. 198–99: Mark Bradford, *150 Portrait Tone*, 2017 (detail); p. 210: Mickalene Thomas, *The Inversion of Racquel*, 2021 (detail); p. 219: Deana Lawson, *Barrington and Father*, 2021 (detail); p. 220: Xaviera Simmons, *Sundown (Number Twenty)*, 2018 (detail); p. 223: Isaac Julien, *The Last Angel of History*, 1989/2016 (detail)

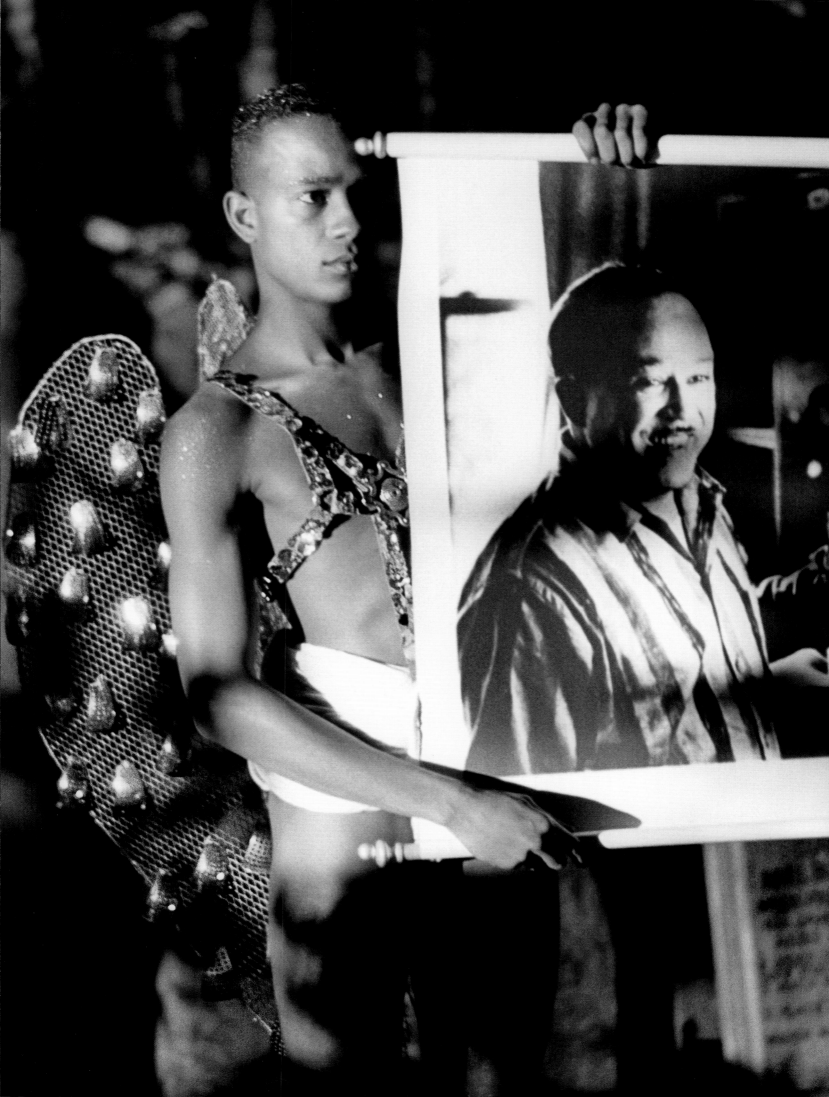

Published in conjunction with the exhibition *Black American Portraits*.

Itinerary
Los Angeles County Museum of Art
November 7, 2021–April 17, 2022

Spelman College Museum of Fine Art
January 30–May 14, 2023

Memphis Brooks Museum of Art
September 23, 2023–July 1, 2024

Generous support for the *Black American Portraits: From the Los Angeles County Museum of Art* publication was provided by the 2021 Collectors Committee; Karma, New York; and Catherine and Michael Podell in honor of Janine Sherman Barrois and Lyndon J. Barrois, Sr.

*Black American Portraits* was organized
by the Los Angeles County Museum of Art.

Presented by

**BANK OF AMERICA** 🇺🇸  **GUCCI**

Principal sponsorship provided by **Snapchat** 👻

Major support provided by Janine Sherman Barrois and Lyndon J. Barrois, Sr.; Ina Coleman; Brickson E. Diamond; The Claire Falkenstein Foundation; Kristen Boggs Jaeger and Jeffrey Jaeger; Jill Lawrence and Paul Koplin in honor of Martha Koplin; Arthur R. Lewis; Janet Dreisen Rappaport; and D'Rita and Robbie Robinson.

Generous support provided by Alpha Kappa Alpha Sorority, Incorporated®; Stanley and Joyce Black Family Foundation; Kimberly A. Blackwell; Lizzie and Steve Blatt; Rebecca and Troy Carter; Ava L. Coleman and Debra L. Lee; Far Western Region, Alpha Kappa Alpha Sorority, Incorporated®; George and Azita Fatheree; Danny First; Foundation for Advancement in Conservation and Tru Vue, Inc.; The Gilford Family; Deon T. Jones; Gail and George Knox; Chrystal and Melvin D. Lindsey; Andrea Nelson Meigs and John Meigs; Issa Rae; Jason and Susan Riffe; Julie and Bennett Roberts, Roberts Projects; V. Joy Simmons, M.D., Ryan Tarpley; Treehouse; Abbey Wemimo and Taylor Goodridge; Ric Whitney and Tina Perry-Whitney; and Dr. Francille Rusan Wilson and Dr. Ernest J. Wilson III.

Copublished in 2023 by

Los Angeles County Museum of Art
5905 Wilshire Boulevard
Los Angeles, CA 90036
(323) 857-6000
lacma.org

and

DelMonico Books
available through ARTBOOK | D.A.P
75 Broad Street, suite 630
New York, NY 10004
artbook.com
delmonicobooks.com

For LACMA
Publisher: Lisa Gabrielle Mark
Editor: Claire Crighton
Proofreader: Polly Watson
Rights and reproductions: Dawson Weber
Administrative support: Tricia Cochée and Sarah Applegate
Designer: Adraint Khadafhi Bereal

For DelMonico Books
Production Director: Karen Farquhar
Color separations: Echelon Color, Santa Monica

This book is typeset in Neue Haas Grotesk and in Carrie, a typeface designed by Tré Seals based on images of the 1915 march for women's suffrage in New York City. The endsheets are typeset in Harriet, a typeface Seals designed based on the Underground Railroad Quilt Code.

Library of Congress Control Number:
2022943435

Copyright © 2023 Museum Associates/Los Angeles County Museum of Art and DelMonico Books, New York

ISBN 978-1-63681-016-4

Printed and bound in China

Front cover: Bisa Butler, *Forever*, 2020 (detail)
Above: Artists at LACMA for the opening of *Black American Portraits*, November 5, 2021. Far left (left to right): Paul Mpagi Sepuya, Todd Gray, Reggie Burrows Hodges, D'Angelo Lovell Williams, Kahlil Joseph, Hank Willis Thomas; center back (left to right): Kambui Olujimi, Shepard Fairey, Karon Davis, Kohshin Finley, Chase Hall, Umar Rashid, Glenn Kaino, Ian White, Isaac Julien, Kwame Brathwaite Jr., Kenturah Davis; center (left to right): Shinique Smith, Kehinde Wiley, Amy Sherald, Martine Syms, Lezley Saar, Genevieve Gaignard, Sadie Barnette, Ming Smith, Mickalene Thomas; center front (left to right): William Scott, Allison Saar, Deborah Willis Thomas, Samella Lewis, Betye Saar, Renee Cox, William Cordova; far right (left to right): Lee Jaffe, Richard Wyatt Jr., Cedric Adams, Otis Kwame Kye Quaicoe, Fulton Leroy Washington (aka Mr. Wash), Henry Taylor, Clifford Prince King, Rico Gatson, Kim Dacres, Chelle Barbour, Bisa Butler, Calida Rawles, and Tavares Strachan
Back cover: Jacob Lawrence, *Woman with Groceries*, 1942